DESIGN
a personal brand

STAND

BUILD
a killer portfolio

OUT

FIND
a great design job

DENISE ANDERSON

STAND OUT: DESIGN A PERSONAL BRAND.
BUILD A KILLER PORTFOLIO.
FIND A GREAT DESIGN JOB.

Denise Anderson

PEACHPIT PRESS

Find us on the Web at www.peachpit.com.

To report errors, please send a note to errata@peachpit.com.

Peachpit is a division of Pearson Education.

Copyright © 2016 by Denise Anderson

ACQUISITIONS EDITOR: Nikki Echler McDonald

PRODUCTION EDITORS: Tracey Croom, Becky Winter

DEVELOPMENT EDITOR: Jennifer Bohanan

COPY EDITOR: Cathy Lane

PROOFER: Kim Wimpsett

ART DIRECTOR: Denise Anderson

COMPOSITORS: Margaret Grzymkowski, Kristin Leu

INDEXER: Valerie Haynes Perry

COVER DESIGN: Stephen Sepulveda

INTERIOR DESIGN: Denise Anderson, Margaret Grzymkowski

PRODUCTION ARTISTS: Laura Menza, Kristin Leu

ILLUSTRATOR: Margaret Grzymkowski

DESIGN ASSISTANTS: John Weigele, Stephen Sepulveda, Brooke Roderick

ISBN 13: 978-0-13-413408-6
ISBN 10: 0-13-413408-7
9 8 7 6 5 4 3 2 1

Printed and bound in the United States of America

"*Your portfolio is* A STORY
ABOUT YOU AND YOUR WORK—
an expression of growth
THROUGH ALL THE OBSTACLES,
SURPRISES, SUCCESSES AND FAILURES.
THIS IS YOUR EPIC. *Illuminate*
THE ARC OF YOUR CAREER AND
why you matter."

— Simon Pan

STAND OUT

ACKNOWLEDGMENTS

If you were stranded on a deserted island, you would want my *Stand Out* team along with you on the adventure. Jennifer Bohanan would develop and articulate an "SOS" message so compelling that you would be rescued straightaway. Laura Menza and Kristin Leu would harness their instincts and clarity to design a flawless plan of escape. Margaret Grzymkowski would use illustration to shape and beautify your shelter. John Weigele and Stephen Sepulveda, your "special missions" team, would create a set of aesthetically pleasing and highly functional survival tools. Brooke Roderick would organize and reassure you regularly that "everything will be all right." Thank you all for your time and devotion to the adventure that has been *Stand Out.* I could not have survived it without you.

STAND OUT TEAM

Jennifer Bohanan

Margaret Grzymkowski

Laura Menza

Kristin Leu

John Weigele

Stephen Sepulveda

Brooke Roderick

THANK YOU

Family and friends

SPECIAL THANKS

Gail Anderson

Robin Landa and
Rose Gonnella

Greg Leshé

Jeff Witchel

Simon Pan

FOR ALWAYS LOOKING OUT FOR ME. Thanks!

RBSD FAMILY

Robin Landa

Rose Gonnella

Alan Robbins

Ed Johnston

Chris Navetta

Liz Blazer

Jeff Witchel

RSBD students, colleagues, and alumni

PEACHPIT PRESS TEAM

Nikki McDonald

Cathy Lane

Becky Winter

Tracey Croom

Kim Wimpsett

Valerie Haynes Perry

THE BEST EDITOR (Nikki) WITH AN AMAZING TEAM. THANK YOU FOR THE OPPORTUNITY TO WRITE "Stand out."

FOR THEIR SUPPORT

Dr. Dawood Farahi
President, Kean University

Dr. Jeffrey Toney
Provost, Kean University

David Mohney
Dean, Michael Graves College, Kean University

Rose Gonnella
Executive Director, Robert Busch School of Design, Michael Graves College, Kean University

Stand Out is dedicated to:

MY PARENTS, MAUREEN AND FRANK ANDERSON,
who gave me the core values
at the heart of my true and
authentic self, and the foundation
for my personal brand; and

MY FAMILY, PAULA AND DYLAN,
who inspire me to stay true to
my brand promise, live my values,
and improve myself every day.

FOREWORD

by: Gail Anderson

I teach at the School of Visual Arts in New York City, a school that graduates hundreds of amazing designers every year. Denise Anderson (a fellow Anderson, but no relation) teaches at the Robert Busch School of Design at Kean University. From what I've seen over the years, her designers are pretty swell, too. So are Ellen Lupton's at Maryland Institute College of Art (MICA), and Andrew Byrom's at California State University, Long Branch (CSULB), not to mention those from Art Center College of Design, Rhode Island School of Design (RISD), Portfolio Center, Yale, and so many others. Not surprisingly, competition for the best jobs is fierce, and while you may assume that successfully landing a job is all about your work or where you went to school, it's really about you and the brand you create for yourself.

"Branding" is an overused word in our culture today—almost an eye-roller at this point. What does it mean to brand yourself, particularly when you don't have much professional experience to hang your hat on? And how does a person with little-to-no professional experience even have a brand? How can you create a portfolio that will make you the most memorable job candidate? The answers to these questions are here—you just have to keep reading.

You've taken the first important steps by cracking open this book, by challenging yourself to take it up a notch, and by seeking assistance from resources that can offer the help you need. You've already demonstrated that you have an open mind and a willingness to take a good hard look at yourself and your work—essential qualifications for a successful design professional. Well done!

A good portfolio tells a prospective employer important things about you—not just that you can choose great typefaces or have technical chops, but that you are adept at solving problems. A good portfolio reveals your curiosity and sometimes some humor. It tells your story— the story that is unique to you. Remember, in the end, it's all about finding a good fit. An employer wants to hire a great designer, of course, but is also looking for someone who brings something interesting to the table. How you craft your brand—your personal identity— will make you stand out, and it will make people want to hire you.

Do you have an online persona to share? A blog, vlog, Tumblr, or Instagram account we can peruse? Who you are out there on the interwebs counts these days, and you want to make sure that version of you is someone an employer wants to hire. Keep it smart, and keep it clean. But you knew that, and if you didn't, Denise will tell you how to bring it all together and create a truly stand-out portfolio.

Finally, let me remind you about one other thing your mother taught you. Send a thank-you note. After. Every. Interview. An email is okay, but an honest-to-goodness, handwritten message in an envelope affixed with something they call a postage stamp is thoughtful and will be greatly appreciated. It's yet another thing, like your good work and like your interesting personal brand, that makes you stand out.

Read on, take notes, and hopefully one day, you'll be the one hiring me.

INTRODUCTION

by: Denise Anderson

Students tell me that my Graphic Design Portfolio course is like boot camp without the mud. They're right. The process I put them through requires discipline, hard work, and perseverance. It closely resembles the design industry experience and prepares them for their transition into the professional world.

In 16 short weeks, my "designers" assess who they are and what they want from their future. They define their personal brand and create a visual identity. They develop a portfolio, tailoring the projects they created for their classes, professional internships, or day jobs to the type of industry and company where they want to work. They develop a job plan and learn how to look for a job in the design field and their specialty, create job-specific resumes and cover letters, and produce the touch-points they'll need to promote themselves. Every semester without fail, my students embrace the process, take a deep breath, and make the leap into the next phase of their lives.

In the field of professional design, your portfolio is the single most important apparatus you have for demonstrating your talents, skills, and body of work. Designed to build your confidence as you enter a highly competitive marketplace, the *Stand Out* methodology is practical and proven. Informed by my 25 years as a design practitioner and formulated over my 17-plus-year teaching career, this approach is logical and holistic, and it works.

Stand Out's step-by-step process includes hands-on exercises and user-friendly worksheets to help you sharpen your vision of where you want to go. You will identify the environment where you're likely to shine most brightly and be recognized

for the things you are most passionate about by the people who can truly appreciate what you have to offer. It includes stories of my own experiences, examples from others who have undergone the process, and links to Pinterest boards with work samples from young, talented designers who have made their own journey.

You don't have to be a student to benefit from the *Stand Out* approach. If you're a professional designer in search of your next job or restarting a design career, the methodology I describe will work for you, too. In addition to straightforward and actionable instruction for design job seekers at any stage in their career, *Stand Out* provides support materials that can be used by professors who teach a portfolio course.

Making the transition from learner to professional is a formidable undertaking, but it is absolutely necessary. Understanding its importance, my students consistently move toward their destinies with passion and purpose. I like to think I inspire them, but the truth is, they inspire me. As I witness and support their efforts, I am reminded what a privilege it is to mentor and teach the next generation of design leaders. *Stand Out* is a testament to their talent and commitment, and I hope they will inspire yours.

Let's get started.

TABLE OF CONTENTS

SECTION ONE

DESIGN A PERSONAL BRAND

Create a visual identity that reveals your true and authentic brand. 2

SECTION TWO

BUILD A KILLER PORTFOLIO

Build a body of work that represents the style, type, and industry-specific work you want to do. 78

SECTION THREE

FIND A GREAT DESIGN JOB

Learn how to find a job and launch your career
in the design field. 172

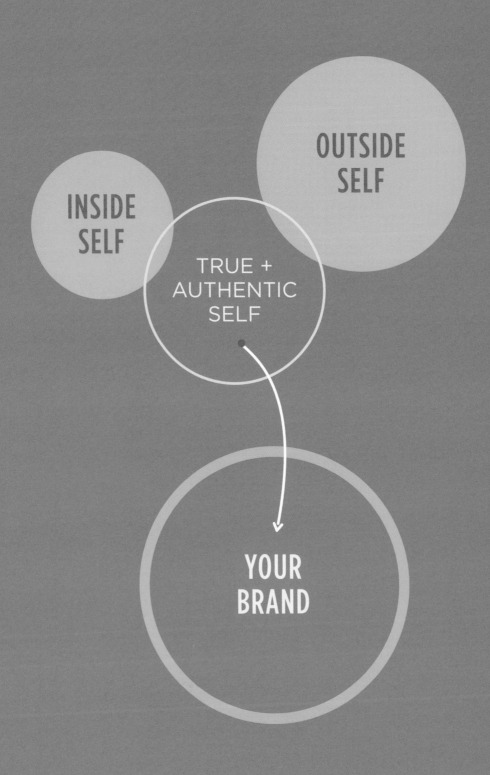

DESIGN A PERSONAL BRAND

Create a visual identity
that reveals your true
and authentic brand.

1. GET PERSONAL WITH YOUR BRAND

Identifying your brand, its purpose, and the attributes that make it your own.

Your personal brand is the past, present, and future idea of you. Intangible and ever-present, it encompasses the sum of your parts: your values, interests, skills, personality, behavior, and style. It is what people think, feel, and say about you when you are not in the room and what you believe about yourself.

Some people have a fairly good understanding of who they are, but communicating one's self to others can be challenging. Taking an active role in defining your personal brand empowers you to take control of what you project to others: who you are, what you want, and why an employer should hire you.

Before you can reveal and unleash your personal brand as a brand identity, you must first tap into your inside self—your true and authentic self—to gain insights on who you are and

what you want to be. You must also gain a clear understanding of your outside self—how the world perceives you—by researching and asking others. Recognizing the connection between how you see yourself and how others see you gives you the ability to develop a compelling and credible personal brand that truly represents who you are.

As you create or update your design portfolio and prepare for the next phase of your life, performing this kind of evaluation is essential for two reasons:

- First, the process will propel your personal and professional growth, and the resulting insights will enrich the story you're telling.

- Second, your insights will translate into visual cues for the design of your brand identity.

Understanding yourself, inside and outside, may even lead you to modify your personal strategy or redefine it to embrace the person you are and the one you're stretching to become.

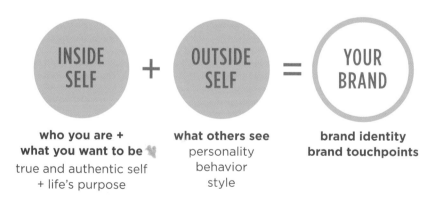

INSIDE SELF **+** OUTSIDE SELF **=** YOUR BRAND

**who you are +
what you want to be**
true and authentic self
+ life's purpose

what others see
personality
behavior
style

**brand identity
brand touchpoints**

THE PERSONAL BRAND SELF-ASSESSMENT STUDY

WORKSHEET:

*standoutportfolio.com/
self-assessment.pdf*

Before you can define your personal brand, you need to do some research. If you're building your portfolio, you've already been through the process of researching and creating a unique brand that reflects a client's character. Doing a self-assessment study is the same thing, except you will be focusing on yourself, to explore, identify, and conceptualize the ideas that represent your brand.

This kind of work can sometimes be uncomfortable, but the outcome is worth the effort. When my students begin this task, I tell them, "Take yourself out on a date. Buy yourself a cup of coffee or a cocktail (if you're old enough), and get to know you better." It may sound silly, especially when you're beginning the very serious journey of launching or relaunching a professional design career, but it is necessary. As you work your way through the exercises in this chapter, schedule time to be alone and reflect. Shut off your phone and disconnect from social media for a few hours. Keep your responses brief, and don't overthink the questions.

PERSONAL BRAND SELF-ASSESSMENT STUDY

inside self

Q1: Who are you?

Understand your true and authentic self, and discover your core values.

1. Ambition
2. Enthusiasm
3. Sensitivity

Q2: What makes you stand out?

Identify your interests, talents, and passions, and learn how they connect you to others.

1. Baking
2. Poetry
3. Skateboarding / Snowboarding

Q3: What are you good at?

Know your strengths and weaknesses so you can present tangible skills to an employer.

Attributes	Design Skills
1. Devoted	1. Illustration
2. Generous	2. Typography
3. Sincere	3. Editorial

Software Skills	Experiences
1. Illustrator	1. Lived abroad in Italy ↗ worked on a farm
2. InDesign	2. Started own henna business
3. After Effects	3. + craft vendor

Q4: Where are you going?

Visualize your life's dream, and plan how

Vision Create immersive human experiences through design.

Who are you?

Understand your true and authentic self, and discover your core values.

You can learn a lot about yourself by looking at what is important to you. When the way you live matches the values you hold dear, life feels fluid and effortless. But when your activities are not aligned with your values, you feel out of sorts and perhaps even truly unhappy. Being mindful of your values is tremendously important. Once you understand what you care most about, you can identify what fuels your purpose, and you will have discovered your true and authentic self.

In the course of my own career, I have been an entrepreneur (owner of a Baskin-Robbins ice cream store and the founder and leader of DesignDMA, a graphic design company), managed the design group of a financial services company (Pershing, LLC), and taught as an adjunct professor in a university (Robert Busch School of Design at Kean University). When I conducted my own self-assessment study in gradu-ate school, I was able to identify

a thread that runs throughout my career—mentoring young people. If I hadn't bothered to do the study, I wouldn't have recognized or been able to embrace such an important fact (or core understanding) about myself. I might have missed out on teaching full-time or sharing what I've learned with others through writing and speaking opportunities. And, I would never have been truly satisfied in my career. Because I took the time to go through this process, I am able to say without reservation that I never feel like I am working because I truly love what I do.

This exercise will help you identify your core values— the principles that guide your attitudes, actions, and who you are. Your answers will serve as benchmarks for evaluating your life choices. Figuring out what inspires you will lead you to a job you truly love and are meant to do.

EXERCISE: Identify your values

- On a sheet of paper, select the twelve values, attributes, or traits you value most and that you believe give your life meaning and purpose. You can download a list of values at *standoutportfolio.com/values.pdf*, but don't let it limit you; you may come up with plenty of your own possibilities.

- Now, reduce your list to the six values that are most important to you.

- Finally, select three values (these are your core values) that are absolutely essential to your core purpose and enter them under question 1 on your self-assessment worksheet.

PERSONAL BRAND SELF-ASSESSMENT STUDY

values

Accountability	Discretion	Humility	Rigor
Accuracy	Diversity	Independence	Security
Achievement	Dynamism	Ingenuity	Self-actualization
① (Adventurousness)	Economy	Inner Harmony	Self-control
Altruism	Effectiveness	Inquisitiveness	Selflessness
Ambition	Efficiency	Insightfulness	Self-reliance
Assertiveness	Elegance	Intelligence	③ (Sensitivity)
Balance	Empathy	Intellectual Status	Serenity
Being the best	Enjoyment	Intuition	Service
Belonging	Enthusiasm	Joy	Shrewdness
Boldness	Equality	Justice	Simplicity
Calmness	Excellence	Leadership	Soundness
Carefulness	Excitement	Legacy	Speed
Challenge	Expertise	Love	Spontaneity
Cheerfulness	Exploration	(Loyalty)	Stability
Clear-mindedness	Expressiveness	Making a difference	Strategic
Commitment	Fairness	Mastery	Strength
Community	Faith	Merit	Structure
② (Compassion)	Family	Obedience	Success
Competitiveness	Fidelity	Openness	Support
Consistency	Fitness	Order	Teamwork
Contentment	Fluency	Originality	Temperance
Contribution	Focus	Patriotism	Thankfulness
Control	Freedom	Perfection	Thoroughness
Cooperation	Fun	Perseverance	Thoughtfulness
Correctness	Generosity	Piety	Timeliness
Courtesy	Goodness	Positivity	Tolerance
Creativity	Grace	Practicality	Traditionalism
Credible	(Growth)	Preparedness	Trustworthiness
Curiosity	Happiness	Professionalism	Truth-seeking
Decisiveness	Hard Work	Prudence	Understanding
Dependability	Health	Quality	Uniqueness
Determination	Helping Society	Reliability	Unity
Devoutness	Holiness	Resourcefulness	Usefulness
Diligence	Honesty	Restraint	Vision
Discipline	Honor	Results-oriented	Vitality

What makes you stand out?

Identify your interests, talents, and passions, and how they connect you to others.

Your talents, interests, and passions are the unique differentiators that help define you and distinguish you from others. It's important to identify what they are and how they relate to your goals, because any one of them could turn out to be the key factor in getting you noticed by a potential employer or hired for the job you've always wanted.

Liz Blazer, motion designer and author of the book *Animated Storytelling: Simple Steps to Creating Animation and Motion Graphics*, uses a whimsical term for this practical procedure: "Finding your pixie dust." What this means is bringing to light your interests (things you find stimulating), talents (aptitudes you are born with), and passions (your developed interests and talents) so you can market and share them in a useful way. My former student, Max Friedman, discovered his pixie dust while authoring and designing a series of books. In grade school, Max had always enjoyed doodling, but working on the book series resurrected his interest, which quickly evolved into a genuine passion for illustration.

Identifying your own unique differentiators (i.e., pixie dust) is essential. Without it, your brand will be lackluster and non-differentiating, ordinary instead of magical. Employers are looking for talented and skilled professionals, but designers with rich experiences, unique interests, and notable passions will captivate their attention.

A caution: Some interests, talents, and passions may be too personal to reveal in a professional environment. They don't have to be specifically related to a design job, but their attributes should translate to the skills you need for the work you want to do. Anything you present should be true and appropriate for both the market you intend to work in and the type of company you want to work for. You should feel good about the personal things you share and understand why you are sharing them.

EXERCISE: Discover your talents, interests, and passions

- On a sheet of paper, identify your interests, talents, and passions. Here's a list of some potential things you may already do that are interesting:

 – Speak another language

 – Illustrate, paint, or photograph

 – Excel in a sport or physical activity

 – Maintain a blog

 – Engage others through social media

 – Dance

 – Serve in the military

 – Sing solo or in a band

 – Travel

 – Cook or bake

 – Play a musical instrument

 – Volunteer in your community

 – Pursue a degree in another subject

 – Humorous and witty

 – Select three from your list and enter them under question 2 on your worksheet.

INTERESTS | TALENTS | PASSIONS

PAINTING

SINGING

NATURE

BILINGUAL

BAKING

POETRY

FASHION

HENNA ARTIST

BIKING

GARDENING

TRAVEL

SKATEBOARDING

PHOTOGRAPHY

MAKEUP

What are you good at?

Understand what you are good at (and not so good at), and how to talk about it.

No one is good at everything, but everyone is good at something. Some designers excel at conceptualizing, while others are better at production. Your strengths are not just the things that you have an aptitude for; they also drive you to the tasks that you enjoy most. Those strengths continue to improve because you spend more time using them.

You may have character or personality traits—personal attributes—that work to your benefit. For example, if you are a good listener, communicative, and organized, you may excel as a team leader. Your positive attributes can strengthen your personal and professional relationships. (The ability to recognize your character and personality traits is in itself a positive attribute.)

You'll find your weaknesses, on the other hand, in the things that don't interest you or for which you have no aptitude. Maybe you lack a skill set or talent to excel in that area, or maybe you just don't enjoy it. Like it or not, there's a good chance you'll be asked about your weaknesses in an interview. If you know what they are, you can find a way to use them to your advantage. For example, you may not like working early in the morning, which is reflected in the quality of your work. Understanding that limitation, you can position yourself as a good candidate for a company with flexible hours that extend past the traditional 5 p.m. quitting time.

EXERCISE: Understand your strengths and weaknesses

- On a blank sheet of paper, make a four-part list of your strengths and weaknesses in the following categories: attributes, design skills, software skills, and experiences. (Or download the form at *standoutportfolio.com/ strengthsweaknesses.pdf.*)

- Circle three answers from each of the four categories that are the most true and enter them under question 3 on your worksheet. Be honest with yourself. You cannot build a true and authentic brand if you are not truthful.

5 lbs

PERSONAL BRAND SELF-ASSESSMENT STUDY

strengths and weaknesses

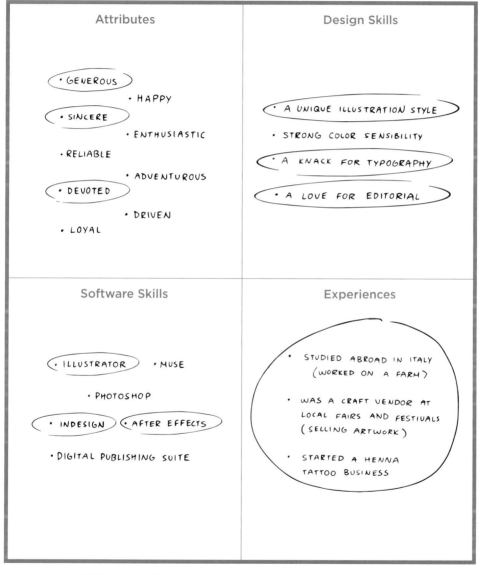

Attributes

- GENEROUS
- HAPPY
- SINCERE
- ENTHUSIASTIC
- RELIABLE
- ADVENTUROUS
- DEVOTED
- DRIVEN
- LOYAL

Design Skills

- A UNIQUE ILLUSTRATION STYLE
- STRONG COLOR SENSIBILITY
- A KNACK FOR TYPOGRAPHY
- A LOVE FOR EDITORIAL

Software Skills

- ILLUSTRATOR
- MUSE
- PHOTOSHOP
- INDESIGN
- AFTER EFFECTS
- DIGITAL PUBLISHING SUITE

Experiences

- STUDIED ABROAD IN ITALY (WORKED ON A FARM)
- WAS A CRAFT VENDOR AT LOCAL FAIRS AND FESTIVALS (SELLING ARTWORK)
- STARTED A HENNA TATTOO BUSINESS

Where are you going?

Visualize your life's dream, and plan how to get there.

After reflecting on your inner self, you now have a foundation for envisioning what you want your life to be. Your vision statement is very personal because it consolidates everything you've learned about yourself so far—your values, "pixie dust," passions, strengths, weaknesses, skills, and experiences—into a precise destination, the dream that awaits no one but you. Your mission statement is the road map you will use to get there.

Based on personal values and beliefs, your vision statement articulates your ultimate purpose or calling in life. It involves detailed visualizing and thinking about what you see happening in your future.

The mission statement is the step-by-step plan you will use to achieve your vision. Comprised of three to four detailed "how to" objectives that will move you toward fulfilling your vision, your mission statement will serve as a set of guidelines to remind you of the goals you have set.

One of my first steps in writing this chapter was to conduct my own personal brand self-assessment study. I have to confess that I panicked for a moment as I tried to figure out how to squeeze each exercise in between writing, teaching a full course load, and caring for my family. But I'm glad I did. I am sure you're thinking something along the same lines as you contemplate creating or refreshing your brand, updating your book of work, and finding a job, especially if you already work or have family obligations. I hope you will trust me—I've seen this formula and these concepts work for my students time and again. Once you get a design job, this leg of your journey will be complete. Take it slowly and enjoy the ride.

On the next page, you'll find my vision and mission statements, along with those of some of my students.

EXERCISE: Develop your vision and mission statements

- On a sheet of paper, write a few sentences that express your vision of where you see yourself in five to ten years.

- Boil it down to one concise sentence (six words or less). This is your vision statement.

- Create a list of three to four bullet points that describe how you will achieve your vision. This is your mission statement.

- Enter both of these statements under question 4 on your worksheet.

Vision:

To create equality through design.

Mission:

1. Establish my own studio.

2. Design for agencies that focus on diversity, equality, and wellness.

3. Work for non-profit organizations.

4. Live in New York or Paris.

5. Become an AIGA gold medalist.

Vision:

To change how branded content is presented.

Mission:

1. Work for a digital marketing agency that specializes in unconventional methods for reaching consumers in NYC

2. Travel abroad to gain a better understanding of how to advertise internationally to multiple cultures

3. Study music/audio and develop new and unconventional ways to use sound to connect a consumer to a product

4. Step back from full-out digital design and rekindle the personal/physical touch between consumer and product

5. Become a member of the ADCNY

Vision:

Identify and work for human design experience companies in NYC.

Mission:

1. Move to NYC!

2. Obtain a MFA in Design for Social Innovation at SVA.

3. Become a member of the AIGA and ADC.

4. Join organizations that have a social cause, and donate my design time.

5. Identify and work for human design experience companies in NYC.

Vision:

To design quirky, spirited, and honest brands

Mission:

1. Earn an MS in Business @ VCU

2. Obtain a job at a cutting-edge branding firm with a focus in digital production

3. Become an active participant in various design organizations, including AIGA and ADC

4. Network, network, NETWORK by attending design-related conferences

5. Establish a design studio of my own

How do others see you?

Learn about you from the perspective of others.

It is time to consider your public persona and strengthen your awareness of how you are perceived by others.

Your outside self is the expression of what others perceive you to be—your attributes, behavior, and personal style. It's important to understand how your friends, family, professors, mentors, colleagues, and acquaintances see you, because those perceptions all add up to a personal brand equity that has already been established.

In your search, you may learn a few things that you don't like. Some observations may be difficult to hear (but don't be surprised if much of what they tell you is positive). If you want to know and embrace the true and authentic you, you'll have to consider the bad stuff as well as the good.

As part of my self-assessment study, I had an online survey sent to 20 friends, family, colleagues, and students. I was excited to see that several respondents perceive me as creative, passionate, and driven. For my weaknesses, someone said I am intimidating. (The survey was anonymous, but

I'm fairly certain this comment came from my good friend Suzanne, who believes this "weakness" is not such a bad trait. More on that later.) Others said I am impatient. (Ouch, and yes I am.) I didn't like everything I read, but that feedback helps me better understand how my personal brand is perceived by others. I can use this information to improve my image.

Here is a breakdown of how others will assess you:

Attributes. These are the qualities or characteristics ascribed to you. They are aspects of your personality that cannot be altered much and would tend to be reflected in the words others use to describe you. Do they see you as assertive or shy? Flexible or difficult? Impulsive or deliberate? Witty or sarcastic? Responsible or flighty? As you learn more about your personality, you'll become increasingly self-aware, and your path for development will become clearer and more direct. Everyone is different: once you understand what your differences are, you can embrace your individuality and build a strategy for becoming the person you want to be.

Behavior. The way you conduct yourself in public, in the class-

room, at a job, or at home can influence how others perceive you. Will a professor provide you with an enthusiastic reference when you're chronically late or your work is sloppy and unfinished? Will your dad lend you the car to get to an interview if you are unreliable and never bring it back when you say you're going to? Like it or not, your behavior communicates the strengths and weaknesses of your character to the people around you. What message are you sending?

Personal style. Your body language, the way you dress, and the people you associate with are just a few of the many personal style choices that speak volumes about your brand. A strong but warm handshake communicates you are confident and trustworthy. A stylish and well-tailored suit conveys that you can dress appropriately in a professional environment. If you want to communicate that you have an eclectic (or conservative or trendy or whatever) fashion sense, that's okay, but you should consider what your choices communicate to a potential employer and how it could impact their decision-making.

PERSONAL BRAND SELF-ASSESSMENT STUDY

outside self

What attributes best describe me?

List up to 10 qualities or characteristics that best describe me.

1. LOVING
2. PERSONABLE
3. LOYAL
4. DETERMINED
5. FOCUSED
6. SPUNKY
7. INTELLIGENT
8. SWEET
9. CREATIVE
10. STRONG WILLED

What am I really good at?

What skills am I good at (strengths) and what skills do I lack (weaknesses)? List up to 5 words/phrases for each.

Strengths	Weaknesses
1. THOUGHTFUL	1. SENSITIVE
2. APPROACHABLE	2. SHY
3. SINCERE	3. DEFENSIVE
4. RELIABLE	4. EMOTIONAL
5. FRIENDLY	5. PERFECTIONIST

What car best describes me, and why?

Cars reflect the personal style of their owner. If I were a car, what kind would I be?

A CONVERTIBLE, SO MY LONG HAIR COULD BE PUT TO GOOD USE AND BLOW IN THE WIND.

What dog best describes me, and why?

Dogs come in a variety of breeds and temperaments. What kind of dog would I be?

BASED ON LOOKS : AFGHAN HOUND OTHERWISE, A COLLIE BECAUSE THEY ARE UP FOR FUN AT ANY TIME AND RELIABLE.

What color best describes me, and why?

Colors have meaning. What color(s) best represents me?

MAGENTA : LIVELY, BRIGHT, A LOT OF SPIRIT & ENERGY MIMICS THE ATMOSPHERE I BRING TO A ROOM.

How do others see you?

Ways to research and solicit feedback from other people.

Create a survey. Create your own customizable survey that asks questions specifically about you. Use a free online survey tool such as Survey Monkey (surveymonkey.com), or create your own form using Adobe Acrobat or Google Forms.

- When you hear my name, what qualities do you think of?

- What am I really good at?

- What are my most likable and most annoying personality traits?

- Have I impacted or influenced your life? Another person's life?

- After all the time we've known each other, why do you still want to hang out with me?

- What color best describes me and why?

- What animal comes to mind that would best represent me?

Interview people. There is nothing more enlightening than sitting in front of someone you know and actually seeing that person respond to one of your questions. Words can lie,

but non-verbal reactions will be much more honest. Here's a tip: select people from your most trusted circle. They will take this exercise seriously and provide the cues you need to form a view.

Assess your social media presence. In social media, you publicly promote your personal brand. Social networking means putting your personal life (and sometimes, your professional activities) on display for anyone to see for an indefinite and possibly extended period of time. When you chat about what you like to do, the movies you see, or your favorite restaurant, you are sharing the private details of your life with everyone. Consider the tone of your posts—are you supportive and encouraging? Argumentative or mean-spirited? Do you post constantly? Are you obsessed with cute kitten videos and trendy memes? (When I discuss this topic with students, I jokingly suggest taking down the pictures of themselves doing keg stands. After seeing the terror on more than a few faces, I no longer consider it a joke.)

EXERCISE: Characterize how others see you

- Customize your survey.

- Take the survey yourself first.

- Send the survey to at least 10 other people from different parts of your life.

- Tally the answers for each section.

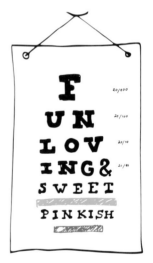

STAND OUT

Understanding yourself, inside and outside, may lead you to modify or redesign your personal strategy to embrace the person you are and the one you're stretching to become.

- Look to your core values when you want to gauge whether your life is turning out the way you want it to be.

- Combined, your talents, interests, and passions make you different from anyone else. They express who you are and what you love.

- Accept what you know to be true about yourself right now. If you're not being genuine, an employer is likely to sense it.

- Whether you are starting your career or reinventing yourself for the *nth* time, periodically redefining your vision and establishing a new plan is essential.

- Everything you do and say communicates something about you. When you understand how others perceive you, you gain the ability to influence their perception and propel your image in a positive direction.

- When you have a newly discovered or renewed understanding of the true and authentic you will see a brand begin to take shape.

2. DEVELOP YOUR BRAND STORY

Finding key insights and forming the core of your brand and visual identity.

Now that you've collected lots of useful information about the characteristics, skills, personality, and style that comprise your true and authentic self, it's time to interpret the data and identify key insights that will define your brand. Analyzing your answers, as well as how they compare and contrast with answers that others have provided, will help you articulate who you are in a way that resonates and connects with your audience. A thorough understanding of who you are and how others see you is the foundation on which you'll build a meaningful, appropriate, and memorable brand.

LOOK FOR INSIGHTS

An insight is the capacity to gain a true and intuitive understanding of someone or something. According to BusinessDictionary.com, an insight is "feedback; ideas about the true nature of something...; knowledge in the form of a perspective, understanding, or deduction." For example, in my own survey, when asked what type of dog best illustrates me, four respondents said I was a German Shepherd for being strong, protective, feisty, and loyal. I see myself more as a Standard Poodle, because I am a thinker, am funny, and like to get dressed up. Although the two descriptions are notably different, I can draw an insight from the contrast between my self-image and how others perceive me. In others' eyes, I come across as more "fierce" than "funny." If I were devel-

oping my personal brand, this characteristic would be worth addressing.

The consistencies in the feedback were even more telling. The answers that the respondents and I shared—creative, passionate, driven, devoted, and entrepreneurial—reveal the undisputed attributes (values, qualities, and characteristics) that make me uniquely me. These insights are evidenced throughout my life and reflect my true and authentic self. I am happily married for 14 years. I have decades-long friendships, and anyone who has ever done business with me knows they can trust me. I am passionately committed to discovering and unlocking my students' potential. Together, these attributes form the core foundation of my brand and visual identity.

EXERCISE: Identify the key insights

Refer to your answers from your completed Inside Self worksheet and the respondents' answers from the Outside Self survey.

- Compare the information on the two worksheets. How are the answers similar, and how are they different?

- Record the commonalities and differences that you observed in the space provided on the Inside Self + Outside Self Analysis worksheet.

- Write two to three statements that express the insights you gained about yourself from this exercise.

THE PERSONAL BRAND SELF-ASSESSMENT ANALYSIS

WORKSHEET:

standoutportfolio.com/ self-assessment.pdf

By identifying and summarizing the key insights from your self assessment, you now have the knowledge required to write your brand story and articulate the value you can offer a prospective employer. Your ability to communicate this understanding of yourself will create an emotional connection to your audience.

PERSONAL BRAND SELF-ASSESSMENT ANALYSIS

inside self + outside self

COMMONALITIES

IMAGINATIVE

DISCIPLINED

COMPETITIVE

PASSIONATE

SPIRITED

GENEROUS

DIFFERENCES

You	Others
ORIGINAL	INFLEXIBLE
GENEROUS	REBELLIOUS
EMOTIONAL	PERFECTIONIST
OPEN MINDED	HARD WORKER

INSIGHTS

WHEN PEOPLE THINK OF ME, THEY THINK OF DANCING.

I BRING STRONG PASSION AND A ROBUST SPIRIT TO EVERYTHING I DO.

MY NEED FOR PERFECTION CAN SOMETIMES INHIBIT ME FROM COMPLETING TASKS QUICKLY.

DEVELOP YOUR BRAND STORY

There is no one "correct" way to write a brand story, and as you become more comfortable telling yours, you may choose to devise your own format. For our purposes here, I ask that you follow the formula I describe. It not only provides the essentials that every brand story needs, but it also works.

Think of your personal brand story as being composed of four fundamental elements: the value proposition, the brand promise, the brand statement, and brand characteristics. In previous exercises, you've extrapolated key insights about yourself and your goals. Now it's time to organize what you've learned into a compelling story that makes sense and engages your target audience: a potential employer.

For these exercises, you will craft three statements about the fundamental elements of your brand to use as strategic objectives and identify the key characteristics of your brand. Record your answers from all of the exercises on a separate sheet of paper and save it. You'll need it for your creative brief.

YOUR BRAND IS A REFLECTION OF YOU.

Your value proposition: What can you offer?

"Why should someone hire me?" is an important question to answer, long before a potential employer is cracking open your portfolio. Your value proposition—the contributions you can bring to a project, team, or organization—comprises your positive attributes and the passions and strengths that you can deliver to help a company meet its goals. To determine how you stand out from the crowd, an employer will look carefully at your particular set of capabilities, the functional benefits they offer, and your design and technical skills.

When I hire interns or designers, my final interview question is usually, "What can you do for me?" To answer this or similar questions, you need to know what your value proposition is, and you must be able to articulate it. Focusing on what you bring to the table will help you differentiate yourself.

Understanding how your particular attributes translate into value can help you build a bridge between what you have to offer and an employer's needs. When the employer sees that your talents, passions, interests, and strengths can be relevant to his or her business, an emotional connection is forged, and your brand is distinguished from others.

EXERCISE: Know what you bring to the table

• Review all of your attributes—characteristics, strengths, skills, and pixie dust—from your self-assessment. Think about the value you can bring to a company, and write five short sentences that describe why someone should hire you.

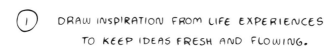

1 DRAW INSPIRATION FROM LIFE EXPERIENCES TO KEEP IDEAS FRESH AND FLOWING.

2 SELF-MOTIVATED (WORKING INDEPENDENTLY) AND HIGHLY COLLABORATIVE (WORKING WITH A TEAM).

3 OPTIMISTIC AND JOVIAL; ORGANIZED AND NIMBLE.

4 EFFECTIVE AND EFFICIENT PROBLEM SOLVER; ADEPT WITH ADOBE SOFTWARE.

5 MAINTAIN COMPOSURE REGARDLESS OF PRESSURE.

Your brand statement: What are you made of?

Every brand, at its innermost core, has a purpose for being. Based on your value proposition, your personal brand statement is a clear and concise articulation of who you are as a person, what value you can deliver to an employer, and why you want to be a designer. Focus on the most important key insights you have identified from your self-assessment and envision the most ideal version of who you are.

Sometimes referred to as an "elevator pitch," your brand statement should be brief, to-the-point, and easy for your audience to grasp quickly. Your goal is to inspire an emotional connection in no more time than it takes to ride from one floor to another in an elevator. A well-constructed brand state-

ment demonstrates that your commitment is well-thought-out and intentional. It can serve as the springboard for building a mutually valuable and lasting relationship based on your true and authentic self—who you are and what you truly believe.

For example: *My name is Amanda, and I am graduating with a degree in graphic design. When I'm not designing, I express my creative side through dance. For me, dance and design spring from the same source and require the same kind of discipline and commitment: both feed my competitive spirit and require a tremendous amount of focus. Whether I'm dancing or designing, I capture and convey the excitement and movement that I feel pulsing through life.*

EXERCISE: Script your elevator pitch

- Using the formula below, construct punchy and memorable sentences that describe the most important components revealed in your value proposition and other key insights you discovered about yourself.

Hi, my name is *Abe*

I am [Key attributes that describe *who* you are.]

A former photojournalist in the U.S Marines.

What I offer [*What* you can deliver to an employer.]

I am both highly adaptable and firmly grounded. With a specialty in mobile design, I am a T-shaped thinker who can seamlessly cross what I learn with what I feel to engage with others across multiple disciplines.

I want to [The inspiration behind *why* you do what you do.]

I'd like to bring my military experience, design education, and distinctive point of view to a full-service design company that appreciates my agility.

Your brand promise: What can you live up to?

Your brand promise is the single most compelling value you can offer and deliver consistently. It describes your unique selling point, which sets you apart from others. It must be believable, admirable, and differentiating. Let's say you're competing with another designer for the same job. It's unlikely that you'll know the person you're competing with, but you can assume that you'll both have similar educations, skill sets, and work experience. How will a potential employer identify the differences between you? There's a good chance he or she will consider each candidate's brand promise to determine who has the attributes, skills, and experiences that will bring the most value to the position. In many cases, it's not about who's "better"; it's about whose promise is most likely to fulfill both the explicit and unstated requirements of that specific job at that particular company.

When I was a young adult, my father—who owned and operated a jewelry store—taught me my first lesson about creating a brand promise, although I didn't realize it at the time. He said that it doesn't matter if you lose everything you own; if you have people's trust, you will always make your way back to the top. His brand promise might have been, "Customers know they can trust me." The attribute he described was integrity. My father delivered on this promise to his customers, and to his family, every day of his life, and it's a legacy he bestowed on my siblings and me.

EXERCISE: Make your promise

- In six or fewer words, describe with passion and power one thing you can promise to a prospective employer and live up to every day of your life. I've included some examples here to give you an idea of how others have expressed their brand promise.

DESIGNS THAT DANCE AND PULSE WITH LIFE.

Execute the assignment quickly and correctly.

TRANSLATE BUSINESS OBJECTIVES INTO COMPELLING OBJECTIVES.

Create animated characters that inspire empathy.

Brand characteristics: What do you want your brand to say about you?

With an understanding of how your perceptions about yourself compare and contrast with others' perceptions, think about how you will use your attributes to communicate your character. As you move into the next chapter, you'll want to keep these characteristics in mind so you can make choices about components like fonts, colors, and imagery that are true to the brand you've articulated. For example, if one of your attributes is "happy," then the elements of your identity should be warm and friendly. If you're a "risk-taker," then you may choose elements that are edgy and non-traditional.

EXERCISE: Identify the characteristics of your brand

- Refer to your answers from your completed Inside Self + Outside Self Analysis worksheet.

- Identify three qualities from the Commonalities section that best represent your personal brand and list them in the Attributes column.

- In the Personality column, list three words that capture your personal style and connect you to others. You can draw from your analysis or use words that you believe are more accurate.

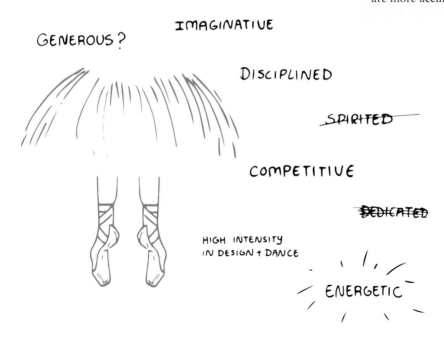

PASSIONATE

IMAGINATIVE

GENEROUS?

DISCIPLINED

SPIRITED

COMPETITIVE

DEDICATED

HIGH INTENSITY
IN DESIGN + DANCE

ENERGETIC

THE CREATIVE BRIEF

WORKSHEET:

*standoutportfolio.com/
self-assessment.pdf*

PINTEREST:

*pinterest.com/ProfessorDMA/
creative-brief/*

A creative brief is a one-page document that summarizes the strategic objectives and creative needs of a project for the creative team. Outlining the project's purpose, target market, brand attributes, value proposition, and a range of other relevant facts, the creative brief informs, guides, and drives the creative strategy. For the purposes of your personal brand, it defines and inspires the meaning of your brand identity.

creative brief | AMANDA

TARGET AUDIENCE (Where you want to work)

Field of interest:	BRAND IDENTITY AND DIGITAL DESIGN
Type of company:	FULL-SERVICE DESIGN STUDIO OR UI/UX COMPANY
Company location:	PREFERABLY NYC, BUT WILL RELOCATE TO ANY LARGE US CITY
Company size:	SMALL ENOUGH THAT I KNOW EVERYONE'S NAME
Type of job:	GRAPHIC DESIGNER OR DIGITAL DESIGNER

VALUE PROPOSITION (What you can offer the target audience)

1. DRAW INSPIRATION FROM LIFE EXPERIENCES TO KEEP IDEAS FRESH AND FLOWING

2. SELF-MOTIVATED (WORKING INDEPENDENTLY) AND HIGHLY COLLABORATIVE (WORKING WITH A TEAM)

3. OPTIMISTIC AND JOVIAL; ORGANIZED AND NIMBLE

4. EFFECTIVE AND EFFICIENT PROBLEM SOLVER; ADEPT WITH ADOBE SOFTWARE

5. MAINTAIN COMPOSURE REGARDLESS OF PRESSURE

BRAND STATEMENT (What your brand stands for)

MY NAME IS AMANDA AND I AM GRADUATING WITH A DEGREE IN GRAPHIC DESIGN. WHEN I'M NOT DESIGNING, I EXPRESS MY CREATIVE SIDE THROUGH DANCE. FOR ME, DANCE AND DESIGN SPRING FROM THE SAME SOURCE, AND REQUIRE THE SAME KIND OF DISCIPLINE AND COMMITMENT; BOTH FEED MY COMPETITIVE SPIRIT AND REQUIRE A TREMENDOUS AMOUNT OF FOCUS. WHETHER I'M DANCING OR DESIGNING, I CAPTURE AND CONVEY THE EXCITEMENT AND MOVEMENT THAT I FEEL PULSING THROUGH LIFE.

BRAND PROMISE (Your unique differentiating proposition)

DESIGNS THAT DANCE AND PULSE WITH LIFE

BRAND CHARACTERISTICS (Qualities that best describe you)

- PASSIONATE
- IMAGINATIVE

DEVELOP YOUR CREATIVE BRIEF

Before you can define your brand and write your creative brief, you must first visualize where your brand will live and thrive. Much like defining a target audience for a project you're designing, you need to consider the field you want to work in, the location you want to work from, and the type of job you'd like to do. (See Section 3: Find a Great Design Job.) Addressing these issues will help you assess whether your professional career goals align with your true and authentic self. If you value collaboration, you may not want to work independently from home; if you value honesty and ethics, you probably won't be happy at an agency with clients who have questionable business practices.

Understanding your ideal destination will help you define a brand identity that will get you there. For example, if you want to work in a design firm doing branding, the art director reviewing your portfolio may gauge how effective your identity design skills are by focusing on your personal logo and other visual components. If you're looking to work in an advertising agency, the art director may just glance at your personal logo but pay very close attention to whether your other identity touchpoints are executed through a well-thought-out concept and promotion.

It's time to sum up what you know by putting together a creative brief about you. To complete this exercise, you'll need the list of answers you created earlier in this chapter so you can complete the Creative Brief worksheet.

EXERCISE: The ideal workplace

- Create a profile of your ideal workplace, and populate all of the fields with the information you have completed in this chapter.

- Save your creative brief; you'll need it for designing your visual identity in Chapter 3: Design Your Brand Identity.

STAND OUT

The truth of your authentic brand lies somewhere between what you believe about yourself and what others believe about you, so it is important to understand those commonalities and differences.

- Learning what's true about yourself, articulating who you are, and identifying what you want are not easy tasks.

- When writing your brand story, make sure it includes rich and believable content that describes what makes you uniquely you.

- Your value proposition comprises the positive attributes, passions, and strengths that you can offer to help a project, team, or organization meet its goals.

- Your personal brand statement is a clear and concise articulation of who you are as a person, what value you can deliver to an employer, and why you want to be a designer.

- Your brand promise is the single most compelling thing you have to offer and can consistently deliver. It describes your unique selling point, which sets you apart from others.

- Your creative brief is essential to outlining the strategy for building a meaningful and memorable visual identity.

3. DESIGN YOUR BRAND IDENTITY

Translating your brand story into a visual identity.

In the two previous chapters, you learned that building a personal brand is virtually impossible until you have done your homework and identified what your brand is all about. By researching your inside and outside selves, recognizing your pixie dust, and extracting key insights from your self-assessment, you have clarified your understanding of your true and authentic self and developed your brand story. Now, you have the foundation for creating a unique visual identity that truly represents your brand.

Intangible and ever-present, your personal brand is the past, present, and future idea of you, encompassing the sum of your values, interests, skills, personality, behavior, and style. Your brand identity and its touchpoints—where your brand and an audience interact—visually communicate your brand story and emotionally connect you to your audience. Your brand identity doesn't just make known your personal brand attributes; it is also a test that a potential employer will use to identify how well you can capture the essence, or the most compelling aspect, of your brand.

Instead of jumping right in and designing the components of your identity (such as a logo and stationery), you'll start by creating a mood board to establish the core elements, including colors, typefaces, and images, that best represent you and the story you want to tell.

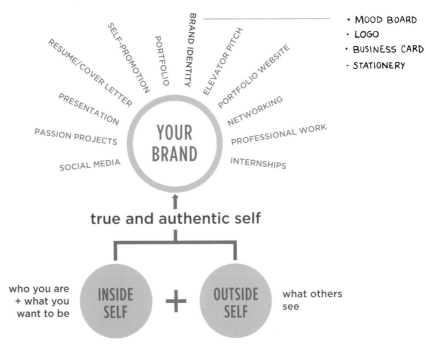

- MOOD BOARD
- LOGO
- BUSINESS CARD
- STATIONERY

THE MOOD BOARD

WORKSHEET:

*standoutportfolio.com/
moodboard.pdf*

PINTEREST:

*pinterest.com/ProfessorDMA/
mood-boards/*

A mood board (sometimes called a visualization board, digital mashup, or pitch board) provides a visual means to communicate an idea, concept, or style of a project through images, colors, or typefaces. By now, you've probably built many mood boards for your portfolio or professional practice projects. Now it's time to build one that's all about you. Once it's created, you'll have a clear path to identifying the core visuals that will drive the components of your brand identity. And, you'll find all of the information you need to support your mood board elements in your creative brief.

You can build your mood board using the template I've supplied or design one of your own in Adobe Illustrator or InDesign. Before you get started, you may want to look at the collection of suggested mood board layouts on my Pinterest page. Have fun with it.

ADVERTISING THAT RESONATES WITHOUT INVADING

CHARACTERISTICS:

Big, Tall Thinker - Passionate - Risk-Taker - Nimble
Hard Worker - Empathetic - Charismatic - Diligent

COLORS:

TYPEFACES:

AVENIR NEXT: REGULAR // **BOLD**
UNIVERS: ROMAN // **BOLD**

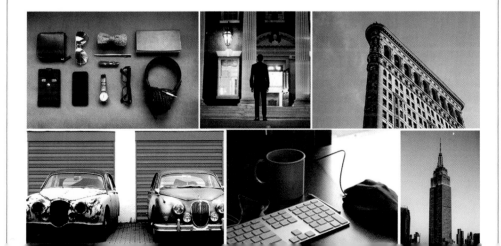

BUILD YOUR MOOD BOARD

What is the "big idea" of
your brand?

All of the brands you've created
for your portfolio have a "big
idea," a purpose or intention,
and your personal brand must
have one, too. The big idea of
your personal brand is your
brand promise, which is the one
unique quality that differenti-
ates you from others. It is the
overarching impression you
make on others, and the one
you want to communicate
about yourself. Without pur-
pose or intention, your brand
will be meaningless, devoid of
emotion, and ineffective for
attracting and connecting you
to your intended audience.

What is the one skill, attribute,
or quality that you want to be
known for? For instance, "Paula
is a communicator who can help
people with opposing views
find common ground," "Dylan
is enthusiastic and helps fellow
students find inspiration for
their design projects," or "Kayla
is persistent and will complete
the task, no matter what chal-
lenges she encounters."

Here is an example: My student
Margaret Grzymkowski intends
to have a career in advertising
(her target audience). To repre-
sent who she is, Margaret has
selected the phrase "feisty, crafts-

person, and lover of donuts" as
her big idea. From my perspec-
tive as her professor, Margaret
is certainly feisty because she is
energetic and relentless in effec-
tively solving design problems.
She is also an accomplished
henna artist (has her own side
business) and illustrates beauti-
ful tattoos on hands, logos, and
donuts. (See Margaret's donut
designs below.)

Margaret's words truly reflect
her brand because she consis-
tently exhibits these traits with
every project she takes on. When
I needed visual examples for
this book, I solicited Margaret's
assistance because I knew that
she would work tirelessly to find
the targeted images I needed.
And, not only would she meet
the expectations of the project,
but she would be fun to work
with because she seeks out fun
and eclectic activities. One of
her favorites? Traveling just
about anywhere to find new
and different donuts. (Note to
readers: As I write this, Margaret
has begun to supply me with
a donut a week. I will let you
know if there is any significant
weight gain.)

EXERCISE: Create your big idea

- Copy the brand promise
 and brand characteristics
 from your creative brief
 in Chapter 2.

- Add your "big idea" to the
 top of Page 1 of your mood
 board. Use it as inspiration
 for your visual identity.

NO MATTER HOW MANY FUN FLAVORS
OF DONUTS MARGARET BRINGS TO THE
STUDIO, JELLY IS STILL MY FAVORITE.

— DENISE

MAX B. FRIEDMAN

TO CHANGE THE WORLD THROUGH DESIGN

DEDICATED
HUMBLE
NIMBLE
FUNNY
DYNAMIC

What visuals best reflect your brand image?

As designers, we can't help but be thrilled by visuals, and now it's time to select some that represent you. Do you identify with high-contrast black and white images that communicate mystery and swagger? Do you gravitate toward pictures of the natural world and beautiful landscapes that convey peace and openness? Or, are you drawn to colorful and abstract imagery that denotes freedom and joy? Pay close attention to the meaning behind the images you select and the feelings they evoke, because each one you choose will communicate something about the attributes of your brand. As you select your pictures, you will see a pattern of image types begin to emerge.

Surf the Internet. Pillage through magazines, your phone, and your camera to find images that you love and that best represent you. Take yourself out on a photo shoot to places you love or somewhere you've never been, and record the mood, style, and visual characteristics of what represents you, and those you want to be associated with.

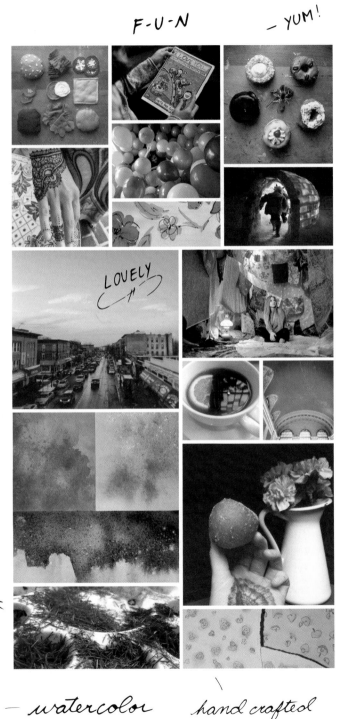

It's better to be overdressed than underdressed

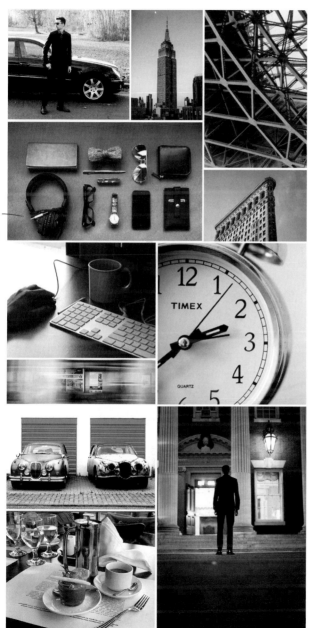

Organized

MODERN

a man with a watch is never late.

Timeless!

Stylish

intriguing

mysterious

sophisticated

EXERCISE: Gather images that reflect your brand

- Refer the descriptive words in the Brand Characteristics section of your creative brief.

- Select 8–20 visuals that reflect your brand image and personality.

- Create a collage of your images. Consider the sizing and alignment of your collage images and the grid you will use. The composition of your collage will communicate as much about the story you are telling as the images themselves.

What colors communicate your brand personality?

Color humanizes your brand and introduces its personality. After shape, color is the second visual cue your audience sees and the one they relate to most. People remember color because it stirs their emotions. The colors you choose should represent your brand and connect with your target audience.

Your brand personality can be expressed through a single color or a group of colors. The colors black, silver, and gold, for example, all share similar meanings (luxurious, rich, sophisticated). When used alone or in combination, they reflect what might be considered an upscale style. Black, used in conjunction with a bright color, elicits a different feeling. For example, with green (growth, natural, youthful), black can signal edginess and chic.

Color creates distinction, and competitors use them to differentiate their brands from their rivals'. Do some research in the industry where you are seeking work and see what colors are trending. Once you figure out the trend, take off in another direction. Do something different to get yourself noticed.

Alexa Matos, for example, loves color. To stand out as a candidate in her search for a job in the branding/identity field, she selected multiple colors to express her brand. Her choice of red (passion), orange (imagination and creativity), olive (sense of adventure and risk-taking), turquoise (calmness under pressure), and purple (curiosity) not only reflects the attributes of her brand but also communicates to a prospective employer that she is capable and fearless about expressing personality through color. Her brand, as well as the brands in her portfolio that she created for others, clearly demonstrates her skill for selecting color, and her ability to use color to tell the story of a brand.

Explore what various colors mean (professordma/color-branding.com). Tap into your knowledge of basic color theory, or read *Design Fundamentals: Notes on Color Theory*, a book by Rose Gonnella and Max Friedman. Inspect your surroundings and identify color trends. Discover which colors evoke what response from the audience you're targeting. Select colors that communicate the attributes of the brand you want to create.

Simply identifying your favorite colors can be a good starting point, or you can review your self-assessment and visualize the colors that come to mind. Do you see yellow because you are warm, happy, and self-motivating? Or maybe orange, because you're energetic, optimistic, and determined? Regardless of the colors you choose, select wisely. Each has meaning and makes a statement. They should reflect your brand and resonate with others.

EXERCISE: Create your brand colors

- Review the descriptive words in the Brand Characteristics section of your creative brief.

- Pick one or two colors that accurately reflect your brand. This is your primary color palette.

- Select two to four other colors that enhance the first one(s) you chose. Make sure that the additional colors you choose match, complement, and support one another in terms of value, similarity, and differentiation. This is your secondary color palette.

- Add your colors to Page 2 of your mood board.

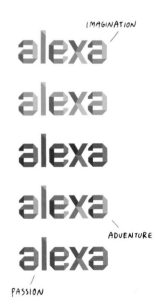

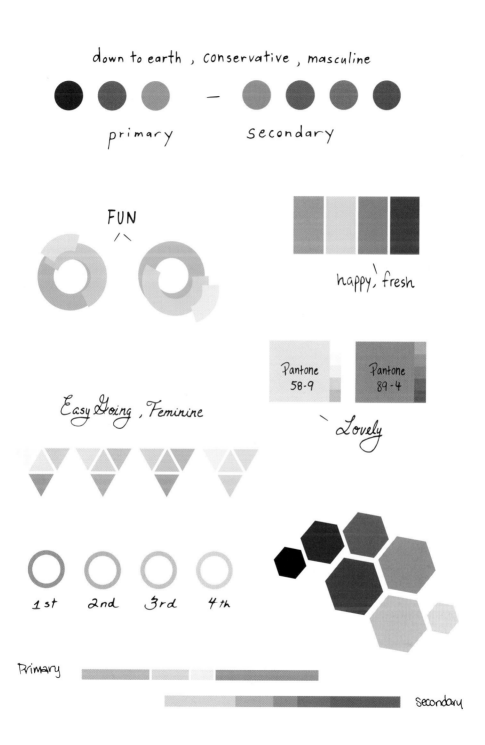

down to earth , conservative , masculine

primary secondary

FUN

happy, fresh

Pantone 58-9 Pantone 89-4

Easy Going , Feminine

Lovely

1st 2nd 3rd 4th

Primary

Secondary

What typefaces best describe your brand?

In your typography and design classes and in designing brands for your projects, you've become familiar with identifying and utilizing typefaces that appeal to you based on type personalities (e.g. elegant, playful, masculine) and type families (e.g. condensed, bold, expanded, italic). Are there fonts you find yourself using repeatedly, simply because you like them? Do any of these typefaces represent who you are? Start with a single typeface that communicates your brand and, through trial and error, add combinations of fonts.

What happens if you select the wrong typeface? Consider these scenarios: A leader of a conservative financial services company chooses a frilly font with flourishes and curlicues—would you think he has the credibility to run a company that is responsible for other people's money? If an engineer selects a font that is difficult to read and has comic overtones, would you trust her to design and sign off on plans to build a replacement bridge for a highway traveled by busy commuters? Look for typefaces

that create an impression about you. Select those that sing your brand attributes, evoke emotion, connect to others, and are highly readable.

Lettering artist and typeface designer Ray Cruz (cruztype design.com) recommends steering clear of the fonts offered for free on websites because some are missing characters and are rendered poorly, which can lead to printing problems. Ray suggests that when you're selecting typefaces, you should consider purchasing (not sharing, which is unethical and illegal) the entire family instead of a single-weight font that will have limited usage. A font family will give your personal brand, and its print and online touchpoints, a cohesive look.

If you're still not sure what "type" you are, other websites can guide you in selecting combinations of fonts for your brand such as Fonts by Hoefler & Co. (typography.com/techniques) and Type Connection: A Typographic Dating Game (typeconnection.com).

EXERCISE: Select your typefaces

- Select two to three typefaces that reflect your personal brand.

- In a page layout program, such as Adobe InDesign or Illustrator, design test combinations of type usages. (See examples below.)

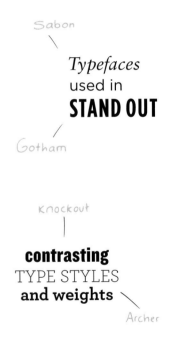

Sabon

Typefaces used in **STAND OUT**

Gotham

Knockout

contrasting TYPE STYLES **and weights**

Archer

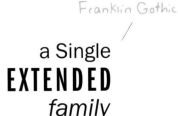

Franklin Gothic

a Single **EXTENDED** *family*

Avenir

Avant Garde

Conduit

DIN

Franklin Gothic

Futura

Gill Sans

Gotham

Gotham Condensed

Helvetica

Knockout

Trade Gothic

Adobe Caslon

Adobe Garamond

Archer

Bodoni

Courier

Cheltenham

Fenice

Minion

Perpetua

Sabon

Times New Roman

TRAJAN

CREATE YOUR BRAND IDENTITY

Resist the temptation to run to your computer and start developing a logo for yourself. You're almost ready but not quite there yet. Remember, your logo and the other touchpoints of your identity will be far more powerful and relevant if you follow and trust the design process and consider the recommendations that follow.

Your name. What will you name your brand? Is it your full name (Margaret Grzymkowski, Designer); a nickname, such as something you are known for (HennaCrafts); an acronym (MGD); or a company name (Feisty Girl DesignWorks)?

I urge my students who are just starting out to use some variation of their real name. Some choose not to heed my recommendation, and that's everyone's prerogative. But consider Connor Paglia. After branding himself as a design company, Undr-grnd (undr-grnd.com), he found a job as a designer for Major League Baseball. He's earning a personal reputation for the work he does for MLB; when he moves on to a different firm, he'll undoubtedly have clients who want to look him up wherever he lands. They know his name but probably not Undr-grnd. How will they find him? Although he did not take my advice initially, Connor must have come to the conclusion that I was right. He has since changed his website URL and now markets himself under his name: connorpaglia.com.

Logos. It may seem like the options for creating a logo that represents your personal brand identity are endless. You're right. You can narrow down the choices and release the potential of your brand story by identifying your personal preferences. Does an icon or a mark best capture the "big idea" of your brand? Does your passion for type mean that your brand will be best represented by a logotype or hand-lettered solution? Do you want a combination mark that includes a symbol and type treatment? There's no wrong answer, but creating a relevant identity that represents you as a designer and is appropriate for the industry you're seeking a job in can be challenging.

Over the course of my 25-year design career, I have started and stopped the logo design process many times, abandoning the pursuit when I hadn't done a proper self-assessment or when I was unable to find the right symbols or fonts to represent my brand. To this day, I have designed only three logos for myself: the first, as a student preparing my portfolio; the second, to represent my design company, DesignDMA; and most recently, while designing this book. Each logo is different and reflects my brand at the time I was designing it.

The logo I designed as a student stemmed from my love, at the time, of 1950s iconography. In the pre-computer age, I used pen and ink to create the elliptical icon and burnished transfer lettering to create my name. To combine the elements, I enlarged and reduced the logo and type to the correct size on a Photostat (photographic copying) machine. After a few hours in production, I had my logo. I distinctly remember looking at it and feeling that I had created a true representation of me. (I look at it now and ask myself, "What was I thinking?")

My professional logo evolved ten years later, starting as a straightforward personal mark that was the acronym of my full name: Denise Maureen Anderson, or DMA. When I went into business for myself, my logo mark came along with me for two reasons: First, I was too busy doing projects to brand my business, and second, because the mark represented the elegance and sophistication I wanted my design company to be known for. The olive and purple colors were a just a little bit offbeat (edgy) and the two typefaces I chose (Avant Garde and Adobe Garamond) supported the upscale refinement of the design and financial services clients I did business with at the time.

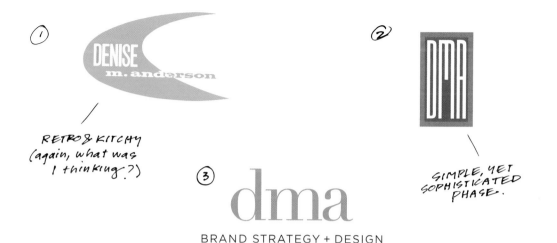

① DENISE m.anderson
RETRO & KITCHY (again, what was I thinking?)

② DMA
SIMPLE, YET SOPHISTICATED PHASE.

③ dma
BRAND STRATEGY + DESIGN

In my most recent rebranding effort, I created a simplified logotype solution that combines Didot (a classic typeface) with Gotham (a sans serif typeface). Olive green (a color I identify with) and black embody and reinforce my "established, elegant, and modern" brand message.

Business cards. A business card is a major touchpoint of your brand identity because it can be used as a key takeaway when you're making a connection with someone or networking for a job. A business card also provides essential contact information, including your portfolio website address, phone number, and any other relevant details you want a potential employer to keep on hand.

Of all of your stationery components (including letterhead and envelope), your business card is important for three reasons. First, it makes an initial impression of your brand essence;

second, it contains information on how to contact you for a job; and third, it creates a sensory brand experience.

Many designers (especially those seeking jobs in advertising) approach business card design not only as a communication of their identity (consistent use of their logo, colors, and typefaces) but also as a promotion of their brand. When you're designing your business card, you'll want to consider different size formats and printing techniques to reinforce the unique nature of your brand. For example, graphic designer Dave O'Connell wanted to communicate a way to share contact information and created a perforated business card that could be quickly and neatly torn in two, with the same information on both halves. His concept that the recipient could keep one part of the card and share the other part with some-

one else. The distinctive format allowed Dave to stand out from the crowd.

Other ways to stand out in creating a business card design is to use different printing methods (letterpress, silk-screening), unique paper stock (seed paper, wallpaper), and finishing techniques (embossing, ink stamping). Remember, the format, paper stock, and printing/finishing process not only enhances/complements the uniqueness of your brand personality but also communicates your knowledge of design, production, and printing. Your business card should look effortlessly professional. To take it a step further, how about creating a business card that engages other senses such as hearing, smelling, or tasting? The idea might not be so far-fetched in the competitive environment of design.

thesamgarcia.com

amato

maxamato.com

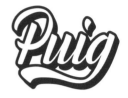

be.net/xavipuigx

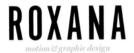

roxana.design

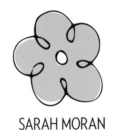

sarah-moran.com

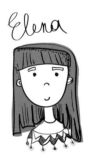

be.net/elenakireeva

be.net/rallodanielle

sydneybuxton.com

francomery.com

sepulveda.design

samizu.co

drumbauskas.com

trianabraxton.com

caitanderson.com

keithrodman.com

juvytorres.com

be.net/johnnybrito

nvelez.com

Attract attention with different shapes!

Hello, I'm
John Weigele
Maker • Explorer • Pilot

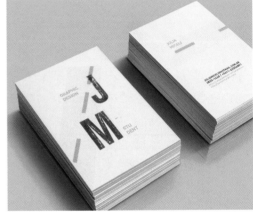

SOMETIMES the BUSINESS CARD MAY BE THE ONLY TANGIBLE TOUCHPOINT OF YOUR BRAND. CREATE ONE THAT IS memorable!

— DENISE

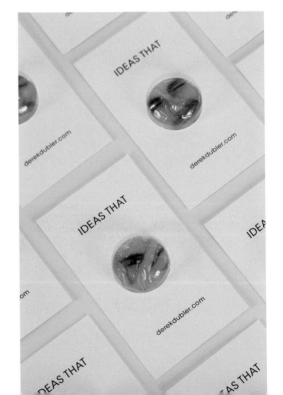

STEPHEN
SEPULVEDA

BRANDING & DESIGN

SEPULVEDA.DESIGN

HELLO@SEPULVEDA.DESIGN

201-982-6629

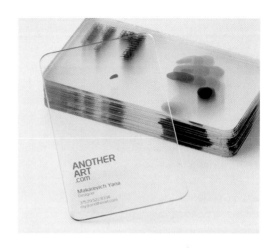

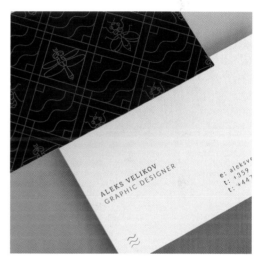

Dave O'Connell
Graphic Designer

hey@iamdaveoconnell.com / 917.653.2990

Tear and share .
(Perforate here)

Back when I was looking for my first design job, there were no digital or website portfolios or email addresses I could forward links of my work to. The main way to get an appointment for a job interview was to respond to a job posting using a cover letter and resume. The process was lengthy, and it was never clear whether a real person actually received information or if it just disappeared into a black hole. These days, the definitive trend is to apply online, so there's no longer a real need to have letterhead and envelopes printed professionally. Few people expect it, and you can probably print your own when you need it. Color printers today are reasonably priced and produce as impressive product as a high-cost professional printer did in years past.

Make the same considerations for your stationery design that you did for your business card. Are the size and format of your letterhead a traditional 8½" W x 11" H, with a traditional #10 envelope to match? Are they horizontal or vertical? Is the flap on the back of your envelope square, rounded, or pointed? Every piece you select for your identity communicates something about your brand. For example, if you are looking for a sophisticated style, you may choose a square flat envelope because of its elegance and not-so-common use. If you're more forward thinking, an oddly shaped envelope may get someone's attention—just remember the cost of postage will be higher!

If you're printing the letterhead and envelope yourself and they

have a full bleed of color, your at-home printer may not be able to handle it. I suggest you modify your design to compensate for this limitation. If you're determined to use an envelope with full color, buy some to have on hand. If your chosen color is too dark to print on, use labels for the mailing and return address.

When I was in professional practice, I took the design of the envelope so seriously that I chose stamps to reflect the promotion, the season, or the message the recipient would find inside. I was even a stickler about stamp placement, because I firmly believed, and still believe, that everything in and on that package reflects the brand.

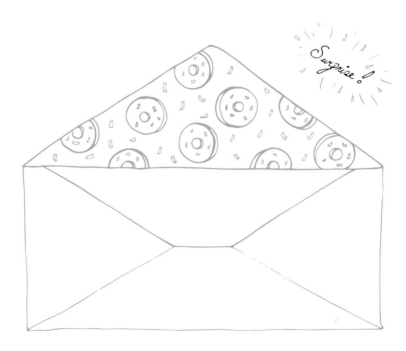

STAND OUT

Your core brand identity sets the tone for your other brand touchpoints. Carefully select appropriate colors, typefaces, and imagery, and use them consistently and cohesively across every one of your pieces.

- Your brand identity should visually communicate your unique brand story.

- A prospective employer will use your identity design to test how well you can brand others.

- When choosing typefaces for your brand, dress for the occasion. Just as you have a favorite sweater or pair of jeans, start with fonts you relate to or ones that you have successfully combined in other projects.

- Your logo direction and style should communicate the attributes of your brand.

- Build a memorable brand that promotes your personal design style and your software skills.

- Design a brand identity that is relevant to the market in which you seek employment.

4. PROMOTE YOUR BRAND

Creating an integrated brand campaign.

Everyone's comfort level for putting themselves out in the world to get noticed is different (although I tend to think that younger people, raised in the age of selfies and social media, are less self-conscious about self-promotion than other generations). Personally, I've never liked vying for attention, and to this day, I find the tasks related to self-promotion—cold calling, meet-and-greeting, and sharing my work and myself with strangers and people I've only just met—downright frightening. When I had my design business, I paid a full-time salesperson to initiate contact with potential clients. It's not that I lack self-confidence, but quite frankly, the idea of being rejected hurts my feelings.

When I was single and looking for someone to share my life with, my good friend Janice told me, "Love will not walk up and knock on your door." Conceding she might have a point, I started networking. I asked my friends and colleagues to set me up with people they knew, and after some awkward

phone calls, bad dinners, and one minor stalking incident, a close friend introduced me to my soon-to-be spouse. Janice was right. I never would have found who I was looking for if I hadn't taken control of my search.

Pursuing a job should be like seeking out a love relationship.

You have to know what your goal is, have a strategy to reach that goal, and then execute your plan. It's great to be wonderful, but if no one else knows your greatness, how will you ever get a design job?

My former student, Connor Paglia (who you met in Chapter 3) grew up playing baseball.

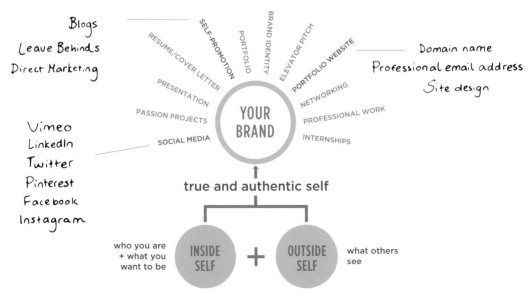

He played all through college, until his senior year when he left the team to concentrate on finishing his degree in graphic design. As a student, Conner was disciplined, hardworking, and a team player (skills he learned, or at least refined, playing baseball). He was also generous, frequently sharing his design and production skills with anyone in class who needed help. His dream job was to work for Major League Baseball.

Just before he graduated, Connor read that the MLB was building a product team to work on third-party clients (consumer brands, not just baseball projects). Connor was well qualified for the position, but his goal was just to get an interview, to get in front of someone so he could demonstrate his devotion for the game and commitment to doing the work. He was confident that he would be a good fit because of the skills he had learned on the field, his branding and

mobile design knowledge, and the professional experience he had earned through freelancing and design internships. Connor hadn't even graduated yet, but he knew he had to take the chance and apply, because if he didn't, his odds of landing the interview (and the job) were zero.

It's not uncommon to want to shy away from exposing your creative efforts and yourself to potential criticism, especially from employers as huge as the MLB. But I can assure you that when you call upon the kind of courage that has brought you this far (getting through design school is no easy feat) and push past your fear of rejection (to reach your true love or job of your dreams), you will put yourself in a position to speak with confidence about your work and its value.

Connor got his interview, and as you know, he got the job with Major League Baseball.

He did it by communicating his ideas, experience, and skills, as well as work ethic and dedication. His website and his other touchpoints communicated the type of thinking, aesthetics, and skills that he could offer. He had a brand strategy, and he promoted himself.

Remember: you only need to connect with one nice person (and there are plenty in our industry) who can give you a break in the form of a job, advice, or your next lead. This is no time to hold back or succumb to feeling intimidated. Devise a plan, develop your message, design the touchpoints, identify the audience you want to reach, and then promote yourself through the channels they use for communication. Reach, don't wait, for your opportunity, whether it's a great design job, networking with other professionals, or making a name for yourself in the public eye.

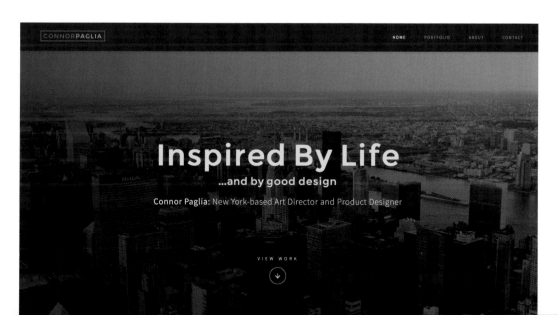

CONNORPAGLIA

HOME PORTFOLIO ABOUT CONTACT

Inspired By Life
...and by good design

Connor Paglia: New York-based Art Director and Product Designer

VIEW WORK

Just as you wouldn't search for true love without a plan (going to a bar to meet someone is basic, but it's still a plan), you have to think through and commit to a search process that you can execute. This effort has two objectives: to gain attention for your capabilities and to create an emotional connection to your target audience. You do this by showing up where your audience is most likely to hang out, with a consistent message about yourself and your brand. The more they see your brand, the more they will grow to trust you and buy into your brand story, and the less likely they are to be dismissive when you approach them for a job interview.

brand strategy | Stephen Sepulveda

WHO:
Identify your target market

- My target market is creative agencies, small businesses and start-up companies looking for a designer to assist them in distinguishing their brand, and their clients' brands, with a meaningful and bold digital presence.
- Organizations that are open to working with an entrepreneurial-minded team player who is willing to roll up his sleeves and collaborate on ways to grow their business with a focus, though not an exclusive one, on design solutions.

WHAT:
Formulate your brand message

"Ideas, stories, and digital strategies that transform brands."

WHERE:
Select your promotional touchpoints

1. Create a portfolio website to showcase my work, passion projects, credentials (including a downloadable resume), and contact information.
2. Establish social media channels on LinkedIn, Facebook, Instagram, and Twitter to promote my website and work.
3. Design a "Views and Brews" direct mail promotion to send as a thank you after an interview.

HOW:
Promote your brand message

- Send out an email blast letting my existing network of professionals know I am looking for work.
- Follow people on social media from companies I want to work for and start a dialogue with them.
- Attend portfolio reviews at AIGA and The One Club to get feedback on my work.
- Upload to social media mini-case studies as a "teaser" in the form of snippets of videos, motion graphics, and still images.

WHEN:
Time your promotions

- Launch website and social media channels simultaneously.

WRITE YOUR BRAND STRATEGY

Per entrepreneur.com's *Small Business Encyclopedia on Branding*, a brand strategy is "how, what, where, when, and to whom you plan on communicating and delivering on your brand messages." Everything you show, say, or do (or don't do) communicates something about your personal brand. For example, consider the Dos Equis man (born from a beer promotion of the same name). Many admire him for his air of mystery, women adore him, and he travels the world in style. His tagline (which would be his brand promise if he conducted his own personal assessment and analysis) says he is the "most interesting man in the world." His brand message is broadcasted consistently and cohesively across multiple touchpoints in traditional advertising (TV, radio, and print), social media (Facebook, Twitter, and Instagram), and online (website and YouTube); I've included some of "his" links on my Pinterest page: pinterest.com/ProfessorDMA/personal-brand-promo/. Dos Equis leverages many of these brand channels by developing personalized content to

communicate his story. Take some time to think about how you will promote yourself by developing, maintaining, and leveraging what you've already learned and expressed about your brand. Use the downloadable worksheet found at the link on the previous page, or write your answers on a piece of paper. You're putting together a plan to communicate and deliver your brand message.

Who
Identify your target market.

You've already done some preliminary research, and your creative brief identifies where you want to be employed. Now you have to drill down into the details. If your brief shows that you want to work at a digital design agency of 150-plus people, then you'll have to identify those companies that fit the criteria; and start thinking about where they're most likely to be located. The more details you have about your target audience, the better you can customize your promotion. Remember: establishing connections that will lead to work is not about how many people you reach; it's about the quality and appropriateness of the audience you engage. For example, Margaret Grzymkowski (the feisty henna artist from Chapter 3) made, decorated, and personally delivered donuts, her business card,

and a handwritten note to the owner of a company where she wanted to work. He responded promptly with an email saying he'd be in touch when a position opens up.

What
Formulate your brand message.

Your creative brief contains the information that will inform and inspire your brand message. Just as skiing, fighting bears, cooking burgers, and attempting to run for the U.S. presidency makes Mr. Dos Equis the "most interesting man in the world," a unified message will communicate your unique value proposition clearly and consistently throughout all of your promotions. What is the one thing you want your target market to think about when they hear your name or see your visual identity? Set the mood. Develop a point of view. Stay true to your brand promise. Own who you are, and don't be afraid to put it out there.

Where

Select your promotional touchpoints.

You can choose to do very little or as much as possible to get yourself noticed, but at minimum you're going to need a website and a social media campaign to communicate and deliver your brand story. (You'll learn more about both later in the chapter.) The world uses these online touchpoints to do business, and you should be using them, too. Conceptualizing and integrating a memorable campaign with today's print and social media channels will help you stake out your territory, differentiate yourself from the competition, and demonstrate an air of confidence.

How

Promote your brand message.

There are many, many ways to communicate your brand message, but you have to use the applications, channels, and platforms that your target audience is most likely to use. For example, if you are a mobile app designer, use web and mobile prototyping software to create your app, and then insert a link into an email blast or post it on your social media channels. If you're a pattern designer, let your audience experience your shapes, textures, and colors first-hand by printing designs on cards or fabric swatches and sending a packaged kit via direct mail. They are two very different approaches, but each is appropriate for reaching and resonating with its particular audience. Not every form of communication works for everyone, so choose wisely.

When

Time your promotions.

Think back to my analogy of finding true love. Do you share everything about yourself in that initial phone call, or do you hold a few things back to reveal when you're on the first date? Likewise, your promotional plan might start with a trickling of key messages—some teasers or pings to gauge whether and how your audience will respond. Identify the date when all of your promotional touchpoints will be ready or in the pipeline to be completed. No matter what your promotion, schedule, or vehicle for delivery is, time your strategy and move the viewer from one channel to the next so they'll have a comprehensive idea of what you have to offer. If you misstep and don't deliver when you said you would, you can lose any trust you've built with your audience, and it could damage your brand.

DEVELOP A PERSONAL WEBSITE

Outside of your logo, the most far-reaching and important brand identity touchpoint is your website, which is better known in our industry as your "online portfolio." Your website is the one touchpoint that can be used as a promotional vehicle to connect you professionally to potential employers and clients throughout your design career. It can be updated easily and inexpensively with a new brand identity or portfolio projects. It advertises your design capabilities, software skills aptitude, and experience. More importantly, art directors and hiring agents use websites to prescreen candidates. In one afternoon, you can reach more people by sharing a link to your website than you could interviewing for a week.

This section is not about website design, but it should call your attention to the importance of having a website and how it relates to promoting your brand. You've almost certainly taken courses on basic web design. If you're more advanced, you can use the information and my recommendations to align your strategy with ways to best promote your brand. The points I highlight are relevant to your brand strategy and the success of your website.

Sombrero dog stole my heart → MINE! TOO! (Denise)

Select a domain name and professional email address

Your name is vital to your brand story, and an appropriate, corresponding domain name is just as important. Your website URL will be your professional handle throughout your career, so I recommend using your personal name as your domain so you can be found through an Internet search, and so no one else can snag it. Personal branding guru William Arruda says, "Buy your domain name. It's like buying property. You want to own the property even if you're not ready to build the house… If you have kids, buy their domain names. If you are going to have kids, don't name them until you see if you can have their domain names." Whatever domain you choose should be easy to remember and self-explanatory.

Use your domain name consistently across all of your touchpoints. URLs are generally inexpensive, and if you're uncertain about what name you want, purchase several, and redirect each to your primary personal website. Register the name for as long as you can. Even if it's only a year, make sure it's set to auto-renew. This will ensure that no one can take it from you.

When I started this book, I did not own the domain name "DeniseAnderson.com" because it hadn't been on the market

for years. I wanted the ".com" because it is the most commonly-used commercial extension, and the one most people try first. As alternatives, I purchased variations of my name:

- DeniseAnderson.net,
- DeniseAnderson.me,
- DeniseAnderson.design, and
- DeniseMAnderson.com.

I want to own any domain name that's closely associated with mine. I also bought Professor DMA.com (my social media handle). DeniseAnderson.com continued to elude me.

Writing this chapter, I did another quick Internet search and was delighted to discover that DeniseAnderson.com was available through a site that owns personal names. A five-minute email chat revealed that it was available, and I negotiated to buy it at less than 50 percent of the asking price. At the start of the negotiation, the vendor, unwilling to budge on price, claimed that more than 200 people had researched the name recently. I responded that the market for my name is small and that I conducted most of those searches. He lowered the price immediately. It never hurts to push back a little. If you are faced with a similar challenge, it can't hurt to try to negotiate and acquire your name.

Options to consider when the domain name you want is not available:

- If the .com extension is not available, try .me, .design, .net, or another option that makes sense to your brand. For example, "JessicaHische.is" creatively uses the extension (for Iceland) to communicate attributes about her brand ("jessicahische.is/aseriousover sharer" and "jessicahische.is/thinkingthoughts").

- Acquire your last name (Anderson.com) and use your first name as the email address (Denise@Anderson.com).

- Use a middle initial (MaxBFriedman.com).

- Be conceptual (ILoveBobBuel.com).

- Add punctuation (Jiali-Ma.com).

- Insert the word "design" (AlexaDesign.co).

- Use a nickname (TheSamGarcia.com).

- If your name is difficult to spell, abbreviate it (Margaret Grzymkowski uses marggrz.com).

SOME NAMING CONVENTIONS FOR
(SELECTING) AN EMAIL ADDRESS

formal →

Denise @ denise anderson . com

Casual ←

DA @ denise anderson . com

Casual →

D @ denise anderson . com

Casual ←

Me @ denise anderson . com

nickname ←

Dee @ denise anderson . com

Hello @ denise anderson . com

friendly →

friendly →

Hi @ denise anderson . com

Info @ denise anderson . com

GENERIC ←

Contact @ denise anderson . com ←

GENERIC

Organize your site

Organizing information (such as the website framework and content) into a well-built layout should always come before site design. Without structure, your website won't flow correctly, and your visitors will have no clear path to the information they want. Organizing your site may seem like a tedious task, but you have to know at the outset what information you want to include. Preparation will help you put forward a strong brand, and the exercise will enhance what you can offer as a professional.

Things to consider when organizing your site:

- Page format (vertical or landscape) and layout grid (columns and margins)
- Navigation (names and style)
- Logo and name (size and placement)
- Typeface and color selection (use the selections and styles created for your brand identity in Chapter 3)
- Images (professional quality photos of your work and/or headshot; size and placement)

- Call to action (critical information about how to get in touch with you)
- Personal work (projects you are passionate about and create on your own time)
- Social media links (sites you use frequently or recommend and those that integrate your brand message)
- Copy (text for each section; your bio and work experience)
- Content (blog, videos, and other design elements)
- A platform that is easy to update and maintain

STEPHEN SEPULVEDA
BRANDING / DESIGN

Identify the type of site you want

When you have identified and organized your information, think about the type of site that will reflect your brand and skill set, and select one that you can build. As a designer, you should have some base knowledge in website design (using Adobe Muse or Adobe Dreamweaver, for example) and programming (HTML, CSS, JavaScript, and HTML5, to name a few). You may already have a portfolio website on Behance or Square-space or one that you've built yourself to display your work. There's a difference between those and a professional site (or the site you are building now) that is part of a bigger brand strategy. For your purposes here, you're creating something that will represent you professionally and serve as your online go-to location for the duration of your career.

As part of your website, consider blogging to promote your brand. A blog gives readers insights about who you are and what you value, and it gives people a reason to check back in from time to time. It can highlight a project or accomplishment that you are proud of or showcase your expertise. It is important to understand up front if blogging is part of your promotional strategy because you may need a site that includes a blogging feature, and it should be easy to use.

If you do decide that you want to blog, keep up with it. When you slack off or stop, people may perceive your brand unfavorably.

Whatever type of site you choose, it will reflect what you know about website design and programming and how to promote yourself to stand out from the crowd. Every semester, my colleague Ed Johnston, who teaches website design, creates a "cheat sheet" (standoutportfolio .com/website-cheatsheet) on how to identify and set up a simple website. Technology changes so quickly, he told me, it's become essential to update it every semester. Webhosting, Creative Cloud, domain names— it can be confusing, but Ed's chart walks you through some options of the type of sites that were available at the writing of this book.

Things to consider when identifying the type of site:

- Responsive (comparable web experience on all platforms)
- Template (i.e., Squarespace); hybrid (template, with some programming capabilities); or fully customized (i.e., unique design created in Adobe Muse)
- Number of pages (loads faster)
- Cost
- Features (blogging, email marketing, e-commerce)

Thanks Ed!

Design your website

As websites and online design portfolios have become simpler to create, the volume of design portfolio sites on the Internet has escalated. With literally countless online portfolios to wade through, employers are challenged to find a designer who can effectively meet their needs. You have to think about what you can do to design a website that stands out in a crowded marketplace.

When I was building brand identities for a living, I applied a formula I called "Simplify, Humanize, and Energize." I applied it to everything I designed. With this formula in mind, I was able to ensure that what I designed was meaningful, relevant, differentiating, flexible, cohesive and memorable, and that it would resonate and con-nect emotionally to the targeted audience and communicate the brand message. Refer to the creative brief and use the brand identity elements you created in Chapters 2 and 3 to align and connect your brand identity to your website design.

Simplify. It may be fun to design and program lots of fancy bells and whistles using motion graphics, videos, and music, but your audience will generally prefer you to get to the point. They'll appreciate a clean, engaging design and navigation that makes sense. Your goal is to help visitors focus on the value of your brand and the content of your message, not on navigating through page after page of busy, blinking images and lengthy, self-indulgent blocks of text.

Humanize. You can't see who's viewing your website, but I can assure you, it's a human being who wants to be treated with respect. So don't look down on your viewers or insult their intelligence. Be personable and welcoming, just as you would if you were inviting them into your studio or home to take a look around, see your work, and stay for a while. Your site should encourage them to participate, have fun, and feel a bond with you. Employers and clients on the receiving side of the screen are really rooting for you, because they're hoping that you're the one who can help them achieve their goals and objectives (i.e., finding the right employee or freelancer to hire).

Energize. Evoke an emotional response from your audience. Use your brand colors in a new and exciting way or crop and arrange your images to create movement and fluidity through the site. Use original images. Be honest, thought-provoking, and relevant. Your copy should support and enhance your brand but shouldn't overwhelm or tire your audience. Your site should grab and hold their attention, but too many images can be distracting. A savvy art director will recognize attempts to hide poor ideas or badly rendered designs behind a lot of frippery.

Other things to consider when designing your site:

- Validate that your website communicates the essence and message of your brand.

- Design the layout and organize content to make the website easy to navigate.

- Focus on the content and then the presentation.

- Confirm a clear hierarchy of information.

- Integrate typefaces, colors, and image styles from your mood board.

- Include personal projects, even those not design related, that reveal your other interests.

- Select and use quality images.

- Add a copyright signature to the bottom of each page; for example, "Copyright 2015 YourFirst LastName. All rights reserved."

ABOUT DESIGN & ILLUSTRATION BLOG

Test and launch the site

Many website browsers and electronic devices on the market can help you confirm that your site is functioning properly and that your design is proving to be the experience you want it to be. Interactivity is as critical as content. After you have examined all of the site's functions, ask others to test-drive it. Better yet, have them visit the site in front of you so you can watch them navigate and see how they access information and how quickly. The time to modify and fix problems is before you launch.

What to consider when you're testing your site:

• Check site functionality on Google Chrome, Mozilla Firefox, and Safari browsers.

• Review your website's respon-siveness on Macs and PCs, iPhones and Androids, tablets, and any of the most popular devices.

• Triple-check the accuracy of the content on your site, such as spelling, grammar, punctu-ation, text formatting, image correctness and sizes, and contact information. If text

is not your strong suit, ask an acquaintance to proofread it for you.

• Assess how quickly your pages, images, and fonts load.

• Confirm that links for your email, resume, and social media are working properly.

why make
one first impression ...
when you can make seven ?
(alternating homepage image)

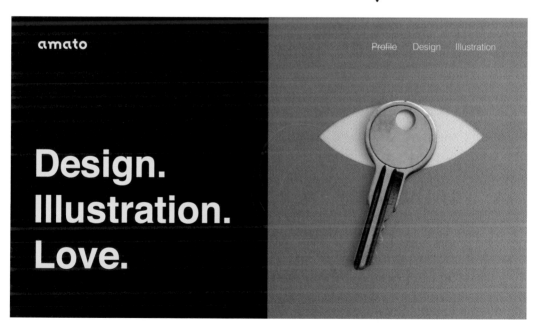

CHOOSE YOUR SOCIAL MEDIA PLATFORMS

Promoting and integrating your brand using social media is no longer optional. Platform preferences may differ from person to person, but most business people use sites like LinkedIn and Twitter to learn about their colleagues, associates, and potential new hires, whether their scrutiny is covert or obvious. I find that most young people today are agile and comfortable with all kinds of social media in their personal lives, but surprisingly few know how to use it to promote their professional brand. Some can even do damage because they confuse their professional contacts with friends and family by taking an approach that's too casual. Social media is today's venue for promoting your brand, exercising your skills, displaying your work, and revealing your personal interests. Just as you use it to build and maintain personal relationships, you can establish strong, lasting connections with other design professionals, colleagues, peers, and vendors. Pay attention to the trends, because what's hot, and what's not, is always changing.

Social media marketing touches every element of your brand from your conventional website and blog to the mobile web. Others can promote your brand for you by sharing, recommending, and re-tweeting something you've done or said. An art director who includes you as a connection on a social media site can catapult you instantly into the limelight. Robert Busch School of Design star Max Friedman is a good example. When he won the 2015 ADC All-Star award, numerous design leaders posted his information on dozens of social media channels. By the end of the day after the ceremony, Max had received a handful of email invitations (through the link on his website) to interview at top advertising firms in New York City. Social media is a powerful tool—in an instant, everyone can know your business.

As you think about your brand strategy, you should be considering which social media options will help you promote yourself the most effectively. Hina Paracha, a social media manager assisting start-ups with their social media marketing in the UK, talks about "The 5Cs of a Killer Social Media Strategy" (wersm.com/the-5-cs-of-a-killer-social-media-strategy/). In her blog post, Hina highlights five key ingredients that constitute a successful social media marketing strategy.

"The 5Cs of a Killer Social Media Strategy"

1

Content is king. Whatever you post on your social media pages reflects your brand. Keg-stand photos of you and your friends and pictures of cute animals may resonate with your buddies, but if you want to resonate with a professional audience, you should post content that will interest them and keep them coming back for more.

2

Consistency. Just as a cohesive brand builds trust with your audience, so will a uniform approach across all of your designated social media channels. Stay on top of changing trends, and keep experimenting: a post that's exciting today may not be relevant tomorrow.

3

Conversation. Engage your fans and followers in meaningful conversations. Talking about what matters to your audience is the heart and soul of your social media strategy. When potential employers see that you care about what they care about, you establish an emotional bond that will predispose them to look favorably upon your brand.

4

Customer service. You may think you don't have to worry about customer service before you're employed as a designer, but your assumption would be incorrect. Long before you are working for someone, you are demonstrating the quality of service you can provide, and your actions speak volumes about you. Answer your emails, respond to tweets, and reply to LinkedIn requests promptly to send the message that you will be responsive to your employer and their clients when you're hired.

5

Crisis management. How should you respond to someone who doesn't like one of your projects or posts negative comments on your blog? Before it actually happens, you should have a plan to mitigate potential damage. I've seen hotel managers promptly respond to customer complaints on TripAdvisor; when I see the manager's polite comeback, I can't help but wonder if there was truly a problem with the establishment or if that guest just wanted to play troll.

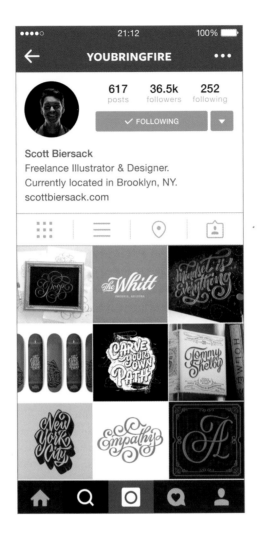

Social media has changed my life;
without Instagram, Dribbble, Twitter, and
the Internet as a whole, I wouldn't be where
I am today. Being able to take a photo of my
work and share it with thousands of people is just
nuts. It's even crazier that creative directors and
art directors can see my work and potentially hire me.
My experience with social media has been amazing and
I owe my entire career to the wonderful people
that follow and share my work.

—Scott Biersack

My colleague, Distinguished Professor Robin Landa, has authored 21 books about design, branding, advertising, creativity, drawing, and art. I asked her to share some pointers, and she generously provided these practical and educated insights about promoting your brand through social media:

Be authentic. Your voice (tone, word choices, and sentence/phrase structures) should be in sync with your personal brand, the copy on your website, and your bio and resume.

Be positive, not negative. When you're building a personal brand, social media channels are not complaint forums but places for you to shine.

Be informed. Find the right audience. Use Twitter to follow recruiters, agencies, design studios, and corporate CCOs (chief communications officers) and CMOs (chief marketing officers). Connect with them on LinkedIn, too. Check out your competition—see what they're doing and whom they're following.

Promote a little/inform a lot. Share information that your audience will want to spend time with. Contribute to society, entertain, inform, and educate. If you talk only about yourself, people will tune out. If you inform, educate, and write interesting posts or post shareworthy imagery, people will pay attention. Remember, you are competing for attention with everything that's online. Ask people to share your posts.

Showcase your passions outside of design or advertising. Whether you are passionate about music or in the midst of a personal project, share information and images (without violating any copyrights). Make sure to give proper credits when sharing others' works, words, and posts.

Follow influencers—re-Tweet and re-post! If it's interesting or enlightening to you, others will probably appreciate the share.

"Your designs fly to new heights when they are influenced by your life passions. The best forms of inspiration often come from outside the field of design."

– John Weigele

LINKEDIN

Connect to professionals, business owners, and B2B customers to generate leads and establish professional relationships. LinkedIn is the number-one networking site for professionals.

FACEBOOK

Communicate your brand message in ways that connect, inform, and entertain. Leverage your social community by networking with the largest number of social media users.

TWITTER

This "microblogging" channel allows users to post quick, short messages. It's a powerful networking tool for building a loyal following and driving people to your website or blog.

INSTAGRAM

Share your photos, videos, and other visuals to a variety of social networking platforms like Twitter and Facebook.

GOOGLE +

Reach out to early adopters, B2B professionals, and general social media users. Hangouts is a video chat service that you can use to connect with prospective employers. This platform integrates several social channels, including Google Profiles and Google Buzz, Circles, and Sparks.

VINE

Post short videos that loop to communicate your brand and display work samples for your portfolio. Vine can help you advertise how you can be creative in a new way.

PINTEREST

Promote your brand story with visuals. Pinterest is great for personal projects. It is a strong driver of traffic to websites. The target audience is mostly women.

VIMEO

This site, known for high-quality videos without distracting ads, allows you to share, discover, and be inspired. It's used by professional creatives and filmmakers to showcase their work.

YOUTUBE

Promote your brand by posting tutorials and other videos. Make a dynamic impression on your website by embedding YouTube videos.

STAND OUT

Want your brand to stand out? Keep these ideas in mind as you devise your plan, develop your message, design touchpoints, identify your audience, and promote yourself.

- Think about how your website connects to your other touchpoints, including your brand identity and other applications you have yet to create.

- Reach, don't wait, for your opportunity by having a clear plan and proceeding with confidence based on your skills, experience, and brand.

- Connect with your intended target market using the platforms and channels they use.

- Focus on the content first and then the design and presentation of your promotions.

- Select domain names, email addresses, and social media handles that make sense for your brand and are easy to remember, spell, and search.

- Establish a professional social media presence that is different from your personal image, and remember that a potential employer will most likely be looking at your posts at any time.

- Be consistent throughout all of your promotions.

5. CASE STUDIES: BRAND IDENTITY

Exploring student brands that stand out.

Defining your brand is a deeply personal process that can help you move with purpose through a transitional period of your life. As a designer, you have the opportunity (and you are expected) to create visuals (logo, business card, website) that communicate your brand attributes, express your personal style, and boast about your design capabilities. Each visual identity touchpoint you create has the potential to engage and connect with a potential employer. As a designer who has hired others, I see every designer's identity project as an opportunity to get to know them better, even before we've had a chance to meet. A compelling personal identity (along with great work) is much more likely to score a job interview because it kindles a desire to learn more about the person who created it.

The work you'll see in this chapter did not come easily to the students who produced it. Whenever I ask students to design their personal brand identities, I watch them fight their way through Dante's nine circles of Hell. (I am exaggerating, but it seems to feel like that to some of them.) This tends to happen because the work is hard, and it requires introspection and research to find your true and authentic self. No tips, tricks, or shortcuts will get you there. However, I promise that if you spend time on the personal self-assessment and analysis

exercises outlined in this section, you will become confident and capable of creating a meaningful, relevant, flexible, and distinctive personal brand identity. Remember, there is no computer or design publication that can define your brand, nor any book that can design a logo that represents you. Just as you work strategically to build projects for your portfolio, you must take the same approach in creating your personal brand.

The examples in this chapter are the work of my students at the Robert Busch School of Design. Each brand has a

unique personality and reflects the identity of the person who created it. Each student used the information contained in their creative brief to build a relevant, meaningful, differentiating, and memorable visual identity. Long after they've left my classroom and found their place in the world, I will remember these students through the echo of the personal brand stories and identities they have created for themselves.

What is your true and authentic personal brand identity? Share it on my Twitter page: #*Stand OutIdentity.*

DON'T FORGET ABOUT ME!

creative brief | Denise Anderson

TARGET AUDIENCE (Where you want to work)

Field of interest:	Design education, graphic design, and design entrepreneurship
Type of company:	College/University
Company location:	NJ/NYC
Company size:	Small to medium
Type of job:	College professor

VALUE PROPOSITION (What you can offer the target audience)

1. 25 years of professional practice, and 17+ years of teaching experience.

2. Proven ability to create, establish, and manage businesses.

3. Respected industry leader and subject matter expert for design portfolio development.

4. Passionately committed to discovering and unlocking the potential of others.

5. Dedicated to facilitating change through the power of design.

BRAND STATEMENT (What does your brand stand for)

My name is Denise Anderson, and I am an educator, graphic designer, and design entrepreneur. As an educator, I discover and unlock the potential of others. As a graphic designer, I create change through design thinking. As a design entrepreneur, I use my creative skills and business knowledge to bring ideas to market. Regardless of the task at hand, when I am inspired, I give it my full attention and commit myself to seeing it through.

BRAND PROMISE (Your unique differentiating proposition)

Unleash and empower others with design thinking

BRAND CHARACTERISTICS (Qualities that best describe you)

Attributes:
- Passionate
- Creative
- Driven

Personality:
- Devoted
- Feisty
- Entrepreneurial

MAX FRIEDMAN

VISUAL CREATOR

To change the world through design.

creative brief | Max Friedman

TARGET AUDIENCE (Where you want to work)

Field of interest:	Graphic Design
Type of company:	Advertising Agency
Company location:	NYC
Company size:	Large
Type of job:	Graphic Designer or Art Director

VALUE PROPOSITION (What you can offer the target audience)

1. I have what it takes to change the world through design.

2. My passion drives me toward the future each and every day.

3. I enjoy watching my peers and others succeed. It influences me to strive for success.

4. Everything I do will be done with quality and dedication.

5. I believe that there are always possibilities.

BRAND STATEMENT (What does your brand stand for)

My name is Max Friedman, and I am determined to change the world one design at a time. Building experience upon experience, I have come to believe that possibilities can be found in unlikely places, so I seek out and seize upon what others take for granted. My passion for happiness and creativity is revealed through everything I create. I'm not just bringing my designs to the world; I am showing the world that design is possibility made real.

BRAND PROMISE (Your unique differentiating proposition)

To change the world through design

BRAND CHARACTERISTICS (Qualities that best describe you)

Attributes:
- Dedicated
- Humble
- Dynamic

Personality:
- Leading
- Nimble
- Funny

[REE-YAH]

Imagination, inspiration, laughter—inspired by design.

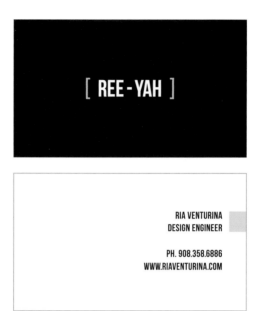

[REE-YAH]

RIA VENTURINA
DESIGN ENGINEER

PH. 908.358.6886
WWW.RIAVENTURINA.COM

[HEL-OH]!

Graphic Designer with a passion for creative thinking and life. Laughter is my religion, and I use it daily. I crave knowledge and exciting adventures. Love to be outdoors and breathe in fresh cold air especially on top of a mountain with my snowboard. Science geek, movie buff, and everything in between.

creative brief | Ria Venturina

TARGET AUDIENCE (Where you want to work)

Field of interest:	Advertising Design, Motion Graphics, and UI/UX Design
Type of company:	Advertising Agency
Company location:	City, nowhere in particular
Company size:	Big
Type of job:	Graphic design, leading to a Creative Director position

VALUE PROPOSITION (What you can offer the target audience)

1. Strong-willed—I know what I want and will do anything to achieve it.

2. I am a spirited creative who uses my wit and design skills to solve any problem.

3. I crave knowledge that motivates me to keep learning.

4. I use my experiences as a competitive advantage.

5. I use humor and creative thinking to bring light to any situation.

BRAND STATEMENT (What does your brand stand for)

My name is Ria Venturina, and I inspire others to do the impossible. I love good stories and unforgettable adventures. Laughter is my weapon of choice, and I try to incorporate it into everything I do. Why? Because a smart man once said, "A laugh a day keeps the doctor away!" and I agree. In that brief moment when you smile, chuckle, or laugh so hard and suddenly that you wheeze, all your problems seem to disappear. Laughter brings people together, and I make people laugh.

BRAND PROMISE (Your unique differentiating proposition)

Imagination, inspiration, laughter—inspired by design

BRAND CHARACTERISTICS (Qualities that best describe you)

Attributes:	Personality:
▪ Comical	▪ Illustrator
▪ Witty	▪ Strong-willed
▪ Imaginative	▪ Daring

an ngo

graphic designer & illustrator

Colorful, witty illustrations with powerful impact.

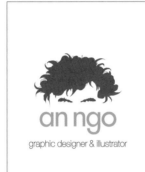

an ngo

graphic designer & illustrator

ancngo.com
an@ancngo.com
732-824-2665

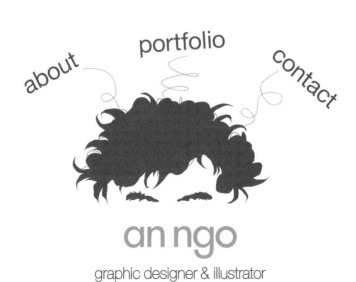

about portfolio contact

an ngo

graphic designer & illustrator

creative brief | An Ngo

TARGET AUDIENCE (Where you want to work)

Field of interest:	Graphic design, graphic novels, conceptual art
Type of company:	Graphic design agency, illustration studio
Company location:	NY tri-state area
Company size:	Any
Type of job:	Graphic designer, illustrator, or graphic novelist

VALUE PROPOSITION (What you can offer the target audience)

1. I take tasks seriously whatever their size.

2. Perseverance—I do not quit easily.

3. I practice strict work ethics.

4. I do not cling to the past, because only the future can be changed.

5. My illustrations transform ideas into reality.

BRAND STATEMENT (What does your brand stand for)

My name is An, and illustration is my passion. My ultimate goal is to show others the beauty and inspiration to be found in the planet we share. In the meantime, I am determined to make each story engaging and delightful, using impeccable designs and a dash of humor. I value this world, and believe I can share what I know through design. I don't know what the future holds, but my imagination and I are ready.

BRAND PROMISE (Your unique differentiating proposition)

Colorful, witty illustrations with powerful impact

BRAND CHARACTERISTICS (Qualities that best describe you)

Attributes:
- Witty
- Understanding
- Patient

Personality:
- Imaginative
- Team player
- Optimistic

DAVID HAASE
ADVERTISING / DESIGN

Advertising design that resonates without invading.

creative brief | David Haase

TARGET AUDIENCE (Where you want to work)

Field of interest:	Interactive Advertising
Type of company:	Digital Advertising Agency
Company location:	NYC
Company size:	150+
Type of job:	Creative Director

VALUE PROPOSITION (What you can offer the target audience)

1. Risk taker. (The most creative ideas are never made by playing it safe.)

2. Empathetic and a good listener. (You connect with your audience by knowing them.)

3. MacGyver. (I can think on my feet and problem-solve with the tools at hand.)

4. Quick study and adept with modern technology.

5. Bold and confident. (I never lose my composure in stressful situations.)

BRAND STATEMENT (What does your brand stand for)

My name is David Haase, and I am a junior art director who has incorporated what I've learned from my travels around the world to develop creative ways for bringing a brand to its audience. My understanding of multiple cultures and my belief in the power of music and sound empowers me to connect consumers to products that embrace their needs. I find the balance between the physical world and the digital universe, and celebrate how they work together. Leaving formulaic traditions behind, I specialize in creating uniquely branded content that reaches consumers in unconventional ways.

BRAND PROMISE (Your unique differentiating proposition)

Advertising design that resonates without invading

BRAND CHARACTERISTICS (Qualities that best describe you)

Attributes:	Personality:
▪ Big, tall thinker	▪ Empathetic and understanding
▪ Risk-taker	▪ Passionate
▪ Hard worker	▪ Structured and organized

MARGARET
art director • marggrz.com

Exceptional work inspired by meaningful relationships.

I AM ...

a blooming henna artist.

ASK ME ABOUT...

funday mondays.

YOU SHOULD KNOW...

Cześć!

i'm bilingual.

MARGARET
art director • marggrz.com

MARGARET WORK ABOUT CONTACT

OH, I HAVE STORIES TO TELL.

CLICK TO READ

STORY | 02

creative brief | Margaret Grzymkowski

TARGET AUDIENCE (Where you want to work)

Field of interest:	Interactive, Fashion, Advertising
Type of company:	Advertising Agency
Company location:	NYC, (South America?)
Company size:	60+
Type of job:	Art Director

VALUE PROPOSITION (What you can offer the target audience)

1. No task is unattainable nor any idea too big. If I can think it, I can do it.

2. Everyone benefits from my love of donuts, because I always share.

3. I strive for strong personal connections as much as I strive for great quality work.

4. Everything in life happens for a reason, so if something goes wrong, I find a bright side.

5. My sensitivity allows me to have strong and genuine interpersonal relationships.

BRAND STATEMENT (What does your brand stand for)

My name is Margaret, and I bring the full depth of my integrity, passion, and devotion to whatever experience I am crafting. I create content that is meant to be shared, immersive, and innovative in hopes of prompting laughter and thought, or when I'm truly successful, both.

BRAND PROMISE (Your unique differentiating proposition)

Exceptional work inspired by meaningful relationships

BRAND CHARACTERISTICS (Qualities that best describe you)

Attributes:
- Determined
- Ambitious
- Genuine

Personality:
- Crafty
- Well-rounded
- Thoughtful

PREPARATION

PROJECTS

YOUR
PORTFOLIO

PRESENTATION

PRODUCTION

BUILD A KILLER PORTFOLIO

Build a body of work
that represents the style,
type, and industry-specific
work you want to do.

6. PREPARE TO BUILD YOUR PORTFOLIO

Eleven things to know before creating your book of work.

A well-defined personal brand may get you noticed, but a professional portfolio is the key to getting hired. Building your book of work is challenging and can seem like an insurmountable task, so being prepared before you begin is critical to your success. Abraham Pendon, a former student who served in the U.S. Army before taking my portfolio course, made this comparison. "Prepping a portfolio is like packing your rucksack to go into the field. And, building a book sometimes feels like a grueling march with no end in sight," he said. "But in either case, having the right tools in your sack—or pieces in your portfolio—and knowing where they are and how to use them can have a tremendous and positive effect on your outcome. It's more than worth the slog."

Just as the first two chapters of this book primed you for building your personal brand identity, Chapter 6 provides 11 important pointers for making your portfolio-building journey more effective and efficient and making the process of marketing your work more enjoyable. Many of these items have entire upcoming chapters dedicated to them, so if you are looking for your first design job, think of this chapter as a checklist of practical tips that you can use to ready yourself for the intensive work you'll be doing in Section Two. If you're looking for your next job, this chapter is a punch list of important points to review and consider.

1. Organize yourself—right now.

Organizing means gaining control over what happens next and allows you to become more goal-focused and productive. The challenge is getting started, so you should begin immediately.

Find a space. When I was in design school (before computers, the Internet, and Pinterest), I had a dedicated drawing table, a two-drawer filing cabinet where I stored clip files, and plenty of wall space to hang my design ideas. If you live in a dorm or small apartment, your space may be limited, but setting up a designated work area that you can walk away from without tidying up and come back to later will increase your productivity. It's also a good idea to switch up on occasion and find other work spaces that inspire you. To write this book, I sometimes work in my local libraries (one is kind of noisy, but they let me bring in my decaf Americano) or several cafes where I can order food and write at the same time.

Organize your files. Some creatives scoff at the concept of getting organized—until they need something and have no idea where to find it. Organizing both electronic data and paper records is not difficult; you just need a system that makes sense to you and that you can maintain consistently. More than simply giving your items a name, organizing your records so that you, your mentor, or a colleague can quickly find, for example, the most recent version of a logo, will save everyone time and angst. Establish and follow a simple and consistent naming convention. Be descriptive and concise, but provide enough information so you know what the file is before you open it.

Back up your work. Every semester, I inevitably have at least one student who tells me in panic, "My hard drive crashed and I've lost everything!" There's no justification for spending months, or even years, creating a body of work only to risk losing it to a virus or hardware failure. Several (free!) online tools, including Dropbox and your school's Google Drive account, make backing up your work easy. Adobe Creative Cloud subscribers get free cloud storage. Or, if you can't trust yourself to back up your own files, buy an external hard drive and let Apple's Time Machine do it for you. CDs and memory sticks work in a pinch but should not be considered a long-term solution. Remove or delete any files that take up too much space and memory. Trust me, you don't want to waste precious time cleaning up your hard drive when you are in the throes of finishing your portfolio. I recommend storing your files in three separate places; at least one should be off-site, in case something happens.

2. Save up some money.

Like it or not, building your brand presence and finding a job requires some investment, so it's not too soon to start thinking about your budget. It costs money to build a website and hire a programmer (if you can't do it yourself); to secure your domain name and related hosting fees; to print business cards and portfolio pages (online sources can be more economical, and even if you have a decent color printer, you still need to purchase paper); to create your project images (hire a photographer, buy mock-ups); to purchase a portfolio book (a physical binder, a digital device such as an iPad, or both); to buy clothes for your interviews (you'll need at least two outfits, in case you get called back); and so on. You may have to lay out anywhere from a few hundred to over a thousand dollars before you go on your first interview. Start saving money now: do without some lattes, call in an early holiday gift, or "change" your birthday so it falls during portfolio preparation season.

3. Assess your work's strengths— and weaknesses.

The old adage, "A chain is only as strong as its weakest link," works for portfolio-building, too. To land a design job, you need to demonstrate that you have a strong, consecutive body of work. This can be accomplished through:

Consistency. Does the website you created include a master grid on every page? Are typeface styles consistent throughout your branding project? Does your ad campaign have diverse pieces that all feel like part of the same family? An art director will quickly assess your ability to make connections both aesthetically and conceptually. Clear, logical connections speak volumes about your design sensibility and sensitivity to details. (See Chapter 8: Create New Projects.)

Believability. Creating brands or campaigns that are smart and have heart can be challenging, but you know you've created something believable when an art director has to ask if she is looking at an actual product or business. The brands and stories you invent should seem real, meet the needs of a plausible audience, and connect emotionally to your viewer. Think in terms of practicing for the real world because when your imagined projects are believable, an art director will perceive you as a viable prospective employee. (See Chapter 7: Select Killer Work for Your Book and Chapter 8: Create New Projects.)

Process and prototypes. In a world of digital assets and social media, it's refreshing to see and touch something real. Include your preliminary sketches or word maps, especially if your process for developing an idea is rich or your packaging or book design is interesting or well constructed. For web or mobile designs, transform static screens into clickable, interactive experiences using free online tools such as Invision (invisionapp.com) or Marvel (marvelapp.com). A physical or interactive examination of your work can help an art director gauge your ability to create prototypes and your attention to detail. The more realistic the project you create, the more marketable you will seem to an employer. When you are attentive to the details of your own work, employers will conclude that you are likely to do the same for client projects. (See Chapter 9: Develop Your Presentation Layout.)

4. Include five integrated campaigns. Eliminate two.

Art directors are busy and need to quickly assess your body of work by identifying what you want to do, what you can do, and how it can benefit them. They don't have time to waste, so filter the projects you include in your portfolio to display only the strongest and most cohesive work. Telling a single story via multiple platforms is a good strategy for connecting your ideas across print and screen channels, as long as you select the appropriate touchpoints for your integrated brand campaigns. (Note: if you are building a specialized portfolio such as illustration or photography, you may want to show an individual project or groups of projects. More on that in Chapter 7.) Remember, it's not necessary (or desirable) to include every design project you've ever completed. Save a few things to display only on your website that complement your portfolio pieces, such as illustrations, a series of book covers, personal projects, or smaller brands that don't need to tell a big story. Whichever projects you select, choose wisely. Your portfolio should represent the best of you. (See Chapter 7: Select Killer Work for Your Book and Chapter 8: Create New Projects.)

5. Showcase some personal projects.

Many good designers graduate every semester, so how can you stand out from the pack? Include projects that fire your passion along with samples of the work you were assigned. If you're an illustrator, challenge yourself to do a daily illustration and create a blog/social media page about it. If you're a graphic designer, come up with a potential business idea and create a brand identity and promotional campaign. If you have an interest outside of design, turn it into a design project, such as a book about your recent trip to Machu Picchu. Personal (or passion) projects not only communicate your ability to design but also reveal something intimate about who you are and how you think. This kind of personal disclosure can connect a reviewer to you, inspire them to refer you to someone who is hiring when they're not, or serve as a conversation starter in an interview. (See Chapter 7: Select Killer Work for Your Book and Chapter 8: Create New Projects.)

6. Let your work speak for itself.

Gone are the days when the only way to get a job was to drag a large print portfolio through a revolving door and into a crowded elevator for a meeting with a creative director. (As design trends go, I appreciate this one because, early in my career, my sizable portfolio and I got stuck in a revolving door on the way to a client pitch.) Much of what you do will be viewed on websites when you're not around, so it's essential that the work speaks for itself. Big, beautiful images look great, but they don't tell an art director how you can effectively solve a problem. If your visuals alone do not easily convey the story, consider supporting each campaign with a line of text communicating the overarching concept. Add details and provide a context for why you selected specific touchpoints, if the visuals alone are not clear enough to support the story. Use a variety of digital presentation formats, such as videos or online prototyping tools, to explain a concept or engage the viewer in a more sensory experience. (See Chapter 9: Develop Your Presentation Layout.)

7. Focus on the work, not on how it's presented.

Beautiful imagery and aesthetically pleasing graphics are one thing, but an art director will see right through a slick Photoshop effect you're using to mask a feeble effort—no amount of "seasoning" will spice up a bad concept or design. Your portfolio is all about your ideas and how you execute them through your projects. If your design does not meet the objectives of the project, solve a real-life problem, or create a positive user experience, it is purely decorative. An art director should remember you for the quality of your content, not the dazzle of your fancy graphics. To help you determine if you're likely to engage an art director's attention, use the following criteria. Your work should be: (1) meaningful, (2) appropriate, (3) cohesive, and (4) memorable. Be honest with yourself. If it's not your best effort, embellishing won't help. (See Chapter 7: Select Killer Work for Your Book and Chapter 8: Create New Projects.)

8. Focus on how your work is presented.

I know I just said don't focus on how your work is presented, but only because you need to create a solid book of work before you go out to market yourself. The types of projects you choose are important, but it's just as important to convey a deeper level of your style and design sensibilities by showcasing a group of individual brands and campaigns and tying in your personal brand. A beautiful type treatment, unusual color palette, or well art-directed photo will be noticed, but a paying job will remain elusive if your staging skills are weak.

Are the comps in your photos clean and neatly constructed, or are the edges dog-eared? Are the drop shadows beyond your projects offset in the same direction (i.e., bottom right), with a consistent color and blur effect? Is your label design displayed around a mock-up bottle skewed in the correct perspective? Showcasing a cohesive body of work is key to marketing yourself and will be carefully scrutinized by art directors because they want to know how you are likely to handle the task with their clients. Your arrangement speaks volumes about your brand, organizational ability, and design style, especially when you're combining a few different brands into your brand presentation. (See Chapter 9: Develop Your Presentation Layout and Chapter 11: Produce Your Pieces.)

9. Ask for advice. Take the advice.

Before you design yourself into a corner or get too invested in an idea, solicit feedback from your professors, mentors, colleagues, and other design professionals. Generally speaking, they will be eager to give you advice on how to improve or display a project and to share a few of their own experiences. Let a fellow student teach you a new software trick, or ask your mentor to walk you through a process that will solve a problem more effectively. Offer to take your internship art director out for a latte to review your portfolio project. Don't be afraid to ask; most people will be flattered that you did. Check your ego at the door and don't be defensive—listen and consider what they tell you. Use every resource at your disposal, because you will probably need all the guidance you can get. You may find that their recommendations have a common thread. Until you really know what you're doing, give their suggestions a try. It doesn't take much time to flush left some text or try a new typeface in a logo. At the end of the day, you're the one who will make the final decision. (See Chapter 8: Create New Projects.)

10. Let a professional photograph your work.

Photographing your work is more difficult than you might think. Most students know little about proper lighting or how to art direct the presentation of their own samples. An art director who is accustomed to professional photography won't be able to appreciate the work if the quality of the images is poor. He will be distracted, and his thoughts will stray to visually correcting whatever problem is evident. Yes, some students are exceptions to this rule, but even a good photographer can benefit from an objective viewpoint. In most cases, hiring a professional or bartering with a friend studying photography is the way to go. (See Chapter 10: Make Images That Show Off Your Work.)

11. Design every touchpoint.

Design is not just a profession; it's a way of life. As a seasoned designer, I intuitively design everything—how I hang the toilet paper (under), what stamps I use on an envelope (thought-provoking images), and what color rooms I live in (a green kitchen makes me happy and want to cook more). As a student, you need to design each point of contact between you and a potential job, for two reasons:

To brand yourself. Every single touchpoint you create is part of the story about YOU, whether it's a handshake, a quiet conversation, or how you arrange your spoon and cup at the coffee shop. Each is a window to your unique qualities and design sensibility. The way you handle the world around you may not be unique, but it sheds light on your style and, coupled with your design aesthetics, may mean you'll be the candidate who stands out.

To pass the test. An art director who receives an email link to your website, your business card, or your resume by mail cannot help but grade, even subconsciously, your proficiency in layout design, typography, and color. If you're deemed a good designer, and "pass the test," your name will likely make the list of designers under consideration.

Are you ready? It's time to build a killer portfolio that shows potential employers what you can do for them.

I WISH I WOULD HAVE KNOWN ...

The idea and story are just as important as the execution of the work.

STEPHEN SEPULVEDA

I WISH I WOULD HAVE ORGANIZED MY TIME MORE EFFICIENTLY.

MARGARET GRZYMKOWSKI

exactly what to specialize in before portfolio.

Natalie Rodriguez

how much it cost to create my portfolio and personal brand, I would have found a second job this summer.

Nancy Fuentes

A better understanding of myself & where I want to be in the future

- Ashley Cordero

7. SELECT KILLER WORK FOR YOUR BOOK

Choosing projects that reveal your skills, talents, and passions.

Your portfolio is an organic, fluid, and evolving representation of your work and personal brand. The projects you create for your book of work, the examples you include, and the way you present them all communicate your creativity, skills, range, thinking ability, and ambition. Your portfolio is the single most important vehicle you have for finding employment. It needs to be nurtured and updated frequently to reflect your evolving skills and experience. However prestigious the design school you attended, without a strong portfolio, no one will ever see or understand what you have to offer.

Selecting the right projects, arranging them logically, and presenting them in a way that is unique and engaging takes forethought and planning, and when you're just starting out, predicting what will captivate your audience most effectively can be difficult. This is when the value of understanding your personal brand becomes clear; it takes the guesswork out of your decision making. If you're unsure about something, you can weigh your options against the framework of your creative brief. My design assistant Margaret (from Chapter 4) perfectly meshed her two passions, donuts and henna art, to provide a feast for the eyes that entices viewers to learn more about her work (and to crave a sweet treat).

When the pieces you select are true to your brand, you can be confident that you are making good choices. And, when your decisions are validated by an invitation to interview for a job, you'll feel like you've won an Academy Award.

In the meantime, no matter where you want to go, you need a well-thought-out portfolio to get you there.

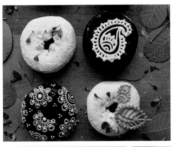 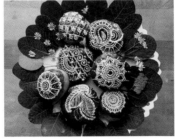 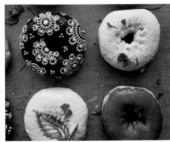

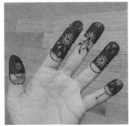 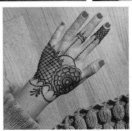 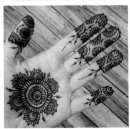

THE PURPOSE OF YOUR PORTFOLIO

Your portfolio's main purpose is to promote your work and your brand. You can use it for a multitude of functions, such as finding full- or part-time work, networking to get an adjunct teaching position, scoring freelance projects, or selling branded goods directly to customers. Before you build your portfolio, you should identify your primary purpose at this moment in time (understanding that it may change in the future) so you can select the appropriate projects and present them in the best possible way. Need some extra motivation? Your portfolio has the power to generate revenue so you can pay back student loans more quickly, establish a retirement fund earlier, or splurge on a vacation to somewhere that refreshes your creative spirit.

Employment. Finding a job is the most frequently intended use for a portfolio. Do you want to work for an in-house design team, a large advertising agency, or a UI/UX design firm? Think about projects you have completed that are relevant to the industry, type of company, job position, and size of the organization where you want to work. When your "ideal" employer sees that you have at least some experience, familiarity, or the desire to do what they need done, you're likely to make the short list of people who get called for an interview. Your portfolio provides necessary insight about your personality, giving your employer an idea of your work style and how you might interact with others in your shared workspace.

Freelance. The popularity and widespread acceptance of personal websites (your own) and portfolio websites (such as Behance and Coroflot) can offer fledgling designers an unprecedented opportunity to promote their expertise and make their availability known to potential buyers. Freelancing has its pros and cons (especially if you're simultaneously holding down a full-time job—more about that in Section Three), but it offers virtually limitless potential for making money and building your portfolio, whether you're looking for traditional employment or not. Freelancing can pay bills when you're revving up to strike out on your own or filling the income gap between gigs.

Network. Just as I took control of my romantic destiny in Chapter 4 by asking friends, family, and colleagues to help me find love, you have to seize control of your professional future by networking. If you're going to end up where you want to be, you need to spread the word about your talent. Make connections with other designers who can give you job referrals. Ask someone to invite you to Dribbble (a show-and-tell website for designers) so you can solicit feedback on your current projects and works in progress. Identify where the people you want to work for tend to congregate (online or in person), and then show up and introduce yourself. (Gentle and professional stalking is generally permitted.) Actively seek out new venues for promoting yourself wherever you happen to be gaining experience or getting educated. Regardless of where or who you choose to schmooze, make your portfolio available to everyone you can because your contacts, as well as the people they network with, are likely to spread the word that you are good and that you are available.

Commerce. You may be an excellent illustrator, product designer, or design entrepreneur, and that means you may have a product you can sell directly to someone who needs it. While you're creating your personal brand and the brands or campaigns in your portfolio, you could come up with some good ideas that are commercially viable. RBSD industrial designer Dominic Cullari's love of watches inspired him to design a line of elegant unisex wearable timepieces (domeni company.com). His colleague,

Alex Lorenca, designed a line of wallets made of wood. I purchased three of them, which were quickly scooped up by my son Dylan to use for storing his Pokémon cards.

The pathways to making money from your talents are many, and it's easier now than it's ever been to sell stuff online using e-commerce websites that produce, ship, and market your

wares to a global audience. If you're looking to create your own line of clothing, wallets, or other goods, these websites may support your selling efforts and help you generate some income right now: Print Aura (printaura .com), Big Cartel (bigcartel.com), and Etsy (etsy.com). I have been encouraging the donut-obsessed Margaret to take her henna drawing talents to yet another level—designing a line of furniture that she can sell. When it comes to selling products online, the potential opportunities are limitless.

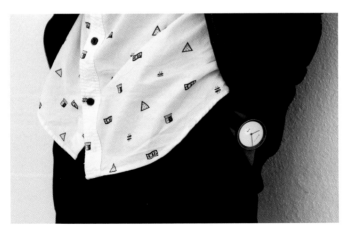

WHAT TO INCLUDE IN YOUR PORTFOLIO

There is no such thing as a one-size-fits-all portfolio, so you have to figure out what's right for you. In addition to the framework of your personal brand and creative brief, the guidelines in this chapter (including the tools I mention at the end) will help you identify and qualify samples that will dazzle whoever looks at your book, as well as give them a clear idea of who you are and what you can do. The projects you include should reflect what you want to do and give your audience insight into your interests. If you are already a practicing professional, don't show work that is more than five years old, unless it was a significant project. This type of project works best as a case study.

Work that reflects what you want to do

The projects in your portfolio should show off your best and most original ideas, and they must be well executed. Showcase the work that you love and the type of work that you'd like to be hired to produce. Anything you include should demonstrate your skills, abilities, range, talents, and experience. For example, if you want to be an art director at a large metropolitan advertising agency, integrated promotional campaigns will highlight your ability to tell a single story across multiple print and screen touchpoints. If you want to work as a graphic designer in a small, local agency, a more diversified book that includes identities, packaging, websites, and mobile designs will demonstrate your range.

Whether you use work created in the classroom or actual professional projects, the pieces you select should resonate with your audience, be relevant to your desired industry and company, and reflect the role you'd like to fill. The more your portfolio targets the real needs of a company, the more attractive you'll be as a potential hire. Remember, you don't get extra points for quantity, and including too much can actually work against you. Choose wisely, and save a few items (such as illustrations, a series of book covers, personal projects, or smaller brands that don't need to tell a big story) to display only on your website, where you can use them to complement your portfolio pieces.

THE 300 WISHES

300 PEOPLE RANGING IN A DIVERSE AGE GROUP WERE ASKED THIS QUESTION TO SEE IF OUR WISHES CHANGE OVER TIME. AT WHAT AGE DO WE GET SENTIMENTAL ABOUT OUR WISHES? AT WHAT AGE DO WE START WISHING FOR A BETTER FUTURE FOR OUR FAMILIES THAN A BRIGHTER FUTURE FOR OURSELVES? ACCORDING TO THE GRAPH, THE AGE GROUP THAT CONTRIBUTED THE MOST IS THE 16-20 YEAR OLDS. THEIR WISHES COMMONLY FELL INTO THE GREED CHARACTERISTIC. THE GREED CHARACTERISTIC IS THE MOST POPULAR OF ALL THE WISHES ESPECIALLY TO THE 16-20 YEAR OLDS. BE IT A MILLION MORE WISHES, A MILLION DOLLARS, OR INFINITE KNOWLEDGE, IT TRULY IS NEVER ENOUGH. OTHER THAN RANDOM, WHERE THE WISHES IN THAT CATEGORY DO NOT FALL INTO ANY OF THE OTHER DESCRIPTIONS, THE NEXT POPULAR IS FANTASY. THE AGE GROUP IN FANTASY RANGE FROM 6- 46 YEAR OLDS EVENLY. NO MATTER HOW OLD WE ARE, WE STILL HAVE THAT INNER CHILD THAT WISH TO BE A SUPER HERO, A DRAGON, OR EVEN A CAT.

IF YOU COULD HAVE ONE WISH, WHAT WOULD IT BE?

| 5 – 10 | 11 – 15 | 16 – 20 | 21 – 25 | 26 – 30 | 31 – 35 | 36 – 40 | 41 – 45 | 46 – 50 | 51 – 55 | 56 – 60+ |

It's Never Enough — Future — Self-Worth — Romance — Fantasy — Education — Family — Other

Work that reveals your interests

As I mentioned in Chapter 6, personal or passion projects reveal something intimate about who you are and how you think. Any designer vying for a position in a top company may have a great portfolio, but no professor or art director can teach a designer to self-ignite and be inspired on their own time. Your portfolio can make that clear before an employer has to ask. Well-known designers Jessica Hische and Jessica Walsh are great examples; they both used passion projects to communicate that they consider design a way of life. By promoting the things they love, they attracted recognition far beyond the design industry. Their success came from effectively communicating a deeper understanding of what they care about (drop caps) and connecting to others through experiences that were deeply personal (dating).

Passion projects often connect to the viewer more quickly and dynamically because they are memorable. Advertising major and illustrator Ria Venturina designed a poster for a personal project she initiated before completing a course. Via social media channels, she asked 300 random people from diverse age groups, "If you could have one wish, what would it be?" (riaventurina.com/assets/300wish.pdf).

Graphic design major Jaime Mazauskas conceptualized a business idea for a bar crawl event that coincided with WrestleMania (jaimemazauskas.com/maniacrawl.html). Both students were passionate about their topics; their enthusiasm for their projects and their ambition to go beyond what's typical invited and inspired lively conversations about their concepts, progress, and outcomes.

Including self-initiated projects in your portfolio will give a potential employer greater insight to your thinking abilities and ambition. What inspires you? What are you passionate about? Include at least one personal project in your book and make sure the work is of the same caliber as your other projects—engaging, organized, and well-executed. Your personal project captures and reflects your pixie dust; it can help you stand out from your competitors.

300 WISHES (UP CLOSE)

AGE 32: TO FEEL HAPPY FOREVER.

AGE 94: THAT PEOPLE WOULD NOT SUSPECT I LIE ABOUT MY AGE.

AGE 16: I REALLY WISH TO BE A FAMOUS YOUTUBER ONE DAY.

HOW TO SELECT WORK FOR YOUR PORTFOLIO

Now that you know the types of projects your portfolio should include, you must evaluate and qualify the specific samples that will populate your book of work. Even though you'll include individual projects that represent your range of capabilities, your overall presentation should still have a theme. My former student Kaila Edmondson's "Femme Forms?" uses a classic dress pattern and female body parts to express a clear idea about female body image, a theme that ran through her entire portfolio. Selecting (and setting aside, at least for now) work samples is challenging no matter how long you've been practicing design. When you're starting out, you probably won't have all the projects you need for your dream job or that job posting that looks interesting to you. That's to be expected, and it's okay. Based on what you've already produced, the following guidelines will help you identify which pieces need further development or refinement, what you need to start (or restart) from scratch, and which items you might want to leave out. As always, don't try to go it alone—solicit feedback from your professors, mentors, colleagues, and other design professionals. They'll help you qualify whether the projects you select are portfolio-worthy and, if they are, offer some guidance on how to improve them.

Tell good stories

"Project" stories. Just like your personal brand story, the stories you create for your individual brands and campaigns must be authentic, rich, credible, and composed of details about what makes them unique. To qualify for your portfolio and intrigue an art director, each campaign must visually and verbally communicate a story that is "smart" (believable) and "with heart" (emotionally intelligent). Your audience will appreciate the effort that your story reveals and the outcome—quality work. Some of my job-hunting students have been told that their brands are so "real," they could go to market with them. I love hearing this. It means that their stories are compelling and credible. It tells me that they have learned how to connect to their audience. Be prepared to say something interesting about any of the images you've included in your book, but remember you may not need to say anything at all if your viewer's style is to appreciate the work on its own merit.

"Process" stories. You'll usually find that one of your projects was more challenging or fun to work on and the outcome more satisfying than others. Identify that project and build a case study around it. Learning about a project's back story allows your viewer to better understand the concept, design direction, or process that made it successful. Remember to include the requirements outlined in the project brief, any challenges or obstacles you had to overcome, and how the solution (technical, design-thinking) communicates your problem-solving abilities. If it's a professional project, do you have metrics to support its success? Do you have client testimonials to praise your efforts and endorse your results?

Always make sure your story is believable; do not exaggerate, invent facts, or make it any longer than it needs to be. When you give people a reason to care about each case study, they'll keep reading. Include details about how you created a particular icon or a repeating tiled background. Write about how each idea came into being and why it was rejected or accepted.

EXERCISE: Write your story ideas

- In plain speak (avoid lavish details and big multi-syllable words), write a short paragraph (i.e., brand statement) describing your story idea.

- Consolidate your paragraph into one succinct sentence of no more than six words, as you did with your personal brand promise.

- Write three short sentences (i.e., value proposition) on what you can offer the target audience.

- If this was a professional project, make use of any data that validates its success.

Diversify product types and include a range of touchpoints

One thing I love about living in a city is the confluence of many things, not the least of which are food choices. On any given day, I can stop at a French bakery to pick up my decaf Americano and a baguette. (Sometimes, it's an Escargot a La Cannelle—a cinnamon swirl pastry—because they look so irresistibly scrumptious.) Then, I can walk a few doors down and buy some Japanese rice balls with Indian curry for lunch. Across the street, I purchase freshly made marinara and raviolis for dinner. In a matter of 15 minutes, I can tour three countries and relish three different sensory experiences—the lingering aroma of butter and warm yeast wafting through the bakery; the firm, smooth texture of the seaweed paper that encircles the rice balls; and the fading yet evocative posters and thickly accented English that send me right back to my visits to Italy.

Selecting work for your portfolio is a lot like the food tour we just took together. My city and its food choices are the brands and campaigns you have created. The eateries we visited are the touchpoints that your viewers will experience as you guide them through the sights, smells, textures, and feeling of each project. Your portfolio should offer the viewer a diversity of experience; each piece should tell them something about who you are and what you love to do.

Let's say you want to work in a firm that creates brand identities. To engage your audience, include a range of identity and client types (rebranding, retail, not-for-profit, corporate). Each should show a mix-and-match of cross-platform touchpoints (print and screen). Variety is important, because it demonstrates you can approach projects in different ways, and employers like to see your

versatility and agility with a range of platforms. If you are applying for a specialized position (website design, for example), you should still show some variety rather than limiting yourself to three replicas of three similar company and client types.

You may want to consider having more than one portfolio to choose from. This will allow you to tailor the strengths you promote to meet the needs of the person who may want to hire you. Remember, your book is fluid and ever changing; you will swap out, mix-and-match, and update pieces according to the opportunity you're pursuing.

project touchpoints

3D models
Ad banner
Announcement
Annual report
Apparel
Augmented reality
Billboard
Blogs
Brand identity *INTERACTIVE*
Brochure
Bus shelter
Bus wrap
Business card
Catalog
Company intranet
Corporate events
Digital billboard
Direct mail
E-newsletter
Email signature
Employee relation materials
Environmental graphics
Event *TEAR - AWAY POSTER ?*
Games
Greeting card
Guerilla marketing
Hang-tag
Interactive billboard
Investor relation materials
Invitation
Invoice
Kiosk
Label
Legal graffiti
Letterhead
Logo

Magazine *CUSTOM INSERT*
Menu
Micro website
Mobile application
Mobile billboard
Motion graphics
Movie trailer
Newsletter
Packaging
Point-of-purchase display
Pop-up shop
Postcard
Poster *PARTNER UP WITH LOCAL BUSINESS*
Premiums
Presentation
Press/media kit
Print ads
Proposal
Radio spot
Sales kit
Signage
Social media promotion
Social networking
Standards manual
Stationery
Sticker
Subway ad
Taxi ad
Tent card
Trade show booth
Uniform
Vehicle graphic
Video
Wayfinding system
Website
Window display

Communicate wicked skills

The work you choose to showcase in your portfolio should communicate the skills you can offer. The more skills you reveal, the more marketable you'll become to a prospective employer. For example, if you want to build websites or mobile apps, you can stand out by showing off your technical abilities and code your online touchpoints. But don't leave out the other creative talents you can offer. For instance, if you are a good photographer or illustrator, include and make note of any images you created for your projects. My former student Triana Braxton (trianabraxton .com) promoted her skills by blending them into a single digital portfolio. Her ability to promote herself through her skill set landed her an in-house job for a national health club chain immediately after graduation. When you consolidate your individual talents together into a bigger overall presentation, such as your portfolio website, you

effectively advertise what you can do for an employer.

Also, consider any skills you have that fall outside of design. (Your "inside self" Personal Brand Self-Assessment Study in Chapter 1 has this information.) My former student and illustrator Max Friedman has been skateboarding since he was a kid. Mike DeBisco, also one of my former students, has been a disc jockey since high school. Like Max and Mike, you may have skills that seem unconnected to your design talents but can be used to paint a fuller, more detailed picture of who you are. And better yet, those skills may be the factor that connects you to a real job, because a potential employer sees how you fit into their company culture. Your outside skills can even offer you an advantage over other candidates: maybe the company just snagged a large skateboarding client and can use your expertise on the account,

or the art director has a regular Saturday night gig spinning tunes at a nearby nightclub. You never know who's looking at your portfolio or what their outside interests are, so it's better to include what's interesting about you than to leave it out and miss an opportunity to get their attention.

Art directors and hiring agents look for designers with skills that go beyond design. So think critically and seek out the nuances that nudge you past the competition. Find ways to visually or verbally show off your wicked and individual talents and skills, and weave your personal brand story into your overall portfolio of work. You may need to highlight your story as a case study or list your accomplishments in a credit roll. Regardless of what your individual talents are, communicating with passion about your talents will be perceived as a skill in and of itself.

JAM OUT TO LOCAL MUSIC WHILE DOING LAUNDRY

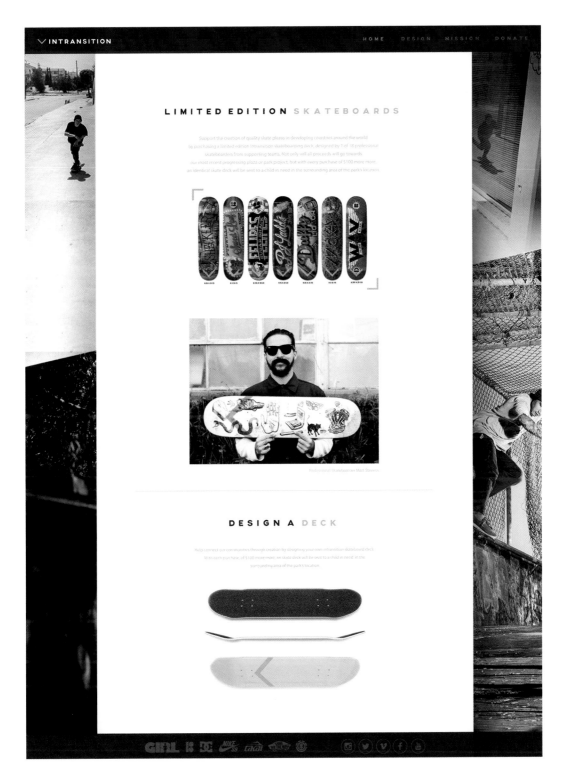

Choose the right number of pieces

I once asked my father-in-law Tony how much garlic it takes to get his sauce to be so tasty. "Just enough so you always want to take one more bite," he answered.

How many projects should a design portfolio include? How many do you need to tell your overall brand story? You may find my answer frustrating: it depends. Only you know what it takes to communicate your brand and provide a sampling of what you can do. The answer will vary from function to function and audience to audience. Are you presenting an online, digital, or print portfolio? What are the expectations in the industry where you seek employment? Many art directors estimate that a portfolio should include no more than 15 to 20 pieces total. (Some say less; others more—see what I mean?) At the RBSD, we recommend that Interactive Advertising

and Graphic Design majors present four to five integrated brand campaigns (18 to 24 pieces) with four to five pieces per brand. Photographers and illustrators may show 12 to 15 pieces of their best work and then send the viewer to their website for more.

As I've said before, art directors are busy, and they need to quickly assess your body of work to find out what you want, what you can do, and how your offering fits with their needs. They don't have time to waste, so filter the projects you include in your portfolio to display only the strongest, most cohesive work. Think of it this way: your portfolio will be judged not by your best work but by your worst piece. Choose quality over quantity. There is no "correct" number when it comes to your portfolio pieces (or garlic); you just need your viewer to crave another bite.

EXERCISE: Create one worksheet for each project in your portfolio

- Populate the information at the top of the page (i.e., your name, design specialty, mentor[s]).

- List the portfolio project number, name, date started, and deadline (work with your professor or mentor).

- Add the project story idea (six words or less) and your three value proposition statements.

- In the "Touchpoints" section, categorize each piece you plan to include for that project in the appropriate column: Complete (and approved by your mentor), Refining (those that need minor changes), and Developing (new pieces or those that need major changes).

PROJECT WORKSHEET

WORKSHEET:

*standoutportfolio.com/
project-worksheet.pdf*

The project worksheet is my students' most helpful tool for planning and selecting work to populate their portfolios. I consider it a contract between the student and me, and I use it to track their progress throughout the semester. The following is an example and bullet points on how to use it. Create your own version or modify my worksheet for your projects.

NAME: Stephen Sepulveda DATE:

project name:

PROJECT OBJECTIVE:

TARGET AUDIENCE:

KEY INSIGHTS: * YOU WILL LEARN HOW TO COMPLETE
 THESE FIELDS IN CHAPTER 13. FOR NOW,
 FOCUS ON THE TOUCHPOINTS SECTION BELOW.

BIG IDEA:

TOUCHPOINTS		
Completed	Refining	Developing
Logo Mobile app	Mobile app) (modify colors) + enlarge type	Social media campaign: " Find the code monster in you." Event signage (vertical banners) Floor graphics Event ID card + lanyard

PROJECT CALENDAR

WORKSHEET:

*standoutportfolio.com/
project-calendar.pdf*

For example :
16 - week schedule
to build a killer portfolio

The project calendar works in tandem with the project worksheet to help students schedule the design and production of their projects, in addition to developing discipline and strengthening their organizational skills. To use it, start at your deadline and, working backward, establish due dates for developing the components of your projects. While writing and designing this book, I used a similar calendar, and it was immensely helpful. (It's also helpful to have an editor who keeps tabs on my deliverables and progress, just as your professor and/or mentor will monitor your progress.)

EXERCISE: Create one calendar with all your portfolio deliverables

- Customize your calendar for the month, weekday, and date, based on the timeline you are establishing.

- Add the start and end (deadline) dates for each of your projects (this information is on your individual project worksheets).

- Add any important dates that will preclude you from working (i.e., special events, classes, work, etc.).

- Working backward, factor in milestones such as due dates for various stages of your project into your schedule.

NAME: _____ DATE: _____

project calendar:

WEEK #

Add to your calendar:
- - - - - - - - - - - - -
- 10 weeks to design projects
- 2 weeks to develop your presentation layout
- 1 week to make images
- 2 weeks to produce your portfolio(s)
- 1 week of presentation layout refinement

STAND OUT

Your portfolio is a fluid, evolving representation of your work and personal brand that communicates your creativity, skills, range, thinking ability, and ambition.

- A portfolio has a multitude of functions; you can use it for finding employment, soliciting freelance opportunities, networking for referrals, or selling branded goods from your project ideas.

- A portfolio showcases the kinds of work that you'd like to be hired to produce and projects that you are passionate about.

- Although there's no magic "correct" number of pieces, your portfolio needs just enough to communicate smart, compelling, and evocative stories; showcase a diversity of projects and touchpoints; and promote your talents and skills.

- As you're building your portfolio, solicit feedback and guidance from professors, mentors, colleagues, and other design professionals.

- Use portfolio-building tools, such as a portfolio worksheet and calendar, to help you organize and track your progress, as well as establish a realistic schedule.

8. CREATE NEW PROJECTS

Adding work to complete your book.

On a recent school break, my son Dylan decided it was time to ride his bike without training wheels. He was eager to reach his goal and passionate in his pursuit of success, but it took a few tries and a few failures. On several occasions, he had to be rescued—we pulled him out of a hedge where he had landed face-first, nursed some bumps after he bounced off a rock, and bandaged a cut that resulted from his knocking a landscape light out of the ground. Sure, there were tears, first-aid spray, and even a little blood, but we encouraged him and he persevered. By the end of the week, he was riding his two-wheeler like a pro. Like Dylan, most of us master riding a bicycle at some point, and the real lesson we learned probably isn't "slow into the turns" but rather "practice makes you better."

I worked as a graphic designer for seven years before I felt like a professional. And when I "arrived," it happened suddenly, when I was assigned a project. I don't remember much about the design details—a brand identity and collateral materials for an event on behalf of a large telecom company. The colors were purple and copper metallic, printed on textured paper with illustrations of lightning bolts—but its significance was almost blinding. It was the first time I was given responsibility for every aspect of a program, from holding client meetings and concept development to design, production, and printing. By the end of the project, I felt incredibly accomplished because it met the client's needs, it was aesthetically pleasing, and my art director was delighted with the outcome. But that accomplishment didn't spring from some untapped well of superhero powers; it was the result of the seven years I had already put in, my determination to learn as much as I could about the design business, and my willingness to take on the next learning experience. Just as runners train for a marathon, chefs study recipes to prepare for cooking contests, and musicians run scales for years before they perform in front of an audience, designers need to exercise their visual and verbal problem-solving skills. The more you practice, the better you'll be.

Stand Out is not about teaching you how to create projects—there are endless resources for that online and at your local bookstore. But it's important that you see (and perhaps become inspired by) how others have approached this challenge by reviewing the projects and portfolios that they worked hard to build.

CRITERIA FOR CREATING PRACTICE PROJECTS

The projects you create in school and those you make up on your own (your passion projects) are dress rehearsals for the professional design world. When I create assignments for my students, I make it a point to replicate the types of projects and processes that are generally required in professional practice. As an educator, I allow room for a broad range of interpretation and encourage students to customize themes according to their interests, skills, and the industry where they want to work.

My objective is simple: identify and assign practice projects that call upon a variety of skills, develop a designer's abilities, and teach different design-thinking strategies. Whether you are a student building your own portfolio or an instructor in search of projects to assign, these activities will guide you to finding and creating projects that will give breadth and depth to a book of work, in addition to providing the experience and skills that a professional practitioner needs.

Create projects with a focus on different industries (e.g., entertainment, retail, not-for-profit, and start-ups) to enhance exposure to a variety of fields. One may spur an interest or ignite a passion.

Create different project types (e.g., rebranding, branding, advertising, and promotion) as an introduction to the variety of strategic problem-solving approaches to design problems and to diversify the portfolio.

Solicit not-for-profit projects to gain professional design experience and assist an organization with its mission. Each semester, I ask my branding students to contribute to a *pro bono* project; it's not only great for the students but keeps my feet wet and in the game.

Offer multiple options for each project to avoid a potential employer pegging anyone by the college they attend because they see the same project every year. (Not every student is motivated by every project, so if the project you're assigning is, for example,

a rebranding program for a local business, you can offer an alternative option or ask students to come up with a rebranding project of their own.)

Use or improve an already completed project from an internship, freelance gig, or job. Practicing with real professional projects is great, but they should be good enough to appear in a portfolio. Students should always ask permission from the client or an employer to use their project in their personal book of work.

THE CREATIVE BRIEF (FOR PROJECTS)

A creative brief is a one-page document that summarizes the strategic objectives and needs of a project for the creative team. In Chapter 2, you used a creative brief to define your personal brand, outline your purpose, target your audience, make your brand statement, offer your unique selling proposition, and provide a range of relevant facts about who you are. In this chapter, the creative brief has been modified to use for developing your portfolio projects. Simply complete the form with your project in mind rather than your personal brand.

Just as you have to do the work in order to reap the rewards of your true and authentic personal brand identity, you have to follow a process to get the most benefit from designing meaningful projects. Creating or using a supplied creative brief is absolutely necessary if you want your project to have a strong foundation and a clear purpose. Your work might be beautiful, but an art director wants to see design thinking, problem solving, and the ability to understand and fulfill a set of requirements. (Revisit Chapters 1 through 3 to brush up on how to capture the background information.) In the professional world, the creative brief sums up the project details you'll need to meet the client's needs, expectations, and requirements.

PROJECT OBJECTIVES

Describes why the project was initiated and its purpose. List up to five objectives and anticipated outcomes that will be used to determine whether the project is successful.

TARGET AUDIENCE

The characteristics of your intended market. List key points about the demographics (i.e., gender, age, ethnicity, economic status) and psychographics (i.e., attitudes, taste, emotions) of the project's target audience.

PROJECT DELIVERABLES/ BRAND TOUCHPOINTS

How the brand identity will be delivered to the audience and how selected touchpoints will visually communicate the brand story. Select appropriate touchpoints across multiple channels (print and screen) that emotionally connect your brand to the audience.

AUDIENCE NEEDS

How the project design fulfills the needs and expectations of the audience. List up to five needs your audience may have, and describe how you will meet those needs through the components of your design and how you expect your audience to respond.

BRAND STATEMENT

A clear and concise articulation of your story idea. Write a short paragraph describing the idea behind your brand story. Make sure your story includes rich and believable content that illustrates what makes your brand unique.

VALUE PROPOSITION

The unique, positive attributes, passions, and strengths that you can deliver to help the project meet its objectives. Write three short sentences describing what you can offer the target audience (that no one else can).

BRAND PROMISE

The single most compelling value you can deliver to the project on behalf of your client. Your brand promise sums up what sets you apart. In six words or less, describe with passion and power one value that your product, service, or brand will live up to every day—the promise your target audience can rely on.

BRAND CHARACTERISTICS

Attributes that communicate the character of the brand. List up to six words that describe the personality and style of the project brand, and connect it to the target audience.

creative brief | Tomasselli's Barbershop and Social Club

PROJECT OVERVIEW

PROJECT OBJECTIVES:

- Create an experience that has a sense of exclusivity, "for men only."
- Introduce a style of "old world charm," but with a modern twist.

TARGET AUDIENCE:

- Metrosexual men ages 21-45
- Men willing to pay for higher-priced grooming services + products

PROJECT DELIVERABLES / BRAND TOUCHPOINTS:

- Logo
- Business card
- Product packaging
- Website
- Merchandising

AUDIENCE NEEDS:

- I want a high-end grooming experience.
- I want to feel part of something special.
- To hang out with men with similar interests.
- To buy quality masculine hair + skin products.

BRAND STATEMENT

When I was a kid, I didn't know anybody as tough, strong, or proud as my grandfather. He was an Italian immigrant educated on the streets of New York who served with the U.S. Marine Corps in WWII. An unapologetic and prolific storyteller, Grandpa bestowed wisdom upon everyone he met as he held court over a few drinks. He taught me to take pride in my work, reminding me often, "A job is not worth doing unless you are going to do it to the best of your ability." Even though he wielded a meat cleaver rather than a straight razor, he is my inspiration for Tomaselli's Barbershop and Social Club.

VALUE PROPOSITION

1. A cool and hip social club hangout with a 1920's speakeasy vibe.
2. A one-of-kind, all-inclusive, men's club experience.
3. Quality services and exclusive products.

BRAND PROMISE

A gentleman's barbershop and social club reminiscent of an old speakeasy.

BRAND CHARACTERISTICS

- Retro, 1920's style
- Exclusive, quality, friendly, inviting
- "Old New York" speakeasy personality
- Masculine, sophisticated energy

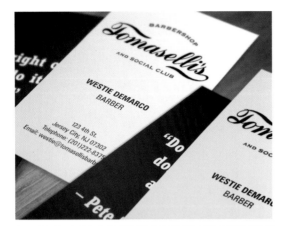

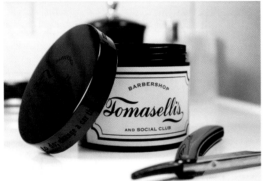

The objective of this assignment was to design a brand identity for an exclusive "men's only" barbershop. I asked my students to develop projects that communicated the style of work that they wanted to be known for. Even with the same project objective, each student added a twist that showcased his or her skills, experience, and interests. Jon produced a gentleman's barbershop for the Zen crowd that communicated the type of business he wanted to frequent. Sean, who loves graphic novels, designed a Japanese barber and sticker shop. Inspired by his grandfather, Dave created the experience of a 1920s speakeasy social club. Before actual designing took place, each student had to develop a brand concept based on the project objectives I provided. The creative brief for Dave's "Tomaselli's Barbershop and Social Club" is included on the previous page.

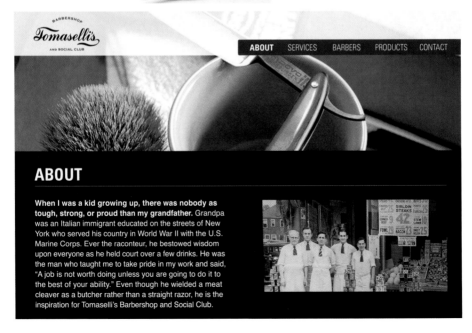

ABOUT

When I was a kid growing up, there was nobody as tough, strong, or proud than my grandfather. Grandpa was an Italian immigrant educated on the streets of New York who served his country in World War II with the U.S. Marine Corps. Ever the raconteur, he bestowed wisdom upon everyone as he held court over a few drinks. He was the man who taught me to take pride in my work and said, "A job is not worth doing unless you are going to do it to the best of your ability." Even though he wielded a meat cleaver as a butcher rather than a straight razor, he is the inspiration for Tomaselli's Barbershop and Social Club.

JON MUI: *jonmui.com*

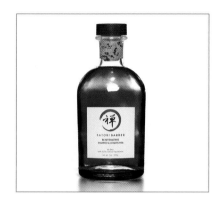

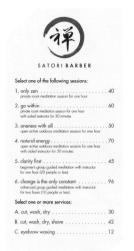

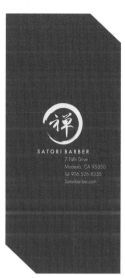

HSIEN-WEN "SEAN" SHU: *hcdesignsean.com*

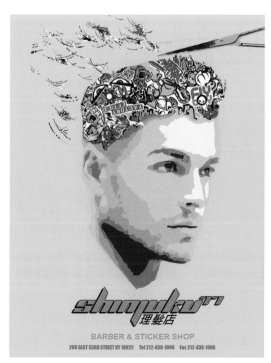

JEFFERSON SALDANA: *jeffersonsaldana.com*

ALEXA MATOS: *alexadesign.co*

together for tomorrow
the campaign for mustard seed school

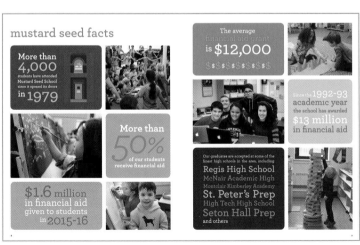

mustard seed facts

More than
4,000
students have attended
Mustard Seed School
since it opened its doors
in 1979

More than
50%
of our students
receive financial aid

$1.6 million
in financial aid
given to students
in 2015-16

The average
financial aid grant
is $12,000
$ $ $ $ $ $ $ $ $ $ $

Since the 1992-93
academic year
the school has awarded
$13 million
in financial aid

Our graduates are accepted at some of the
finest high schools in the area, including
Regis High School
McNair Academic High
Montclair Kimberley Academy
St. Peter's Prep
High Tech High School
Seton Hall Prep
and others

THE CREATIVE PROCESS (REVISITED)

When you initiate a design, you tend to follow a set of steps, and odds are you will repeat many of those actions with every project: that's the foundation of your creative process. This is not an inflexible regimen; you should be able to tailor your approach to considerations such as purpose, medium, and style. Your creative process should be elastic and adaptable enough to provide a structure you can fall back on when you are challenged or stumped. Few designers achieve their goals without following a consistent process.

You've learned about the creative process as you've progressed through design school, so you probably have a good understanding of what it takes to execute. Unfortunately, technology and competing priorities make it very tempting to take shortcuts. Be advised: choosing the easy path is rarely the wisest route in the long run. Never let someone hand you a "canned" solution. (There's no app for that!) You are responsible for initiating, developing, designing, and producing the brilliant ideas in your portfolio just as you will be responsible for initiating, developing, designing, and producing the brilliant ideas in your workplace.

Creative processes can vary from designer to designer. Some work through the night, while others add coffee breaks and power naps to their schedule. A process will evolve that works best for you. In the meantime, this diagram contains the standard main phases of a creative process that you can follow. Feel free to create your own and hang it in your workspace so you won't forget any of the components, and to remind yourself of the design steps that are most effective for your process.

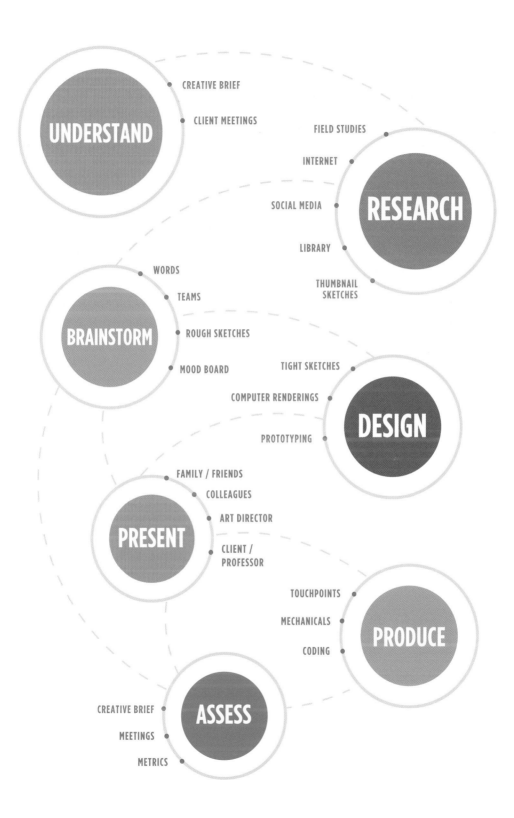

UNDERSTAND
- CREATIVE BRIEF
- CLIENT MEETINGS

RESEARCH
- FIELD STUDIES
- INTERNET
- SOCIAL MEDIA
- LIBRARY
- THUMBNAIL SKETCHES

BRAINSTORM
- WORDS
- TEAMS
- ROUGH SKETCHES
- MOOD BOARD

DESIGN
- TIGHT SKETCHES
- COMPUTER RENDERINGS
- PROTOTYPING

PRESENT
- FAMILY / FRIENDS
- COLLEAGUES
- ART DIRECTOR
- CLIENT / PROFESSOR

PRODUCE
- TOUCHPOINTS
- MECHANICALS
- CODING

ASSESS
- CREATIVE BRIEF
- MEETINGS
- METRICS

UNDERSTAND

Gather information on the scope of the project so you can prepare and plan an approach.

- Review the creative brief carefully to understand the expectations for the project. Make notations where you need clarification.

- Meet with your client (or professor), ask questions, and hear his or her answers.

- Set expectations about deliverables and scheduling.

- Inform and educate the client (or professor) about your progress.

RESEARCH

Analyze and form conclusions.

- Identify the demographic and psychographic attributes of your intended audience.

- Go to where your target audience does business and observe their behaviors.

- Do field studies to understand the problem you need to solve.

- Gain insights by understanding the client's business goals, mission, vision, values, brand equity, and what others think about the brand.

- Research competing brands, evaluate their similarities and differences, and identify one or two things that will make yours stand out.

- Sketch small thumbnail drawings based on free association of ideas.

BRAINSTORM

Identify ideas and meaningful solutions.

- Create a word list that encapsulates the passion and personality of the brand.

- Sketch a mind map (a diagram that organizes information visually) and look for connections between your ideas.

- Assemble a team of people and listen for different views and opinions.

- Develop a storyboard and organize ideas into a refined visual sequence.

- Do something else. The best ideas often come when your focus is elsewhere.

- Build a mood board via Pinterest or your own template to select the images, colors, and typefaces that reflect and represent your brand image and personality.

- Review findings and mood board with your personal network ("your people"), ask for feedback, and improve on the ideas before presenting them to the client or your professor.

DESIGN

Develop ideas visually.

- Develop only one or two of your best ideas that effectively meet the objectives of the project.

- Select and design the touchpoints (i.e., logo, ad, or multiple channels) that are most appropriate for the target audiences and those that meet the needs of the project.

- Render tighter drawings on your computer, and prepare two to three prototype touchpoints for presentation.

- Ask for feedback, and refine and improve before you present.

- Quality-check every piece before your presentation.

PRESENT

Sell your ideas.

- Rehearse your presentation, with your prototypes, to ensure that you are well-organized and prepared. The ideas you include in your presentation should be substantiated and supported by research-based data.

- Modify what doesn't work, and rehearse again.

- Present your designs, ask for feedback, and be open to your audience's (professors, mentors, design colleagues) reactions and suggestions.

- When your project idea is approved, go back to the design phase and rework or refine your presented ideas and develop additional touchpoints for the program as needed.

PRODUCE

Execute final touchpoints.

- Generate final layouts for all of your touchpoints.

- Gather and produce the content (i.e., copy, high-res visuals, graphic elements).

- Prepare and distribute printing and coding specs for pricing (if it's a professional project).

- Pre-flight check all of your files to confirm they were saved in the correct format (i.e., PDF, EPS, JPG), file size (300 dpi versus 72 dpi), and color profiles (CMYK versus RGB).

ASSESS

Evaluate and finalize your solution.

- Meet with the project team (this is your professor for a class project) and discuss the merits of each project.

- Evaluate the objectives outlined in the creative brief and make sure the project is on point and that you have satisfied the requirements listed.

- If metrics that measure the success of the program are available, include them in your assessment (percentage increase of website traffic, social media chatter, incoming calls, and so on).

- Use the best practices you discovered in this project in the creation of future projects.

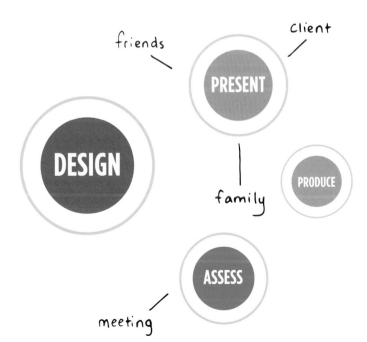

CREATIVE PROCESS
JUBENAL TORRES

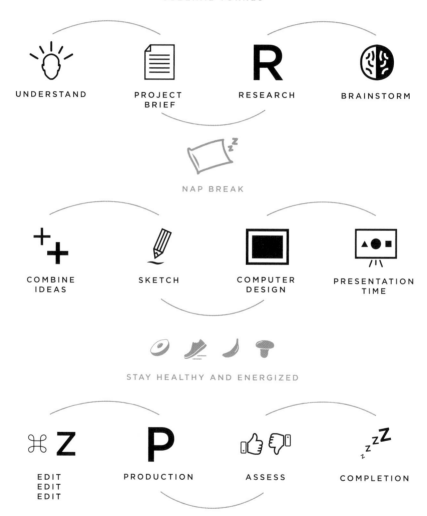

UNDERSTAND PROJECT BRIEF RESEARCH BRAINSTORM

NAP BREAK

COMBINE IDEAS SKETCH COMPUTER DESIGN PRESENTATION TIME

STAY HEALTHY AND ENERGIZED

EDIT EDIT EDIT PRODUCTION ASSESS COMPLETION

STAND OUT

The more you exercise your ability to solve design problems both visually and verbally, the greater your value to an employer will be, bringing you a step closer to your goal of practicing design professionally.

- When you're identifying (or assigning) practice projects for portfolio-building purposes, look to call upon a variety of skills, develop and enhance the designer's abilities, and reflect diverse design-thinking strategies.

- To give your designs a strong foundation and clear purpose, develop a creative brief for each project.

- Before the design phase begins, generate (or request and review) a creative brief in order to understand a project's purpose and the client's strategic objectives and needs. If you create your own document, confirm your understanding of the details with your instructor (or client).

- Never take shortcuts when designing. Use a creative process that guides you through each stage of initiating, developing, designing, and producing your projects.

- Creative processes vary. As yours evolves, make sure it is elastic and adaptable and provides a structure you can fall back on when you are challenged or stumped.

9. DEVELOP YOUR PRESENTATION LAYOUT

Designing a portfolio that communicates who you are and what you can do.

Packaging your portfolio is like wrapping a gift. After exercising your creativity and selection skills, you carefully place your work in a box and thoughtfully fold your personality and design style around it. Then you hand it over to its recipient, who will inevitably judge the packaging as well as the content.

Just as there are an endless variety of wrapping papers, ribbons, and box styles, many options are available for packaging your book of work. But before you break out your glue gun and pinking shears, it's important to think about how your gift will stand out in a competitive marketplace. Will it intrigue or confuse? Engage or alienate?

Does it connect to your personal brand and your career objectives? Every element of your portfolio tells a potential employer about you. The pixelated pup of my former student Brian Maya's "Token of Appreciation" project, for instance, immediately signals that the viewer can expect to step back into the world of retro video gaming as they move

forward to learn more about Brian and his brand. When you put a together package that speaks to your audience and they respond positively by inviting you to interview with them, you can walk into the meeting with confidence because you'll be talking about what you're proud of and what you can bring to their table.

PORTFOLIO TYPES

Before locking into any of the many different portfolio types available today, you should understand each one's potential for helping you promote your work effectively to the right audience. Keep in mind that the choices are constantly changing. Even in the several years I've taught Graphic Design Portfolio at the RBSD, portfolios have evolved from a single print book to having two or more (digital) versions required. Having to design and manage more than one portfolio can weigh heavily on a designer, because each book is unique but still needs to tell a consistent, cohesive personal brand story across the one or many platforms you choose. Rethinking and retelling your story after putting so much

of yourself into the original version can be difficult and emotionally draining, but it's also unavoidable if you want to reach the right audience with the right pieces.

When you're looking for a job, you'll need at least two types of portfolios. The first is a website—it's how the world does business today, everyone has one, and your audience expects and appreciates a quick and easy way to view your work. You also need a print or digital book to bring with you when you interview in person.

The cost of a portfolio can vary widely. Splurging on a high-end, custom presentation book or expensive, next-generation tablet may or may not be worth it.

Remember, the mission of your portfolio is to offer a preview of the great work it contains and a promise of the great work that is coming. A savvy art director will very often judge your book by its cover, so make sure the one you choose complements your work and brand and so allows the viewer to connect to what's inside.

To help you understand your options, I've put together a list of the most popular portfolio configurations and reviewed their advantages and disadvantages, as well as the estimated costs to produce them. (The Resources section at the end of this book provides more detailed information.)

The traditional print portfolio

In our all-digital, all-the-time world, there's something refreshing about a "traditional" print portfolio book—a physical binder with pages where you can arrange and display your work. A print portfolio allows you to carry and showcase actual prototypes of your best projects (packaging, product designs, renderings) so an art director can hold, touch, and experience your brand. On the other hand, it is static, has weight, and takes up real space, so the amount of content it can hold at any given time is understandably limited. A traditional portfolio can be reviewed only in person and reaches a very small audience. However, most portfolios today are presented digitally, so a one-and-only original book will tend to differentiate you from your competitors.

You can purchase a pre-made portfolio book, with or without a case, and customize it to be one-of-a-kind; design your own and put it together yourself; or have someone else fabricate what you've designed. To protect your portfolio book, I recommend a portfolio case, which can also accommodate additional prototypes and samples, resumes, business cards, or a pad of paper for taking notes.

- 8 x 11-inches to 13 x 19-inches (larger sizes are available, but I do not recommend them for a designer's portfolio); includes international formats (A4 and A3)

- Landscape or portrait

COST

- Quality store-bought portfolio presentation books and cases can cost $70 or more, depending on the size and the materials they're made of. There are plenty to choose from (portfolios-and-art-cases.com), but I recommend Pina Zangaro presentation books because they offer a vast selection of sizes and materials, some economical customization features, and overall good value.

- If something off the shelf doesn't work for you, consider creating a customized solution, but keep in mind that it may cost more to get exactly what you want, depending on size, materials, and finishing options—in the vicinity of $300 and up. When I was in professional practice, I designed a custom case out of mappa burl wood, with a drop bottom (for samples) and a compartment for my presentation book. Many of my clients were in financial services, and I wanted them to see how DMA's style and presentation fit right in with their industry.

- The cost of crafting a portfolio of your own can start as low as zero dollars, but that doesn't make it the easy route. You can use found or purchased materials, but you (or someone you know) has to have the skills to build it. One of my former students, Christi Merchant, constructed her book from debris she found on a New Jersey beach after Hurricane Sandy. Her personal brand was about travel and the environment, and the book she created captured and communicated her personal promise.

PERSONAL

&

TANGIBLE

• Don't forget to plan for paper and printing expenses. A heavier weight paper stock will give you the option to laser-print on one or both sides, because you can't see through it to the work on the back. (Note: Even if you're not printing on two sides, you may still want two-sided paper because it tends to be brighter, which makes the work stand out.) If you decide to use a Pina Zangaro presentation book, I recommend prepunched, matte inkjet paper because you can simply print and place it in your book. Twenty-five sheets of paper can cost upward of $65, but you can reduce your expenses by printing a practice book on regular paper and reviewing everything carefully before you print the final. Adhesive strips are a less expensive option, but you'll still need to buy paper, and you have to be a good assembler or your pages will be uneven and wavy. You may be wondering where I stand on plastic sleeves. I'll just say this: they are outdated, and I do not recommend using them.

PROS

• One-of-a-kind portfolio case

• Experience the sense of touch

• Project details can be viewed up-close

• Does not rely on a computer or the Internet to display

CONS

• Static format and slightly outdated, as per industry trends

• Limited content (no links to videos, PDFs, or social media)

• When you leave it with a hiring manager or client, you're without it and may have to follow up to get it back

• Potential to sustain damage or be lost

• Project details can be viewed up-close (a negative if fine details are not your forte)

• May be costly to purchase

• Need access to a color printer or have the ability to purchase printing services

• Labor intensive, and craftsmanship skills required

BEST FOR

• Designers with a focus on the print industry and those who have physical assets to show (i.e., print, packaging, interior, textile, industrial)

• Designers applying for positions at companies that do little or no digital design work

• Anyone who wants a tangible, non-digital presentation

The interactive PDF portfolio

An interactive PDF (a.k.a. digital portfolio) is a portfolio on the go—you can take it with you to wherever you're meeting someone, flip it open, and show your work. It's light, easy to carry, and has become as commonplace as a print portfolio once was. Like a website, your digital portfolio offers a full range of interactive content, but its use is typically limited to in-person presentations. Designers tend to prefer the iPad (the full-size Retina version is better for viewing projects), but there are also good PC versions on the market. Although some designers rely on the Internet for their tablet presentations, I encourage you to download your files onto your device (to view via Acrobat Reader or iBooks), so you can pull it out on the fly and show your work even when you have no Internet connection.

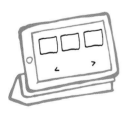

INTERACTIVE

LIGHTWEIGHT

- iPad Air: 2048 x 1536 pixels; iPad: 1024 x 768 pixels; Nook: 1,440 x 900 pixels, to name a few

- Landscape, portrait, or a combination of both

COST

- The cost of purchasing Apple's top-of-the-line iPad could run you north of $800 for the Wi-Fi and cellular model, but there are other devices available for around $400. If you cannot afford to buy one, ask to borrow one from a friend or relative, but it should be in good shape and available for impromptu interviews.

- Some apps for displaying your work are free, such as Adobe Content Viewer, Adobe Acrobat Reader, iBook, and others. If you have a subscription to Adobe Creative Cloud, you can post your portfolio online and open it up in the Adobe Acrobat mobile app. There are plenty of other apps out there that you have to pay for, and they are similar to a website building application—you drag your work into an existing template. I recommend you use Behance instead and design a layout yourself.

- You should protect your PDF as you protect your presentation book, so consider buying a case, cover, and/or stand for your tablet for carrying or presenting your work. Buying a case and incorporating it into the overall presentation speaks volumes about your ability to address the details.

PROS

- Truly interactive presentation

- Embeds or links to videos, PDFs, and social media channels

- Provides the viewer with an engaging experience of your projects and personal brand

CONS

- Requires a certain level of technical knowledge

- Initial tablet cost

BEST FOR

- Designers who want a presentation option other than, or in addition to, a print portfolio

- Designers who want to show off technical proficiencies (website, motion, video, mobile apps)

- Designers who want to create an interactive experience

The website portfolio

When you have a website, anyone connected to a digital device (computer, tablet, phone) and the Internet can see your portfolio 24/7. A website portfolio is interactive; includes a broad range of content (print, motion graphics, videos, web links); can be accessed quickly via a web link; and has the potential to reach a large audience through social media and other channels. Most hiring agents will screen your website to qualify you before they schedule a face-to-face interview. In addition to your customized site and unique domain, websites such as Behance or Coroflot can be a great resource for connecting your work to networks of creatives and recruiters scouting for talent.

ESSENTIAL

SIZES AND FORMATS

• Screen sizes vary, so when you're developing your website, think in terms of resolution and designing for your audience. According to Global Stats, 1366 x 768 pixels is most common. Remember: the higher the screen resolution, the smaller everything will look. Consider how your layout and images will appear in a responsive design.

• Landscape, responsive

COST

• Purchase a domain name (costs vary, must be renewed periodically)

• Subscribe to a web hosting plan (costs vary, must be renewed periodically)

• Behance and Coroflot are free, but some creative networks may charge you. Behance ProSite is included with your Adobe Creative Cloud subscription at no extra charge.

PROS

• Easiest and quickest way to show your work (via URL link)

• Embeds or links to videos, PDFs, and social media channels

• Provides the viewer with an engaging experience of your personal brand

CONS

• Time-consuming to create

• Requires a certain level of technical knowledge

• Recurring annual costs (domain name and hosting plan)

• Requires Internet access to view

• Potential browser compatibility issues

BEST FOR

• Every designer is expected to have one

• Designers who want to show off their technical proficiencies (website, motion, video, mobile apps)

The interactive PDF mini-portfolio

The mini-portfolio is the same thing as an interactive PDF portfolio, but smaller. For many job openings, you may be asked to submit a PDF portfolio that showcases a handful of design samples. Hiring managers look at these mini-portfolios first and then head to your website if they like what they see. As always, take the time to customize your samples to the needs of the company and position you're interviewing for. It's easy to create a series of PDFs that target specific audiences for specific types of work (websites, illustrations, logos). Create several PDFs that target different audiences and communicate your specialty. Select two to three projects—or eight to ten pages—to tease your viewers about what's to come. Include web links to relevant videos or websites. Upload everything to your cloud account: if you meet someone, you can send him or her a quick email with your work.

SIZES AND FORMATS

- You can design any size, but I recommend that you keep the same format as your digital or print books so you can minimize the need to modify your layouts. Select a size that can be viewed on a digital device or printed on standard 8.5 x 11-inch paper.

- Landscape, portrait, or a combination of both

COST

- See Interactive PDF Portfolio

PROS

- Easy to email or send digitally from the cloud

- Embedded; little or no difficulty reading files

- Easy to print

- Can be created relatively quickly

CONS

- Static

- User needs to open the file

- Shows a narrow scope of what you can do

BEST FOR

- Designers with a specialty skill or presentation targeted to a particular job, company, or industry

EASY & HANDY

PORTFOLIO CONTENT

The content of your portfolio must be substantial and varied, or no one will understand your range of qualifications. You need to pack a lot of substance into your portfolio, and the choices you make about page layout, portfolio type, and content says a lot about your brand. Be sure that everything you include works in the context of each portfolio type you create.

Introduction. A starter page that introduces your brand.

This "handshake" page can be your logo, a personal brand statement, or an animation/video. Its purpose is to set the tone of your portfolio and create an intimate, yet quick, introduction to wonderful you.

Index. A list of projects included in your portfolio.

The index helps your viewer understand the content and context of your portfolio and helps them get to the projects they want to see, based on their needs, interests, or subject matter. For a print portfolio, this is your table of contents; for the web, it is your navigation bar.

```
[ WORK ]  [ ABOUT ]
   [ CONTACT ]
        ↖
```

Project images. The images that explain a concept or create an engaging sensory experience.

A variety of digital presentation formats, such as custom photos, digital mock-ups, composed graphics, videos, motion graphics, or interactive prototyping tools can give your portfolio focus, depth, and energy.

```
AIM FOR A
SIX-WORD
BRAND IDEA.
---   ---
```

Text. The words and sentences that help communicate concepts when it is not easily conveyed through visuals.

A small paragraph or well-placed line of copy can enrich how you showcase a project or help your viewer make important connections if the visuals alone can't do it. Text can provide details, background, or a context for why you selected specific touchpoints. Some stories, such as an in-depth case study that reveals your process, require more text than others.

About. A short, insightful description that reveals something about you.

Share your vision statement, explain how you are different from the competition, or tell the story of how you became a designer. Be animated and approachable, but don't spill it all too soon. Save some revelations for the interview.

Resume. A detailed summary of your education, skills, and professional experience.

Your resume is a more expansive and comprehensive overview of who you are, what jobs you've held, and the responsibilities and accomplishments you've accumulated to date. You should review and adapt your resume whenever you apply for a particular job or if you're targeting a particular industry. Post it to your website for potential employers.

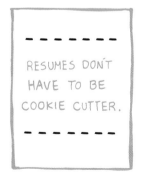

```
---   ---
RESUMES DON'T
HAVE TO BE
COOKIE CUTTER.
---   ---
```

Contact. A professional email address and phone number where you can be reached to discuss a project or arrange an interview.

As you break into professional practice, it's a good idea to have an email address associated with your domain name, and limit your personal email addresses, such as a Yahoo or Google, to personal use. Many designers link their social media accounts to give potential employers and clients additional ways to make contact, but don't direct people to a platform that you don't use or update regularly. Wherever you plan to send your viewers, be sure to check your incoming messages frequently and respond promptly. And, don't bury your contact information in the dark recesses of your portfolio—your audience should be able to find your information with little or no thought.

Credits. A brief acknowledgment (name and contribution) of who you collaborated with and how it added to your project.

When another designer adds to your project (room schematics from an interior designer, for instance) or collaborates with you to enhance a concept, they deserve some credit. Acknowledging the contribution of others demonstrates your appreciation for their efforts and confidence in your own abilities. Never take credit for work that you didn't do.

Copyright. A line of text that notifies others that the work is proprietary and legally protected.

The copyright identifies who created the work and identifies the year of first publication. This can apply to writings, artwork, photographs, and other forms of authorship protected by copyright.

Pixie dust. A little bit of magic goes a long way.

Without your pixie dust, your portfolio might come across as lackluster and unexceptional. Employers want talented and skilled professionals, but a designer with rich experiences, unique interests, and notable passions will captivate their attention. Let your portfolio stand out!

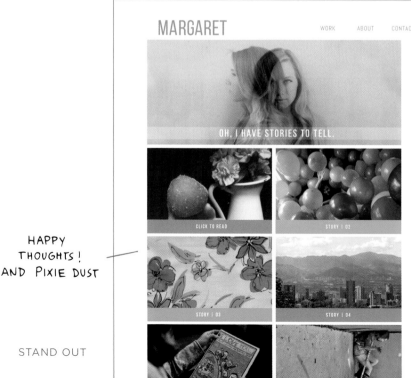

EASY-TO-FIND PROJECTS & CONTACT INFO.

HAPPY THOUGHTS! AND PIXIE DUST

PORTFOLIO DEVELOPMENT STRATEGIES

When it comes to developing a strategy for your portfolio, don't think in terms of right and wrong. Instead, reflect on what you can do to create one that is representative and successful. Before you design the layout, consider how the following strategies will make your presentation seamless, fluid, and focused.

Make the layout simple. The layout you use for individual projects and your overall portfolio must be straightforward, well organized, and all about the work. Keep the bells and whistles (gradients, drop shadows, patterns) to a minimum, because they can interfere with the flow of the layout. Do you tend to ramble on about your project idea and overwhelm your viewer with too much text? Is the composition of your images unbalanced? Has a pattern become a focal point? These are all distractions that can swing your viewer's attention away from the experience you want them to have.

The experience of viewing a portfolio should be like taking a Sunday drive. You set out on the journey with enthusiasm and optimism and, as long as the scenery is beautiful and the ride is enjoyable, you keep feeling pretty good. But when you hit traffic, bumps in the road, and a detour, disappointment sets in because your hopes for

the day have been dashed. The drive is no longer pleasurable; you're just looking for another road to drive on or a place to pull over. If your viewer (the driver) is distracted by your layout choices or unnecessary graphic elements (bumps in the road) or has to ask why you did something (detour), he will undoubtedly move on to another presentation (alternate road) or pull over (stop looking altogether). Hiring agents review many portfolios before recommending a designer, so yours should be effortless and pleasing to move through.

Plan the sequence of projects. There is a strategy for sequencing the projects in your portfolio: show your second-best project first and your strongest one last. The logic behind this approach is to begin with an outstanding project but end with a knock-out. The last project is the one that resonates longest with the viewer, so the impression that lingers will be one of a quality book. The projects in the middle need to act as the bridges that connect one piece to the next. If that flow is missing, you may lose the attention of the viewer before they get to your final portfolio project. Don't place two similar projects together (industry, specialty, like colors) because they can merge into each other and your viewer

may think they're seeing one long project. Go with your gut instinct and determine an order that incorporates your overall brand story and facilitates easy movement from page to page, project to project, and beginning to end.

The sequence of your projects must also make logical sense. For example, if you're applying for a position at a web development company, lead with your website projects. If an employer is looking for someone trained in a particular technology (motion, illustrations, branding), arrange your work by specialty. If you're applying for a position as an art director for an advertising agency, make your focus about solving problems and not your technical proficiency.

Two years out of school, one of my former students, Michelle Neunert, contacted me for advice. She was beginning a search for another job and wanted to consult with me on what should go into her portfolio. Michelle had some professional work to use but needed to supplement with student projects. She asked me to recommend a strategy for sequencing her projects. I gave her the same advice I'm giving you: always show your best projects, targeted to the industry you want to work, and wrap it all in your brand. Let your portfolio tell a story about the talented, beautiful you.

Create an engaging experience. It can be challenging to captivate your audience because every viewer is different and you may be targeting several audiences. Regardless of who's looking at your book, when your viewer discovers something new, all five of their senses will unite to create a sense memory. The more someone's senses are affected, the stronger the memory will be. Dramatic use of scale and focus, interesting and varied compositions, and dynamic color palettes can be applied across print and digital portfolio types, and each component provides an experience unique to the viewer.

Your audience's experience will differ from printed to digital portfolios, but you should aim for creating the same kind of impact. A printed portfolio is a physical object, which offers the advantage of stimulating the sense of touch. You can provide interaction by using different techniques, from creative die cutting and embossed effects to a uniquely constructed carrying case. When your audience has a chance to experience your portfolio with their hands as well as their eyes, your work becomes much more appealing and memorable.

The digital portfolio experience can be just as engaging. Videos and interactive prototyping tools (for app and web design) allow the viewer to participate with your work. (Check out Brian Maya's *Squeaky Lean* mobile app prototype and Vine video at brianmaya.com.) Surprising features and unexpected twists, such as buttons that lead down unpredictable paths, can hook your viewer and keep them moving through your portfolio. Everybody talks about the importance of that "first impression," but when was the last time you considered how important a second impression can be? Nothing beats that moment when you dazzle and delight your audience by surprising them with a brand new element—don't give them everything all at once. An effective presentation is a multi-layered, multimedia experience. You want your audience to be so engaged in your story that they stay for the whole thing.

ENGAGE VIEWERS
WITH A VINE VIDEO.

PORTFOLIO LAYOUT

The way you arrange elements on a page speaks volumes about your design sensibilities. Strong compositions are neat and organized, have a clear hierarchy of information, and have a professional appearance. Your layouts should attract attention, demonstrate a coherent logic, and create consistency and balance. Is the grid you created flexible enough for a variety of layout options? Did you include white space to give your work room to breathe and your images to generate excitement? Do the pages of each layout support the overall project, and do the projects support and enhance one another? Don't be overwhelmed by the amount of potential layout options. This is an exercise in page design, and if you follow the creative process (as you should for all design projects), your portfolio layout will serve as a meaningful and effective showcase for your work.

There are four steps to designing a portfolio layout:

1. Define the margins. Before you create your grid, understand the amount of space you have to work with. Identify the page size, orientation, and if you are working with single- or double-page spreads. Use any predetermined gutter space (between columns), bleed (for printing project pages), and binding margin (space for inserting pages into a print portfolio) to determine the live area. Once this step is completed, define a border around all four sides (with slightly more space on the bottom), and that's the live page area that contains your content. Page layouts differ from print to digital, so make sure you address each before you begin to sketch.

2. Create a grid. A grid is a pattern of vertical and horizontal lines that define and reflect the compositional proportions of the page. Grids are like invisible glue that provides the foundation to the page, balance to the content elements, and order to both print and digital layouts. Art directors are savvy to the grid—they may not quickly identify what your pattern is, but they will know when something does not align.

3. Add the content. Once you select the appropriate and necessary elements for the portfolio you choose, lay them out on the page. There should be a rhyme and reason to where you place these elements. Grids lead to a consistency of layouts per page, per project, and your overall portfolio presentation. Remember, if you're designing for small portfolio types, you may need to reduce the amount of images on a page. Yes, your viewer can zoom in, but you want to make sure they have a full experience from the start.

4. Design the layout. If you're reading this book, it's safe to assume that you have some degree of knowledge and experience in design. You're in this field because you want to design, so this is when you step up, show what you are made of, and create the best possible layout to showcase your work and communicate your brand message. Your overall portfolio layout must communicate the essence of your brand, and your portfolio's appearance must be unified with your brand touchpoints. This includes using the same fonts, colors, images, and layout style that you used for your personal brand identity.

The first time you design the layouts for your portfolios is the most difficult. Once you have a solid foundation in place, updates will come much more easily. Remember, your portfolio represents your vision of who you are and what you can do as a designer—not anyone else's. To help guide you through the process, ask one of your professors, a mentor, or a colleague for their opinion and keep your message on track. By this time, it's probably not news to you that your portfolio is really never finished. Just as your personal brand is organic and ever-changing, your portfolio will be too.

~ FOUR STEPS TO DESIGNING A PORTFOLIO LAYOUT ~

1. DEFINE THE MARGINS

2. CREATE A GRID

* When you know how to use the grid, don't be afraid to break it!

3. ADD THE CONTENT

4. DESIGN THE LAYOUT

* REMEMBER, MAKE IT STAND OUT!

PRINT

MIND THE GUTTER ! (BRITISH ACCENT)

MOBILE

DESIGN FOR THE PROPER FORMAT

WEB (24/7 PORTFOLIO)

Now that you know what is required to design a successful portfolio, it is time to develop yours. Use the worksheet and instructions below to build your portfolio layout.

• Choose a portfolio type, based on its purpose
• Select a format and size
• Choose your portfolio content
• List your project images
• Design a layout template

NAME: _____ DATE: _____

develop your portfolio layout

CHOOSE PORTFOLIO TYPE	Traditional Print Portfolio ☐	Interactive PDF Portfolio ☐	Website Portfolio ☐	Interactive Mini Portfolio ☐
SELECT A FORMAT	☐ Landscape ☐ Portrait	☐ Landscape ☐ Portrait	☐ Landscape ☐ Portrait	☐ Landscape ☐ Portrait
SELECT A SIZE	☐ 8.5" x 11" ☐ 11" x 14" ☐ 11" x 17" ☐ 13"x 19" ☐ _____	☐ 1024px x 768px (iPad) ☐ 1440px x 900px (Nook) ☐ 2048px x 1536px (iPad Air) ☐ _____	☐ 1024px x 768px ☐ 1366px x 768px ☐ 1920px x 1080px ☐ _____	☐ 8.5" x 11" ☐ 8.5" x 14" ☐ _____
CHOOSE PORTFOLIO CONTENT	☐ Introduction ☐ Index ☐ Text ☐ About ☐ Resume ☐ Contact ☐ Credits ☐ Copyright ☐ Pixie dust	☐ Introduction ☐ Index ☐ Text ☐ About ☐ Resume ☐ Contact ☐ Credits ☐ Copyright ☐ Pixie dust	☐ Introduction ☐ Index ☐ Text ☐ About ☐ Resume ☐ Contact ☐ Credits ☐ Copyright ☐ Pixie dust	☐ Introduction ☐ Index ☐ Text ☐ About ☐ Resume ☐ Contact ☐ Credits ☐ Copyright ☐ Pixie dust
LIST YOUR PROJECT IMAGES	☐ ___ ☐ ___ ☐ ___ ☐ ___ ☐ ___ ☐ ___	☐ ___ ☐ ___ ☐ ___ ☐ ___ ☐ ___ ☐ ___	☐ ___ ☐ ___ ☐ ___ ☐ ___ ☐ ___ ☐ ___	☐ ___ ☐ ___ ☐ ___ ☐ ___ ☐ ___ ☐ ___

STAND OUT

A good portfolio will give you the confidence you need to find your dream job or client. Create a killer layout that showcases your best work, engages your viewer, and communicates your true self.

- To best promote your work, start with a full understanding of the different portfolio types available, the purpose of each, and how they're relevant to your objectives.

- Content is king. The quality of the content you select for each of your portfolios says as much about you as the projects you show.

- Creating a successful portfolio is not about right or wrong, but about a strategy that works for you. Before you design your layout, think carefully about how to make your presentation seamless, fluid, and focused on the work.

- Compose layouts that are neat and organized, convey a clear hierarchy of information, and demonstrate a professional appearance that will attract attention, clarify order, and create consistency and balance. It will speak volumes about your design sensibilities.

- You'll never really finish your portfolio. It's a work that's constantly in progress, but it's a labor of love.

10. MAKE IMAGES THAT SHOW OFF YOUR WORK

Composing visuals that support and enhance your project stories.

Your images—how you create them and which ones you select—can give your audience lots of useful information about your ability to organize, art direct, produce, and present a body of work. Images for your portfolio can be produced in several ways, and each method has relevance for different audiences and types of work. As you're making decisions about creating and choosing your pictures, remember that each image needs to visually communicate the story behind your work and add to the overall essence of your brand. My colleague Al Montagna (unarthodox.com) tells students, "A graphic designer is a visual salesperson. Select the medium that sells your story the best."

To help you determine whether your images are doing their job effectively, ask yourself these questions:

Do your images simply "look" great? All of the images in your portfolio must be aesthetically pleasing, but looking good is not good enough. The pictures you use should entice your viewers deeper and deeper into your book of work. Are you showing high-quality images that are appropriate for the medium? Are the images composed in an aesthetically pleasing arrangement? Just as a bite of a deep-dark chocolate cake can make you yearn for another forkful (yes, I am projecting my own personal weakness), your first few portfolio images must establish an emotional connection with your viewers and make them crave more. When you use quality images consistently throughout your book, you build trust with your audience.

Do your images communicate the idea of your project? Order counts when it comes to assembling individual images into a space—your viewer should be able to follow along without being aware that he or she is being guided. Do you ever look at a commercial ad campaign and quickly understand the message it's communicating? Every detail was created, considered, second-guessed, recreated, and rearranged many times before that campaign was approved and launched. Your use of portfolio images requires the same level of deliberate thought. You can use text to connect the visuals and explain complex concepts, but your images have the most pronounced impact on your viewer and will be the primary vehicle for telling your story. If your viewer doesn't get the gist of your message within a few seconds, he may never get it at all—or even bother to try.

Do the elements in your images look believable and consistent? After getting an initial impression, an art director will instinctively take a closer look at the details captured in your images. Does your photo reveal that the edges of your package design are dog-eared? Is the style of your digital mock-up consistent with the surrounding images? Did you highlight the appropriate parts of the app prototype you designed so the viewer understands how it works? Paying careful attention to the elements within each image is essential for creating a successful project: if an art director sees something off-kilter, he or she may move on to another portfolio. When you display your work using images that are believable and well-executed, an art director is more likely to perceive you as a viable prospective employee.

IMAGE-MAKING MEDIA

The images you make and select for your portfolio can help you demonstrate what you know about the importance of composition, consistency, lighting, and image types. No matter what combination of media you use in the creation of visuals, your final portfolio needs to represent a cohesive body of work and should not come across as a patchwork compilation from a handful of designers. Displaying a fundamental consistency, as well as your range, requires thought, planning, and attention to detail if you want to tell your project stories effectively. Photographer and artist Greg Leshé says, "The quality of your images speaks volumes about you as a designer. It shows how much skin you have in the game, your commitment to the craft, and your willingness to be a professional."

Photography. Designers who have 3-D touchpoints to present (printed pieces, packaging, interior spaces, products) or who want to express their project ideas in a compelling way often choose this medium to capture and display their images. Photography gives you control over the expression and assets in each image because you design and select the composition, background, and theme. One of my former students, John Weigele (johnweigele.com)

says, "Photographs stand out the most. If you design and physically create a traditional prototype of a book cover, then you should go through the process of photographing it instead of using a digital mock-up. The end product will reveal the effort you put into it."

When it comes to photographing images for their portfolios, I encourage students to hire a professional or barter with a photography student who has the equipment and expertise to do the job well. Some young designers choose not to take my advice, but the photos they create themselves often diminish the greatness of their work, despite their best efforts.

Designers who are familiar with cameras and Photoshop are better able to visually communicate their work than those who aren't, so if you don't want to enlist an expert to help, you should get some experience long before you set up a photo shoot for your portfolio. Every designer should own a quality SLR (single-lens reflex) digital camera and make it a point to learn and become practiced at making great photos and videos. Your understanding of how great photography is accomplished in the visual communications world we live in will serve you throughout your career and your life.

I believe passionately in using photography (and the talents of an experienced photographer) to tell project stories visually, yet I also understand that many readers, much like my students, will reject my suggestion to work with a professional. For those who are determined to do-it-themselves, this chapter provides a process for simply and effectively photographing your own work. Before I forge ahead on that, let's look at some image-making alternatives that may be just as important for your portfolio.

Digital mock-ups. Digital mock-ups use Photoshop or Illustrator layer files to create realistic-looking images. Final images closely resemble a photo or graphic, but they are created using prefabricated digital templates, your own stock or custom photography, and illustrations. A vast selection of free or for-purchase mock-ups is available online; the ones that use Smart Object layers can speed up the workflow, retain the quality of your images, and reduce file size.

Many designers use mock-ups for presenting their work because downloading a template is simpler and more cost effective than comping your designs and setting up a photo shoot. Mock-ups also provide immediate visual gratification. Sometimes I see students use them for the wrong reason or in the wrong way. For example, an inexperienced designer will sometimes choose a single mock-up image

for the style, layout, and coloring, but neglect to consider how the image works with others or how it can affect the portfolio as a whole. Another example, which I call "stickering," happens when a designer slaps creative assets (such as a logo, colors, and graphics) into a template with little or no modification of the layout. A designer who relies on these shortcuts communicates that he or she can't be bothered or doesn't have the skills to tell a story properly through images. When you show that you are willing and able to do something yourself, an art director will conclude that you are likely to do it properly on the job as well.

As you've probably sensed, I'm not a big fan of using stock digital mock-ups: designers who rely on what is provided by others get a false sense of security that there's a "perfect" stock solution to represent their work. Stock mock-ups

are great for quick prototyping to sell an idea, especially for one-off projects or in the early stages of development, but they limit the creativity and expression of a project. Your images require thinking and planning—creating your own series of custom mock-up images, with complementary themes and consistent elements (shadows, contrast, sizing) is an infinitely more effective approach than pulling someone else's composition off the Internet.

" Choose mock-ups that enhance, not distract from, your project ideas."

Interactive prototypes. Interactive prototyping turns static files into working designs to provide a rough idea of how the final product will behave and function. This can be especially helpful for designers who create mobile apps and websites. Interactive prototypes can engage viewers through a compelling sensory experience they can interact with. Developers find prototyping useful because they can identify bugs, glitches and other issues before they invest time into coding. Combined with static photography or custom digital mock-ups, this type of image-making medium complements and changes up the viewer experience. As part of his portfolio presentation, my former student Brian Maya's "Token of Appreciation" project (Chapter 9) successfully utilizes interactive prototyping tools to demonstrate his capabilities.

My colleague, Professor Ed Johnston, who teaches digital design courses at the RBSD, says, "With prototyping, designers can bring an audience into the initial design of a web site or app, and team members or clients who experience the interface can offer useful feedback—before the project moves into the development stage."

Online tools tend to be intuitive and fairly easy to use, and most designers will find one they like and can embed in their online and offline portfolios to give viewers a sensory and interactive experience.

Moving images. If you want to learn how to do anything these days, search YouTube. In the classroom, I often use videos and motion graphics for teaching, simply because students pay better attention when more of their senses are engaged. Everything you see online combines static and interactive content. And people have become accustomed to having many sensory experiences simultaneously.

When my students tell me they want to work at a particular agency or design firm, I advise them to visit that company's website and look at how they present information. Without fail, the most sought-after companies use two- to three-minute videos for their presentations.

Rich Tu, a senior designer at Nike, says, "Most new technologies are so 'motion heavy' that your ability to go beyond a still image to tell your story has be-

come a critically important tool. Motion is so prevalent that you have to think about a motion component, regardless of the medium. Even a simple GIF or cinema graph can enhance your narrative. Whenever it's appropriate, I try to include a bit of motion either as an enticer, like a GIF meant to be clicked, or as a supplemental piece, like behind the scenes (BTS) video."

People want to be entertained, and you want your portfolio to be remembered, so including motion graphics, videos, and animated GIFs is a smart strategy. To change up a portfolio presentation and exercise your movie-making and editing skills, embed a moving image piece into your website or digital portfolio using Adobe After Effects or Final Cut Pro.

"WHENEVER IT'S APPROPRIATE, I TRY TO INCLUDE A BIT OF MOTION ..."

– RICH TU

IMAGE-MAKING STRATEGIES

Now that you understand the most prevalent ways to create portfolio images, the following strategies can help make them professional and compelling, no matter which medium you decide to use.

Create dynamic compositions. The types of portfolio you selected in Chapter 9 (print, website, interactive) will dictate the format and composition of the pictures you need to create. A strong composition will attract attention, clarify understanding, and engage your viewer, whether the project is print- or digitally based. By applying such design principles as scale, hierarchy, grids, proportion, and color, you can create compositions that give your images style, depth, and movement. Or, you can use composition to change a point of focus and explain the details of your project stories.

When you're composing images, remember to show your work in scale. A business card is smaller than a brochure, a brochure is smaller than a poster, and a poster is smaller than an elephant. (I don't know if you will use an elephant in your image, but if you do, go with a small figurine that integrates well with your touchpoints' sizes, not a circus animal.) Be mindful of the relationship and arrangement between the images in a project and from project to project.

This formula will help you create dynamic images within a project to tell your project stories more effectively:

• The first image sets the tone of your project and introduces your overall story idea to the viewer. Displaying all or most of your image as one composed picture is an excellent place to start. You're beginning a conversation and planting a seed that will connect to someone.

• The next three to five images reveal some details about your story. This could be a group of packaging examples, varying product views, or a series of posters. Consider this the middle of your conversation with your viewer. Find something interesting that connects with them on a deeper level and holds their attention.

• The final one to two images completes your project story. Leave your viewer (now ideally an active participant) something compelling to think or ask about in an interview. If you want to be invited back, what message would you like to leave behind?

The more engaging the composition is, the more likely your viewer will keep looking and remember your work.

Select an appropriate theme. Images can be styled in many ways, and they need to communicate the essence of your project ideas. What type of background, props, or lighting (to name a few) could you choose to develop, elevate, and support your work? Creating images around a central theme (technical, mood) is the easiest and most consistent way to tie your images together and tell the most comprehensive stories about your work.

When I distill down the options for my students, I generally recommend two ways to select a theme. The first option is to select a neutral background (white, off-white, light gray, black) that complements every project and then use it in every scene. For example, if you have projects with colors that contrast dramatically, such as one brand that uses white and another that uses black, select a medium charcoal background as the neutral and consistent underlying element. As an alternative, you could select the same type of background (smooth, matte surface), but use varying colors that enhance and support your individual projects. This theme works best for designers who want a simple, clean, and direct approach. It's also good for less experienced designers because it reduces the need for concept development and art direction.

MAX USES PROPS TO INTRODUCE THE STORY IDEA.

HE STAINED AND LASER-CUT HIS LOGO ONTO THE BOX!

* NOTE THE CONSISTENCY AND COHESIVENESS OF THE IMAGES.

Select an appropriate theme.
A second option is to create a different theme for each project. This approach is for the more experienced designer who has well-developed art direction skills. Creating a unique experience for each of your projects requires careful planning, but executed effectively can be the catalyst that makes you stand out.

My former student Max Friedman (from Chapter 5) was very successful at creating different themes for each of his portfolio projects. For his Scrub'd brand (grooming products for men with beards), he created a hipster-style image. He used soft lighting, props—a wooden box (that he created) and a flag and knife (his grandfather's)—and other images to expand his project idea. Props can create a sense of environment, enhance the experience, or communicate your project stories better. But don't overstage your scenes. Remember, your objective is to feature the work. The props you use should enhance the elements in your images, not distract your viewer.

Choose a consistent style.
Regardless of your theme, the elements within your images should be treated consistently and cohesively. For example, if you have app designs in two of your projects, both should be displayed the same way. This includes using the same layout, type of device (iPhone 6, for example), and size. If you decide to photograph one project and shoot your images with a particular perspective, use the same perspective for every project in your book. There are, of course, exceptions to every rule, but conventional wisdom says that whatever you do for one project, you do for the others. You want to show that each project got the attention it deserves, like parents loving each of their children equally. (My mom and dad told us this, but my siblings and I knew our youngest sister got away with more than we ever did.) An art director is unlikely to give you—the parent of your designs—any leeway if it's obvious that you love one project at the expense of others.

The style of your images can be a consistent, unifying element throughout your portfolio, including:

Image perspective. Use a similar approach and type of viewpoint across all of the projects in your portfolio.

For example, each individual project could consist of one image that showcases your overall brand accompanied by several other close-ups that fill in the details of the story. This creates consistency for your viewers and teaches them what to expect as they move through each page.

Lighting. The brightness of your images should be consistent throughout your portfolio. If, for example, some of your brands are bright and crisp, while others are dark and murky, you may give the viewer the impression that you don't know how to regulate light in the making of your images or how to correct it post-production.

Shadows. Be consistent across every image. For example, use the same position (bottom, right), gradient, and color for each.

Cropping. Removing unwanted details can improve the composition of an image and create a more interesting viewpoint. By cropping out all but one part of a picture you can enhance your layout and add to the dramatic story you're telling about your project.

HOW TO PHOTOGRAPH IMAGES

Photographing your work is more challenging than you might think. As an art director, I can appreciate the quality of a well-produced photograph, and I can instantly spot one that is poorly produced. When I was in professional practice, art directing photo shoots was one of my favorite things to do, and Greg Leshé (gregleshe.com) was one of my favorite photographers to work with. I met Greg early in my career. He sent a direct mail postcard printed with a 1950s image titled "Kitchen Pretty" (shown below) to the studio where I worked as an art director. Intrigued by the subject matter (I was in my kitschy period), I invited Greg to present his work to me in person, where he engaged me again with another image that inspired a deep discussion. I instantly felt connected to Greg through his work and photography style. (And it doesn't hurt that we both have red hair.)

Two decades later, after partnering on countless professional and personal projects (starting with a "Toaster Pretty" [page 152] image to pair with "Kitchen Pretty," which we used for a postcard promotion of both my studio and Greg's), I asked Greg to collaborate with me on this chapter to provide some professional insights on using photographic images for a portfolio.

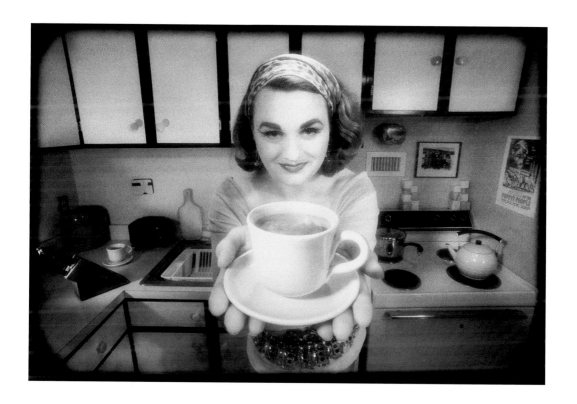

If you're photographing your own work, Greg and I recommend that you follow these guidelines:

1. Gather the tools.
- Buy, rent, or borrow an SLR digital camera with a telephoto lens (averaging between 35 – 70mm) and an override option for manual exposure and focus. (Greg says the 18 to 55mm lens that came standard on my Canon Rebel camera will do the job.)
- Obtain a tripod on which to mount the camera and manage positioning, and an electronic release cable to prevent undesirable movement when working with slower shutter speeds.
- If you don't have access to a photo studio at your school or a basic lighting setup for shooting still life images, you can purchase three inexpensive work lights with clamps. Daylight fluorescent bulbs are inexpensive and do not generate the heat that older-style tungsten bulbs do. Fluorescent bulbs can be purchased at your local camera or hardware store. If you have some money to splurge, a complete lighting package with stands will set you back about $300.
- Gather miscellaneous tools for propping and arranging the images you plan to photograph, such as thumbtacks, tape, tape measure, small level, sticky tack (a reusable adhesive that rolls like clay),

and a can of compressed air or a manual squeeze bulb to blow off dust from the scene. Select several pieces of 32 x 40-inch foam core (one side black and one side white) so you can add or reduce fill light and contrast.

2. Comp your prototypes.
Comps are mock-ups of your projects. Building mock-ups is not everyone's expertise (certainly not mine), but your comping skills will communicate your attention to detail and crafting abilities. Try to create your own comps, because the person reviewing your portfolio will assume that you did. If you are not good at comping, your photo retouching skill will come in handy for removing dust, rough edges, and other imperfections. To avoid spending hours retouching the many images you want to include in your book, try to make your mock-ups look as neat and real as possible before photographing your work.

3. Set the scene.
On a tabletop, drape a seamless backdrop such as a smooth piece of paper that's longer and

wider than the projects you are photographing. (You don't want the edges to show up in your photos.) Savage seamless paper (savageuniversal.com/products/seamless-paper), which photographers use, is a good choice. Attach the backdrop to a wall and swathe it onto the table. Or, you can buy or borrow a backdrop support system that's designed for this purpose. You may decide to use an alternative background of your choosing; in many cases, the backdrop support system will facilitate this as well.

4. Select the image format.
Based on your portfolio layout, consider the format of your images (landscape or portrait) and sizes. Understanding how you want to use the images will determine how you'll crop them later. Do you want to show your viewer a particular detail of the work? Shoot your images in a way that enhances the content. A greater depth of field shows everything in focus; a shallower depth of field will have only a portion of the image in focus and the rest of it will be blurry.

5. Arrange your compositions.
Arrange the touchpoints you wish to document (such as a menu, packaging, and business card) on your tabletop—this is your "still life." Position the pieces in an interesting and compelling manner that creates a flattering and graphic composition— this is your "scene." If you're arranging groups of multiple pieces, pay attention to harmony,

balance, symmetry/asymmetry, and spatial relationships among all of the elements. (Trust your gut to tell you when the composition is just right.) Remember, the camera is only a tool that records what you create, so spend some time thinking about what you want and whether you've captured it in the viewfinder before you start shooting.

6. Add the lights.

Lighting is where most images seem to go wrong. I've had students who know how to use available light to photograph amazing editorial shots but have no idea how to use light for still life compositions. To bring out details and colors, the images need to be illuminated properly. The working rule of thumb is that our eyes gravitate first to the brightest and most focused parts of the scene. Use that insight to your advantage as you light and organize your scene and use lens focus and depth of field (lens aperture) to emphasize or de-emphasize elements.

Set up and start with one main light. The main light (which points 45 degrees away from the camera) should be angled to illuminate at least one-half or up to three-quarters of the surface of the forms in the composition. (Avoid unnatural reflections and glaring highlights on the figures, surfaces, and still life that are not directly illuminated.)

Once your main light is in place and providing an overall flattering effect to your arrangement,

maneuver a second or "fill" light to control the contrast of the scene. The fill light is typically positioned opposite of the main light, and its brightness ratio is typically one-half or up to three-quarters less bright. You can achieve this lighting ratio by moving the light closer or farther away from the scene, by dialing down the light with some sort of lighting control, or by using a light-modifying device such as a neutral density gel or diffusion material to reduce brightness.

Through trial and error, and by varying the brightness ratio between the two lights, you can achieve a properly contrasting and flattering scene. A third light can be used to illuminate the background or another element of the scene that makes sense visually and graphically. You may also find it helpful to prop up a piece of foam core on the table's surface or attach it to a stand to reflect light from your existing lights back into your scene. This will brighten the image overall, reduce contrast, and impart greater detail to the elements contained in your image.

Don't be afraid to adjust composition, lighting, camera angle, and vantage to the scene until you are pleased. If you're not satisfied, continue to work with the elements until you arrive at a solution that documents your work in a flattering, compelling, and graphic way.

7. Get the angle right.

If you're looking to achieve a consistent vantage point, point of focus, or angle, shooting from a tripod is necessary. If you want to show some different and interesting angles, you can take the camera down and shoot by hand—but first get the shot you want using the tripod. (Once you remove the camera, you will not be able to recapture the same details.) Photograph the same scene from different perspectives—top, bottom, each side, bird's-eye view, etc. Think about the details you want to highlight—typography, finishing (binding, embossing), or texture—and focus on those elements. Changing up the composition or point-of-focus can make your images more compelling.

HOW TO ADJUST YOUR CAMERA SETTINGS

When I was picking Greg's brain to brush up on "adjusting camera settings," he wryly suggested that it might be like trying to cram notes from an intense two-day workshop onto a couple of cocktail napkins, but he was game to help me try. If you already have some photography experience, this section will serve as a quick refresher; for beginners, it's more of an introduction for shooting digital images with an SLR camera. If you're interested in something more in-depth, I encourage you to attend a workshop or find a series of online tutorials such as those on Lynda.com or Peachpit.com. My earlier recommendation to hire a professional still stands, but if you believe you can take good-quality photos with a digital SLR camera and some basic instruction, read on.

Let's start with some basics:

- You should know how to use your camera. Photographing your work without knowing how to use your camera is like flying a hang glider without prior instruction. That may sound overdramatic, but producing poor images could kill your potential to score a job, just as a hang-gliding mishap could lead to your untimely demise.

- You should own or have access to the basic equipment (tripod, lighting, background, photo software) that you'll need to make your photos.

- You should have some baseline technical knowledge because you have taken a photography class or attended a multi-day workshop.

Learning how to use a camera is complex, and every camera is different. Even if you know what you're doing, take some time to read through your camera's instruction manual or another tutorial source to learn and understand your camera's settings. Generally speaking, the following steps can help you achieve the images you want.

1. Select the color space and image quality.

There are two camera settings that allow you to generate an image file with the highest amount of digital information: color space and image quality. Think of both as containers—the larger the container, the greater its ability to capture color and tonal information. The more information contained in your digital files, the greater your number of options will be for reproduction purposes later. (Print requires the most detailed information, while the web requires the least.) When you're photographing still life images for your portfolio, Greg and I suggest you do a one-time setup and hold that setting for all of your images.

Color space. Change the camera's default color space from "sRGB" to "Adobe RGB." The Adobe RGB color space allows the camera to render images in a fuller and wider color gamut and ensures greater color detail and fidelity.

Image quality. Select the "Camera RAW" (or RAW) format in your camera settings. RAW images allow you to obtain the highest native resolution that the camera is capable of capturing, so the images are jam-packed with colors and tones, giving you optimum control to interpret and make adjustments. If you have two options for RAW, select the one that creates a RAW and .jpg file together. Keep at least two 16 to 32GB compact flash cards on hand because the image files you create will be very large. (For example, when I tried this exercise myself, each image file I created was no less than 16MB.)

2. Adjust the white balance. Based on the light source, every scene you photograph with a digital camera has a varying color temperature. I remember watching Greg photograph interior spaces when we worked together; he would always adjust the color balance if he was shooting in an environment with fluorescent lights (which throw off a green tint). Adjusting the white balance is the camera's way of adapting the light-filtering system to accurately record RGB colors. (The "white" business card in your still life maintains its white appearance, with no colorcast.) The WB setting on your camera does this by evaluating and adjusting the color temperature of your scene's light source (warm versus

cool) and the tint (magenta versus green). Professional photographers use a white or gray card, or a color checker, to adjust white balance, but if you're not familiar with this process, you can select your camera's auto white balance (AWB) mode. Greg usually uses AWB as a starting point for color balancing. After he sets his final lighting and exposure, he does a custom white balance. AWB works best with solid neutral color backgrounds, but if your scene has complicated or multi-color patterns, you may need to adjust your white balance at the beginning of your session, like many professionals do. To perform a custom white balance, refer to your camera's manual.

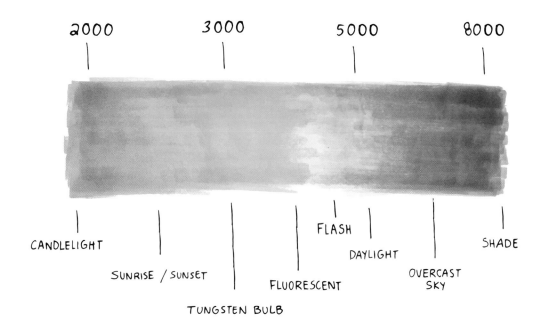

3. Set the proper exposure.

Without proper exposure, your images will not have accurate tonality (lights and darks) and color (RGB), and your camera will not be able to describe the scene correctly. Exposure is created and controlled in three ways: ISO (the camera's sensitivity to light), aperture (the amount of light coming into the lens), and shutter speed (the amount of light passing through the shutter blades). They are interchangeable and must work together for the best possible exposure. The ISO, aperture, and shutter speed are completely interdependent to each other, so changing any one variable will affect the others.

Select the ISO. The "ISO" describes a camera sensor's sensitivity to light and its effect on the creation of a photographic image. Typical ISO settings on a camera are 50, 100, 200, 400, 800, 1600, 3200, and up. The lower the ISO (100), the less sensitive your camera is to light, and your image will have a finer quality and higher resolution. A higher ISO (1600) will create a lesser quality and lower-resolution image.

If you're using a tripod to photograph your still life scenes, start with an ISO between 100 and 200. To ensure that your camera doesn't move or vibrate while you're exposing the image (which would reduce image quality), use an electronic shutter release cable. If you're working handheld, without a tripod, increase your ISO to 400 or higher, as this allows you to work with faster shutter speeds, which minimizes hand-held movement and helps you avoid blurriness.

Set the aperture. The "aperture" opens the lenses so that light can pass through and register on the camera sensor. The aperture controls the depth of field, which is the amount of focus from the foreground to the background. For example, when the opening of the lens is wider (f/1.4), more light passes into the camera, and there will be less focus front to back within the image. When the opening of the lens is narrower (f/22), less light passes into the camera, which results in an image that's more focused across its entire depth of field. Typical aperture settings are f/1.4, f/2.8, f/4, f/5.6, f/8, f/11, f/16, and f/22.

Still life is all about depth of field—what you want to emphasize and how much of the scene you want to appear in or out of focus. Greg says, "Focus imparts visual interest within the overall experience of the still life image." When shooting your still life scenes, start with an aperture of f/8 or adjust your aperture up or down accordingly to impart the optical effects of depth of field you desire.

Set the shutter speed. Light passes through the lens first and then the shutter before it reaches the digital sensor. The shutter speed controls the amount of time the camera shutter is open. Shutter speed controls time and movement, either freezing or blurring things in motion. In still life photography, the primary concern is with focus and depth of field, so the aperture settings are primary (chosen for their effects) and the shutter controls are secondary (determined by the chosen aperture).

If you are using a tripod and shutter release for shooting your still life scenes, you don't have to concern yourself much with motion and image blur. If you are handholding the camera, a slow shutter speed setting (1/2) and longer exposure can result in a blurry image. A faster shutter speed (1/500) shortens the exposure, which means the image will be sharper. A good general rule of thumb is not to handhold your camera at less than 1/60 of a second. Typical shutter speed settings are 30, 15, 8, 4, 2, 1, 1/4, 1/2, 1/8, 1/15, 1/30, 1/60, 1/125, 1/500, and up.

Determining the proper exposure may seem like a challenging proposition, which is why you should practice and become comfortable with it long before you're shooting your work. When you experiment with your camera's settings and take lots of different photos, you will better understand how to expose your images accurately and get your desired effect. Just remember that after you select the ISO and the aperture, rotate your shutter speed dial until the meter centers at "0." Understand that this may not

Photography Cheat Sheet

EXPLORING MANUAL CAMERA SETTINGS

Aperture

| f/2.8 | f/4 | f/5.6 | f/8 | f/11 | f/16 | f/22 |

← Brighter / blurry background Darker / everything in focus →

Shutter Speed

> BRIGHTER < > DARKER <
longer exposure shorter exposure

30" 15" 10" 2" 1" 1/25 1/50 1/100 1/250 1/500 1/1000 1/2000 1/8000

NIGHT SHOTS SUNNY DAYS SPORT SHOTS
blurry photos ‑ ‑ ‑ ‑ ‑ outdoors ‑ ‑ ‑ ‑ ‑ freezes motion

ISO

100 200 400 640 800 1600 3200

← smooth images • • • more noise / grain →

☀ Sunny outdoors ▦ Indoors by window ☾ Night photos

Exposure

UNDEREXPOSED PERFECT OVEREXPOSED

-2 .. 1 .. 0 .. 2 .. +2 -2 .. 1 .. 0 .. 2 .. +2 -2 .. 1 .. 0 .. 2 .. +2

be the perfect setting for all scenes. Scenes that are primarily dark may be overexposed and, conversely, scenes that are primarily white may be underexposed; you may need to adjust your shutter speed accordingly to get an accurately exposed image. Trial and error, as well as practice, will help you take better pictures. In order to become more proficient with exposure evaluation, purchase, learn to work with, and use an 18 percent gray card.

The illustration [page 151] graphically depicts the effects of lens aperture and shutter speed, independently, on focus and depth of field, as well as motion image blur. Additionally, it shows the effects of ISO on image sharpness or degradation.

4. Focus your image.

All digital SLR cameras have the capacity to focus in three ways: manual focus (you set the focus); auto focus (you focus on a specific area in your frame that locks in when you depress the shutter release button halfway); and continuous focus, (the camera focuses continuously on a specified area until you depress the shutter release button). To shoot your still life scenes, select the manual or auto focus mode, depending on your needs.

5. Bracket your exposures.

In photography, the term "bracketing" means using a series of lighter and darker exposures of the same scene, in addition to the exposure you consider to be ideal. Bracketing

is easy when you work with a tripod because it allows you to record the scene without any variation or movement to the frame, other than the additional exposures you create. Greg's preferred bracketing technique is to find the best exposure and then vary his shutter speed in half-stop increments up and down to get at least three lighter and three darker levels of exposure. This approach will ensure that you have an adequate working range of exposures for processing the images.

6. Process your images.

No matter how good you think your photographs will be after you download them, they still need to be properly processed before you can use them. The information you've captured in your RAW digital files will help unleash the potential of your pictures in post-production and make them even better. (As I mentioned earlier, the design of your images will continue until you reach your ideal finished product.) Fine-tuning color and tonality with post-production software such as Adobe Photoshop and/or Adobe Lightroom (digital image-editing software) is an important step for assessing the quality of your images and creating a flawless picture.

Greg recommends these steps: Import your RAW image files from your compact flash card onto your computer and into a named and dated folder. Back up your files in at least two places, and make sure one of them is in the Cloud.

Open Adobe Bridge, view all the images, and star the shots you want to edit further.

- Open the images you've selected in Photoshop Camera Raw (an Adobe Photoshop plug-in) and select the best exposure of each still life scene. Select images based on: focus (verify that the focus is exactly what you want); exposure (images that are not too light or dark); and composition (elements are placed exactly where you want them within the frame).

- Fine-tune the temperature, tint, exposure, and contrast until you have a satisfactory image. Notice that, as you adjust any one of these settings, the "histogram" reading will also change.

- In Adobe Camera Raw, the histogram reading shows how the light and tonal information within your scene is distributed. This is an important tool for assessing and adjusting exposures with a good distribution of highlights, midtones, and shadows that represent a normal and proper exposure. The goal is to make an exposure bright enough to record highlights that look natural, while maintaining detail and information for the rest of the image. Too little exposure will cause the shadows and darker tones to block up and lose information, resulting in an image that is muddy and unnatural. Conversely, cameras and processing are more

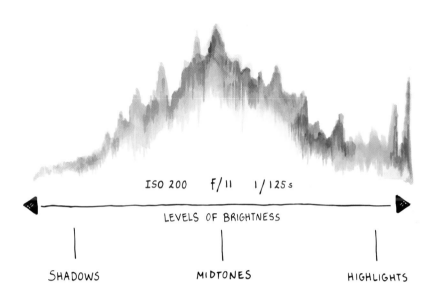

A HISTOGRAM SHOWING PROPER EXPOSURE

ISO 200 f/11 1/125s

LEVELS OF BRIGHTNESS

SHADOWS MIDTONES HIGHLIGHTS

tolerant to overexposure, but too much will also produce similar results on the other end, with blocked and washed out highlights.

- Rename and save the file in Adobe Camera Raw. Remember: Never save over your originals! One of the benefits of working in Camera Raw is that it is non-destructive, meaning it will never destroy or permanently alter the base raw file. The software allows you to save your changes to another image file format— JPEG, TIFF, PSD, etc.—that you designate for the final output. (For example, if you're outputting in print,

save the image as a TIFF; for the web, save it as a JPEG.) Greg says, "I always output my files at the highest possible resolution—either 16- or 8-bit—and my choice for file type is Adobe Photoshop (PSD) format. The Adobe PSD file type is preferred because if you retouch and optimize your files in layers, this is the best and most compatible format. I label and keep my final work completed on master PSD files, and then output the images to other file types, according to the requirements of the final output."

7. Retouch the images.
The ability to manipulate your images can reveal additional skills you may be able to offer an employer. Remember, minor problems with your photos can be corrected in Photoshop, but if the original versions straight out of the camera are mostly not right to begin with, retouching will never get you the quality images you desire. For issues like removing dust and cleaning up the imperfect edges of your work, open your edited photos in Photoshop and make further corrections. You can even cut out your background entirely and create your own shadows and backgrounds digitally.

Sharpening your images is an essential step in photo retouching. It accentuates the tonal difference between the lights and darks in your image. According to Greg, "Every digital image that's taken from a camera will need to be sharpened because they are all inherently soft and unsharp." Before you start retouching, a good rule of thumb is to make sure you never directly sharpen your retouched and optimized master files. Instead, output or convert your master files to the proper file format, size, and resolution, based on how they will be used.

Sharpen those final formatted files, as the last step in your process, using w Smart Sharpen feature. (Images used for print will typically need more sharpening than those used for the web.) Exercise caution to avoid over-sharpening your images.

STAND OUT

The images you create visually communicate the stories behind your work. Select the types of images that tell your story the best.

- Of all the image types, photography gives you the most control over the expression of a scene because you design and select the composition, background, and theme.

- Interactive prototypes turn static files into working designs that show how a final product will behave and function.

- Videos and motion graphics enhance the narratives of your work.

- Hire a professional photographer to photograph your work because they have the equipment, expertise, and knowledge to make your work look great.

- If you want to photograph your images, you need special equipment, and you must have good art direction skills, sensitivity to lighting, and the knowledge to get the right effect.

- Experiment. Fail. Learn. Be creative. Take lots of test shots. Repeat.

- Knowledge of photo retouching is helpful for improving the quality of the image.

11. PRODUCE YOUR PIECES

Understanding the technical aspects of portfolio production.

In the design industry, "production" (digital prepress) is the process of making real the things you have envisioned—and for many designers, it's a highly elusive skill. Some never master production or appreciate the process, but all designers are required to do it from time to time. As a practicing professional, you'll be called upon to produce websites, brochures, logos, 3D objects, and any number of tangible items that come from ideas that you and others have conceptualized. Design and production are two different things, but they work hand in hand: design needs to happen first, and production brings to fruition what you have designed.

Before you jump into your first or next job, take heed: design professionals are sticklers for accuracy and perfection, and they become supremely frustrated with those who are not. If you fail to comprehend the importance of good production skills or give little attention to how you produce your work, you will be perceived as someone who does not care about the work you will produce for an employer.

Production may not be your favorite pastime, but it requires your focus and attention nonetheless. Think about your production strengths and weaknesses: do you send image files with incorrect color modes, not properly sized for the medium? Do you misalign elements in a page grid? Do you neglect to use a page grid or forget to outline your typeface in the final production of a logo? I see these kinds of offenses daily, not just in the classroom but also in the design industry at large. Oversights can sometimes be dismissed as one-offs, but when it happens repeatedly or several mistakes occur on a single project, it becomes immediately clear that the designer lacks production and organization skills or worse, that he or she just doesn't care enough to do it correctly.

Granted, some talented designers spend little or no time in a production role; their expertise may not be relevant to their current position, but you can be certain that they had to demonstrate production skills at some point in their careers to get to where they are now. I'll admit that you may not want me to generate your final files for a large project, but I put in my time doing production early in my career. It's only as I've moved into other roles that I've been able to focus on the skills that truly engage me, such as art direction and hiring the best person to execute large production jobs.

Designers who pay attention and commit to doing every aspect of their job well are the ones who get referred, hired, and are able to advance through the ranks and achieve their career goals. No organization wants to employ a designer whose work has to be checked on constantly because of quality issues. It's like trying to warm up a fat croissant in a toaster oven. (Light, flaky, and bursting with buttery goodness, croissants can catch fire. I can verify this from experience.) When you demonstrate good production skills, your boss is likely to trust you and may consider you for more advanced positions because you've created the perception that you know what you are doing.

BEFORE YOU BEGIN

Technology is constantly evolving, which means that some of the information I have included in this chapter may already have been replaced by something faster or better. Whether you have a strong foundation and passion for production or you're a grudging dabbler, you should find out what's currently available and what's generally acceptable, before you get started. In the meantime, the basics I provide in this chapter can help you generate an online portfolio that appropriately represents you, your brand, and your work, and meets the demands and expectations of the marketplace where you're trying to sell yourself.

Before you begin producing your portfolio presentation, you first need to decide what kind of portfolio you want to present.

In Chapter 9, I introduced you to the different types of portfolios and their purposes. Will you create a print portfolio where you can arrange and display your work in a physical binder or book? Would an interactive PDF portfolio most effectively display the media content you have created, such as video and app prototypes? Or, do you want a website portfolio that is a convenient and easy way to connect your work with others? Regardless of which you choose, start at the end result, and deconstruct where you are going before you proceed.

1. Select the portfolio type(s). There are many justifications for identifying from the outset what types of portfolio you need—differences in page formats and sizes and image color modes, for example— but the most important reason is that each portfolio needs to be designed as intended. Just like an ill-fitting suit pulls and sags in all the wrong places, a portfolio layout that has been poorly retrofitted to another portfolio type will always look sloppy and the assets poorly placed. You should produce the components of your portfolio to fit the format you've selected: the traditional print portfolio, the interactive PDF portfolio, or the website portfolio.

2. Choose the right software. The type of portfolio you're producing determines the software you'll use to create it.

Print portfolios and interactive PDFs can be created using the same program (Adobe InDesign), but the software features you utilize will differ, and the files you create will be saved in different ways.

Print with Adobe InDesign. A print portfolio is comprised of many pages (calling it a "book of work" is no coincidence), so its set up will resemble that of a book, brochure, or magazine. Page layouts should be prepared in InDesign (not Illustrator or Photoshop) because InDesign can produce multiple page documents better and faster. In addition, its features are unrivaled in type formatting (character and paragraph styles) and image handling.

Interactive PDF with Adobe InDesign. An interactive document needs to be created in a program that includes interactive features. InDesign includes such programming capabilities as hyperlinks, bookmarks, buttons, and page transitions that can be embedded in the layout of your portfolio.

3. Choose the right software for your web portfolio.

The options for producing a website portfolio will vary, depending upon your knowledge of code and need for customization. If you are a web designer, you will most likely create a website in HTML and CSS to demonstrate your coding skills. If web design is not your specialty, an online, template-driven site that simply promotes your brand may work best. Web designer and Kutztown University Professor Josh Miller says, "An online portfolio is a great place for web designers to show off their user interface (UI), user experience (UX), and clean coding skills. You want to build a design site that's minimal, but still conveys your unique personality and puts your work in the forefront. Building your own site allows you to integrate some JavaScript, which adds interactivity for a more memorable experience.

Another great option is to take the time to build a custom WordPress theme for your portfolio site, which gives you flexibility for future additions and edits as you add new work to your portfolio. It's also a great skill to add to your resume."

Website with Adobe Muse, Adobe Dreamweaver, or online template sites. There are multiple software options for producing your website portfolio. Some utilize Adobe programs created specifically for this purpose, but alternative online solutions are also gaining popularity. There are plenty of good books on the market to teach you how to use these programs, but for the purpose of building an online portfolio, choose a program that promotes your skills and knowledge for web building.

• Adobe Muse (which is similar to InDesign) allows users to create websites even if they don't know coding (HTML,

CSS, Java). If you do have some coding knowledge, you can customize and enhance your viewer's experience by using Dreamweaver to build your website.

• Squarespace, Weebly, and Wix are three of the many companies that offer an online, all-in-one content management system (CMS) that includes website building via predesigned templates, a blogging platform, and hosting services. These and similar subscription services can provide you with the tools to create and maintain your website and to develop and manage a blog. You can use these sites with little knowledge of coding, but your options for customization are limited. If you go with this option, select a template that best matches your original design layout, or base your website portfolio layout on their template options.

CHECK OUT MY "GO-TO-GUY" ADOBE-CERTIFIED TRAINING EXPERT, JEFF WITCHEL, FOR PRODUCTION TIPS @ JEFFWITCHEL.NET

SAVE YOUR FILES CORRECTLY !
- Denise

image file formats

	PRINT	WEB
RESOLUTION:	300 pixels per inch (ppi) or higher.	72 pixels per inch (ppi) or higher.
SIZE:	**Raster**—images are resolution-dependent; their size is directly associated with their resolution. **Vector**—images are resolution independent; they can be scaled to any size without losing detail or clarity.	Raster images are resolution-dependent; their size is directly associated with their resolution.
COLOR MODE:	**CMYK** (cyan, magenta, yellow, black)—standard colors used for offset printing.	**RGB** (red, green, blue)—colors used for computer monitors and devices.
FILE TYPES:	**AI** (Adobe Illustrator) is a native vector file format for placing images in InDesign.	**JPEG** (Joint Photograph Experts Group) compresses continuous-tone images for the Internet. The downside of JPEGs is that too much compression will cause the image to visibly degrade and appear jagged.
	EPS (Encapsulated Postscript) is a universally accepted file type (both Mac and PC) for vector images, and is the industry standard for commercial printers. For both vector and raster images, this file type has fallen out of use over the years since the introduction of Adobe InDesign.	**GIF** (Graphics Interchange Format) compresses images and makes them suitable for fast downloads. Not appropriate for non-continuous color images—GIF is for flat, solid-colored images. GIFs can be layered on web pages or in artwork, can be animated, and can be placed on a web page with a clear background.
	PSD (Photoshop Document) is a native raster file format for placing images in InDesign. This format is versatile because it retains editing capabilities.	**PNG** (Portable Network Graphic) acts as a hybrid between the JPEG and GIF formats. It compresses both non/continuous-tone color images so they can be layered on web pages or artwork and placed on a web page with a clear background. PNG files are extremely versatile, but can be very large in size and may take a long time to download.
	TIFF (Tagged Image File Format) is a native raster file format for placing images in InDesign. It is the industry standard for commercial printers.	**MP3** (MPEG-1 Audio Layer 3) is used for compressing audio files. Use this file type for embedding audio into your websites and interactive PDFs.
	PDF (Portable Document Format) files can be saved for both vector or raster images, and are an acceptable format for placing images in InDesign. PDF files are compressed, which may impact the quality of an image and limit editing capabilities.	**MP4** (MPEG-1 Audio Layer 4) is used for compressing movie files. Use this file type for embedding video into your websites and interactive PDFs. To convert an original .mov file to MP4, use Adobe Media Encoder.

4. Refine your portfolio layout.
In Chapter 9, you based your portfolio layout on how you want to display your work. Now that you have made the images for your portfolio and developed your project storylines, you may need to refine that layout. This step is necessary to ensure that the overall cohesive experience of you and your work will be just as you designed it.

Things to consider:

- Modify your page layout and grid, if necessary.

- Check your margins to account for gutter space (for binding in a traditional portfolio).

- Identify the number of pages— is it what you imagined?

- Check the size and placement of images.

- Confirm consistency and cohesive flow within the individual projects and the presentation.

5. Choose your final images.
The two main image file formats you will use in the production of your portfolio are raster (photographs or any images created in Photoshop) and vector (illustrations or graphics created in Illustrator). Raster images are composed of pixels-per-inch (ppi), which means that file sizes are directly associated with resolution. For example, a 300 ppi image is high-resolution (or "high-res"), while a 72 ppi image is low-resolution (or "low-res"). Conversely, vector images do not use pixels, so they can be scaled up or down without affecting quality.

Select, process, retouch, and save your raster images at 100 percent (or larger—never smaller) of the intended size before you begin production. If you are producing several different portfolio types, resize and resave your images with the correct color profiles for each medium. (Selecting the correct color profile is critical because the CMYK spectrum is limited and all colors cannot be duplicated from the RGB space.)

When adding images in InDesign, always "place" them to appear in your "links" palette so you can easily update them if you make changes. If you are working with an industry printer or programmer, identify which format he or she prefers for outputting the best-quality images. If you are not certain, refer to the Adobe website— helpx.adobe.com.

6. Finalize your content.
Content is key to communicating your brand offerings and supporting your project visuals. Organize, write, and proofread your content before production begins so you can focus on the aesthetics of the layout and the end-user experience. (If your copy is not finalized before you begin production, use place-holder text styled in the correct font and point size.) Design your resume (in InDesign, not Illustrator) and save it as a PDF, if you want to give your viewer the option to download it. Place your files into folders based on portfolio type and specific project. Organize all your files so they will be easy to find when you go to produce your portfolio.

- Finalize your copy ("About" you, project descriptions, case study text, process stories, contact information, etc.).

- Finalize your resume text and page design, and save it as a PDF (for sending or downloading from the website).

- Get a photograph taken of yourself, process the image, and save it correctly for the intended use (if applicable).

STAND OUT

Strong production skills are necessary to bring the designs and projects you have conceptualized to fruition.

- Design professionals expect designers to be knowledgeable and detail-oriented when it comes to digital file preparation.

- Selecting the appropriate software for each type of portfolio you're producing will give you the best possible tools for creating a compelling presentation.

- In consideration of color space and resolution, images for print and for screen-based applications (digital tablets and websites) are saved differently to achieve the highest quality for the medium being viewed.

- To streamline the process and create efficiencies in the production of your portfolio(s), refine your layout, collect your images, finalize your content, and organize your files before you begin.

- Technology is constantly changing, so select the most relevant and current software to produce your portfolio presentation.

12. CASE STUDIES: STUDENT PORTFOLIOS

Exploring student portfolios that stand out.

Not all students enter college with an interest in or intention to design for a living, but some do, and others get inspired along the way. I do not come from a family of graphic designers, nor was design my first course of study as an undergraduate. (I started with physical education, dabbled with genetics, and settled into fine arts before discovering my passion for graphic design.) Looking back, I can identify two milestones that should have made it obvious to me that design was my calling, long before it did.

When I was growing up, I would walk around my family home repositioning the bowls on the china cabinet and the photo frames on the mantle and hiding anything that shouldn't be out on a counter. I didn't realize it at the time, but I was "art directing," arranging and organizing elements to create visual order and aesthetically pleasing experiences. In middle school, my grandfather (who was a book binder) gave me a Letraset catalog of typefaces. I used to sit for hours and study the letterforms, and then I would copy the letter styles for birthday cards and invitations for special occasions. (I remember the typeface with the rose swirls most clearly,

probably because it was the one I used most.) It was many years later, after meeting Robin Landa, that I realized design was my calling and officially declared myself a student of graphic design.

Not everyone takes a direct path to a design career, and many who aspire to become designers never make it through the rigors of a design school program or break into the industry. Many do succeed and are good at what they do, but some go on to be truly great, because design is their calling.

In this chapter, I highlight students who have demonstrated true greatness; they are creative, inquisitive, skillful,

have a strong work ethic, and freely share their talents with others. From my perspective, they "arrived" as professional designers before they ever left my classroom. When I encounter these students, I'm not afraid to let them know that I have little left to teach them, except perhaps to guide them through the process of packaging and preparing themselves to leave the familiar and comfortable RBSD nest. I dedicate Chapter 12 to these students to let them know how proud I am and how meaningfully they have touched my life. They continue to inspire and remind me why I fell in love with design in the first place.

Max Friedman

maxbfriedman.com

1. Describe the moment you realized that design was your calling. Were you influenced by someone or something?

I did not discover what design was until I was in high school, when my mother brought me to speak with an acquaintance, one of the graphic design professors at Kean University. What was supposed to be a 15-minute conversation about the program turned into a two-hour discussion on the history and nature of art and design, which subsequently hooked me into joining the illustrious ranks of the creative. Oddly enough, years later, that same professor would become my collegiate mentor and co-author on a series of textbooks on the fundamentals of design.

I believe that I am still figuring out what my calling is. Right now, design plays a huge part in my life, yet the road to success holds many twists, turns, flips, flops, blips, dips, and bops that we've got to venture tirelessly through to find what

we're looking for. I'm currently making strides forward, hoping they're in the right direction, as we all are, learning as much as I can each step of the way.

Design is taking someone on a journey, allowing him or her to see the world through your eyes or, at least, the world you choose to paint, and that is what I have come to love. It's the window through which we see and learn more about others and ourselves.

2. What project in your student portfolio made you believe that you could be a professional designer and why?

Developing a student portfolio is a challenge that separates the sheep from the goats. More than any specific project I created for mine, the process itself allowed me to see that I was already well on my way to becoming a professional designer.

Going into this concluding trial of studenthood, time begins to narrow, friends are seldom seen, thousands of granola bars have been consumed, and a good night's sleep is rare. The process culls those who are passionate from those who are not. Creating a body of work that defines everything about you to the rest of the world is no simple task; how you approach it defines you. A student who puts in half the effort and who doesn't take the process seriously will emerge with an average portfolio. Those who work tirelessly and push themselves to create a book of work they can be proud of for years to come will thrust forward into design and make something of themselves. Passion fuels professionalism and progress, and it's evident in the efforts you put forth when the going gets tough.

3. What advice can you give to other students who are building their book of work?

Design gives back what you put into it; hard work and dedication are rewarded with opportunity and endless possibilities. Over the last year, more so than any time before, my design aesthetic seems to have developed tremendously, not because of the hundreds of late nights submerged in the depths of my computer screen with a coffee in one hand and a pen in the other, but because I am having fun with whatever I'm doing. Always try to have as much

fun as possible with your work, because that's what makes it less of a job and more of an experience.

A great designer once told me that to succeed in design you need to have three things: talent, skill, and passion. Talent: you either have it or you don't; skill can be developed and practiced in time; and passion is the thing that makes you want to get up every morning and make something of yourself. I believe that passion is the single most important thing for any student or young designer to have in his or her arsenal. A deep desire to

change the world can be what sets you apart from hundreds of other designers. If you are dedicated, look to the future and drink plenty of hot tea, there is nothing that you cannot accomplish. The harder you work, the luckier you get.

Nicole Trusa

nicoletrusa.com

1. Describe the moment you realized that design was your calling. Were you influenced by someone or something?

Every time I try to pinpoint a time in my life when I realized design was my calling, I realize that the design culture has always been part of who I am. The stories that my parents have told me about my toddler days—how my eyes immediately got wider when I entered a mall for the first time, how I meticulously paired my Barbie doll's outfits together, or when I played "art auction" with my Grandma—have helped me to see that I have always had an eye for design, whether it's interior, fashion, or graphic, before I even knew what design was.

2. What project in your student portfolio made you believe that you could be a professional designer and why?

It wasn't until I saved my final file at 3 a.m. the morning of my last senior portfolio class that I was able to say to myself with complete confidence, "I can do this." Witnessing how all of my hard work finally came together gave me a tremendous sense of accomplishment and validation that I was on the right path to

an exciting future in design. During one short (and I mean very short) semester, I noticed an enormous leap forward in my ability to translate designs and ideas across multiple platforms. The ad campaign I created—a jewelry brand called "Tinseled"—was extremely well received by my professor and her colleagues. Seeing all of my projects woven together into a final portfolio made me believe in myself.

3. What advice can you give to others who are building their book of work?

From the countless lessons that I have learned in the portfolio building process, I still reflect often on these three pieces of advice:

Consider every project as "portfolio potential." Believing that a portfolio can be formed using one semester's worth of work is a mistake. It wasn't until I began shuffling through old classwork files and used-up sketchbooks dating back to sophomore year that I realized my portfolio was (for the most part) laid out right in front of me. Revamping past works and revisiting unfinished ideas can

shape the basis of a portfolio piece or even inspire new ones.

Have a "don't stop at one" mentality. When a professor asks for one poster design, make two more than that. With thanks to Professor Robin Landa for enlightening me about this way of thinking, I have been able to create campaigns rather than individual elements. Going the extra mile can generate stand-out work and push you to discover additional design solutions that may not have been so obvious.

Create with confidence. Receiving what seems like an endless amount of feedback and an excess of personal opinions during the process of creating portfolio pieces can be downright overwhelming. While it is always valuable to remain open-minded to criticism, it is also important to remember that a final portfolio is a reflection of the designer who created it. Every designer has a niche, a certain style, and should shine where it counts most.

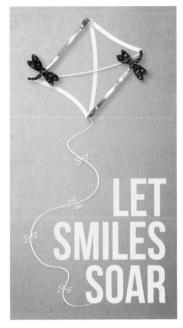
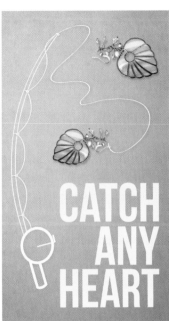
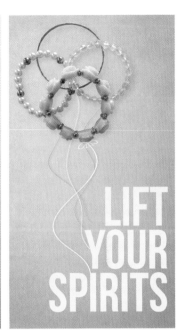

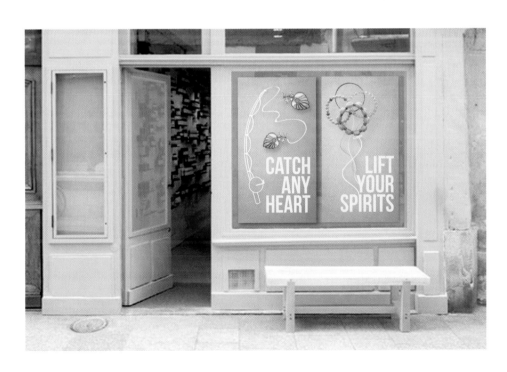

Stephen Sepulveda

sepulveda.design

1. Describe the moment you realized that design was your calling. Were you influenced by someone or something?

In some ways, I feel like I have always been a designer. From a young age, I was enthusiastic about creating images, drawing, and even making video from time to time. I wasn't the type to paint just to paint or sit and make a sculpture, but I found satisfaction in creating things, such as the logo I developed for my skate crew. In fifth-grade shop class, we made racecars out of woodblocks that all wound up looking pretty much the same. I wasn't satisfied with my car until I had given it a paint job and branded it with a lightning bolt.

2. What project in your student portfolio made you believe that you could be a professional designer and why?

I had my "aha" or "eureka" moment when I set out to create Views & Brews, my new business idea that combines hiking with craft beer. The concept is grounded in an incredible, awe-inspiring adventure I had in Colorado, and the project was designed to recapture that sense. It was a great life experience that I was able to turn into a meaningful brand that also speaks to my strengths in conceptualization and execution. The Views & Brews brand shows my capabilities as a designer and gives a glimpse into who I am as person as well.

3. What advice can you give to other students who are building their book of work?

The idea is just as important as the execution.

Beautiful brands are great, but beautiful brands that are viable and original are even better. Create brands for your portfolio that are distinguishable and have a foundation in something that is authentic. Pixel-perfect work without a strong concept backing it up will miss the mark. Let the work speak for itself, and let the pieces in your portfolio put the brand into context.

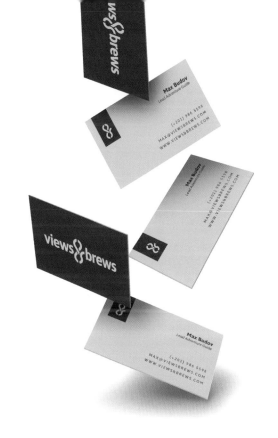

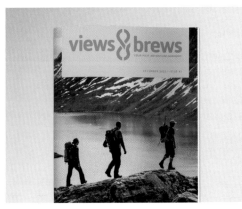

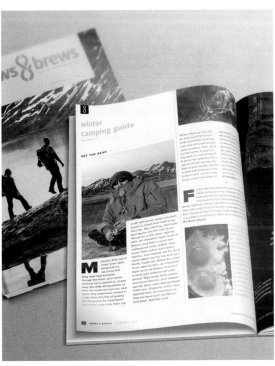

Denyse Mitterhoffer

mineny.com

1. Describe the moment you realized that design was your calling. Were you influenced by someone or something?

I was a designer before I knew I was a designer. As an only child, I had to keep myself entertained and "creating" was my hobby. I also kept tons of diaries where I would write the details of my busy kid life on one page and make some type of visual on another—I was an editorial designer at age 7. After finishing high school, I just wanted a secure job that paid the bills, because I was afraid to fail in such a competitive field as design. After pursuing a different field of study and working for a while doing something I was not truly passionate about, I realized I needed to be true to myself. I went back to school for graphic design and haven't looked back since. People sometimes ask me what influenced my decision to become a designer. There was nothing specific, but I think I admire so many things (probably too many) that everything I touch, see, or smell translates in my head as inspiration.

2. What project in your student portfolio made you believe that you could be a professional designer and why?

Nothing is more reassuring than having others appreciate and praise your work. It's even more encouraging when your work is published in a well-known magazine in your field. My last semester at Kean University, I asked my professor, Robin Landa, to help me edit my description of a project, "The Things I Take for Granted," which was based on a brief she gave us in class. Robin was so excited about it, she gave me the confidence to enter it into a poster series contest for *HOW* magazine. Months went by, and I completely forgot about entering it. When I got an email from the magazine telling me my work would be published, I knew I had a chance.

3. What advice can you give to other students who are building their book of work?

Many things are important to becoming a great professional designer; for me, the most important thing is passion. When you're passionate about something that you've created, it's not only easier to explain what the project entails but the project itself will stand out. Don't work on something for the sake of filling your book—do it because you truly want to; otherwise, why waste your time? During my last semester of school, I started interviewing as much as possible so I could practice talking about my work. I made one thing clear to all the potential employers: I loved every single project I had created. During one interview, I was talking about one of my identity projects, and when I mentioned it was a student project, they expressed disbelief. I had shared so many vivid details that they thought it was the real thing. That's when I realized that my passion truly showed in everything I made, and that's what kept the conversation going.

ELECTRICITY

COFFEE

MY CHAPSTICK

CLEAN WATER

Maria Finelli

mariafinelli.com

1. Describe the moment you realized that design was your calling. Were you influenced by someone or something?

I always knew design was my calling without consciously knowing it. I was drawn to it most concretely through my love for literature and creative writing. In high school, I was appointed to the editor-in-chief position of our school's literary magazine, *Cobblestone*. Selecting the articles to include in the magazine was within my zone of familiarity, but I was also responsible for the layout of the bound booklet. I began acquainting myself with letterforms and the space they claimed. I realized the elements that needed to be highlighted and used hierarchy to express them. You could say it was my first date with design. I began to understand that every execution was part of the general delivery of the message. Each page, comma, image, and letterform would contribute to the success of the final product. I fell in love with this idea of visual construction.

2. What project in your student portfolio made you believe that you could be a professional designer and why?

In my Identity class, I was tasked with creating a brand for any type of event. At this point in my life, I was heavily focusing on my health. I found refuge and spiritual strength in running each morning and respecting my body's needs nutritionally. I wanted to export that enjoyment, so I created an obstacle course event that would simultaneously function as a charity fundraiser. As I started building it, I realized the positive impact it could make. Design should only serve to improve and I felt like the project was accomplishing that in many ways. Our health is often undermined and overestimated. By making a participant's funds contingent on how well they performed physically, I introduced motivation from a completely new angle.

3. What advice can you give to other students who are building their book of work?

Building a book of work is first and foremost uncomfortable. Creativity does not surface in a predictable, monotonous environment. Removing yourself from familiarity will help you expand your personal limitations. Do one thing every day that you wouldn't normally do. Listen to different music; read about political issues; or learn about aliens, drones, jellyfish, or sushi. You're absorbing content and borrowing perspectives that will eventually shape your own. If you feel stuck, try what I call "anti-thinking" as a method to reset yourself mentally. Go for a run or fold some laundry. These activities require simple mental involvement but allow you to be consumed in the rhythm of the task. After giving yourself distance, return to your work refreshed.

Be nonjudgmental of yourself. Make everything a design problem and just create. Produce lots of solutions without trying to filter them in advance. Design is its own language; if you don't keep speaking it, you'll never be fluent.

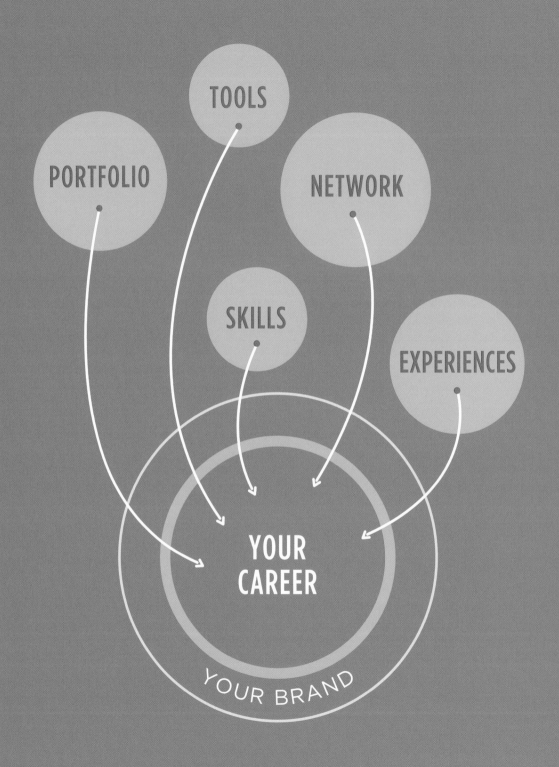

TOOLS

PORTFOLIO

NETWORK

SKILLS

EXPERIENCES

YOUR
CAREER

YOUR BRAND

FIND A GREAT DESIGN JOB

Learn how to find a job
and launch your career
in the design field.

13. PREPARE FOR YOUR PRESENTATION

Initiating a conversation about your projects that reveals your story.

Everyone loves a good story, and the most memorable stories are interesting, believable, and emotionally evocative. At this point in the process, you've created a portfolio that is a visual narrative of your creativity, skills, range, design-thinking ability, and ambition. You've developed touchpoints for engaging your audience in a series of signature and smaller (but meaningful) interactions. Now, when you're called upon to present your portfolio in an interview, you have to become your story's living, breathing narrator and your brand's most enthusiastic advocate. It's time to paint a rich and accurate picture of who you are. The story of your portfolio is the soul and spirit that drives your projects.

When I think about the student projects I've reviewed over the years, the pieces that continue to live in my memory are connected to stories that speak to my values (Alexa Mato's "Adelino Butcher and Wine" identity); tickle my appreciation for wit and humor (Max Friedman's "Blue Peters" craft beer illustrations); or tap into my business side (Jefferson Saldeno's "Dual" soda packaging from Chapter 8). I remember the designers because their stories resonated with me on a deep emotional level. Alexa created her brand to honor her grandfather, Adelino who owned a butcher shop in Portugal. Max introduced his sense of humor through his drawings. Jefferson conveyed his excitement about a new product idea through his expert 3D rendering skills. The students' projects demonstrated the quality of work they are capable of producing, but understanding how each turned a simple class assignment into a personal quest revealed to me who they are.

Connecting to an interviewer by sharing a behind-the-scenes glimpse of your process, your personal journey, and your approach to design is key to getting hired. Your portfolio may be exceptional, but employers don't hire your portfolio; they hire you.

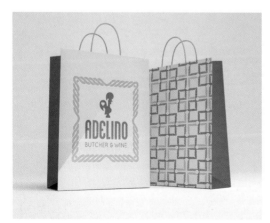

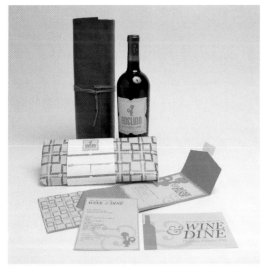

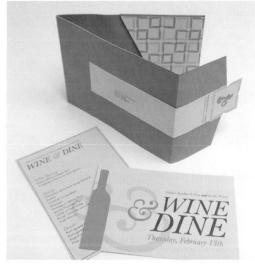

HOW TO TELL EFFECTIVE STORIES ABOUT YOUR PROJECTS

With the right approach, the story behind your work can be as compelling as the design itself, but presentation skills don't come easily to everyone. If you're uncomfortable talking about your work or giving presentations in general, you must develop the ability, because talking about your portfolio is critical to selling your ideas and finding a job.

Presenting your portfolio is simply having a conversation with someone about your projects. Your objective is to (humbly, but proudly) tell the real stories behind the work and how you created it. As you begin to do this, you will find yourself becoming actively engaged in the conversation you've started, because there is no better expert on your process, your perspective, and your experience than you.

Using a combination of spoken words and visual images, your objective during the presentation is to precisely and clearly tell the viewer about the problem and then show them how you solved it.

Highlight the information your reader needs, and focus on the points of the project that make it interesting and exciting. Weave stories about your work into the overall narrative of your presentation. Like a fisherman patiently dangling tasty-looking bait to entice a fish, you want to keep your viewers enthralled and drawing ever closer until, with your last and best project, you "hook" them into a story that's particularly memorable and compelling.

You won't be able to hook everyone you meet with, but each time you cast your line, you learn something you can use the next time. You refine the details of your stories. You focus less on what your touchpoints look like and more on

how they connect to your audience. You leave out one story and add another. You continue to improve your content and perfect your delivery.

As you gain experience, you'll get better at reading your audience and knowing when and how to change gears if something isn't working. In the meantime, I don't recommend winging your presentation, even if you are a natural performer. What you say about each project should be intentional and practiced. Keep your stories short and succinct—all you need is two to three minutes per project—because anything longer can come across as rambling, and anything shorter may seem rushed and unprepared. Show humor, humanity, and authenticity. Be confident, clear, and compassionate. Practice in advance so you can muster up the confidence and energy needed to be your wonderful self.

YOU ALREADY HAVE THE SKILLS TO TELL A GOOD STORY

- You pitch ideas all the time.
- You know how to talk to other humans.
- You can make the abstract tangible.
- You create sensory and emotive experiences through design.
- You can pare down the complex into something understandable.
- You understand yourself and how others perceive you.

Start with the problem.
Graphic designers solve problems. Interviewers want to know how you did it. When you're telling a story about your work, start by giving your audience the context or background of the project. Your viewer will better understand how you used your design-thinking abilities and skills if he or she understands the problem that you had to solve. Neglecting to mention the challenge you faced at the outset is like starting a conversation in the middle; it's confusing for the person at the other end and frustrating for you when he doesn't understand. When you build your stories purposefully, you create excitement and anticipation for what comes next.

Use the creative brief. When you're preparing to talk about your work in terms of its context and the problem you solved, your best resource is the creative brief. Summarizing a project's strategic objectives and needs, the creative brief outlines the purpose, target market, brand attributes, unique selling proposition, and anticipated outcomes that will be used to determine whether the project is successful. (All of the projects in your portfolio should have been initiated with a creative brief. You can make use of them again to recall and highlight the most relevant project details.)

> " It's not that I am smart; it's that I stay with problems longer. "
> – ALBERT EINSTEIN

This background information becomes the framework for talking about the solutions developed. For example, if you rebranded a business, you can share why the company needed the update: "The company was launching a new product line," or "The next generation of the family wanted to go national." State the problem that needed to be solved as simply as possible, preferably in one short sentence.

Share your research insights.
The creative brief provides a context for the project, but before you could solve the problem, you had to do some research and gain additional insights. When you're putting your presentation together, spend some time reviewing your research notes and analyzing what you learned that the creative brief didn't tell you. When you're presenting, talk about those key insights from your research that helped you refine your understanding of the problem and steered you to your solution. Discuss how your discoveries shaped your strategy and led you to the "big idea" of the project.

When I'm working on a problem myself, I think about an Albert Einstein quote I cut out of a newspaper years ago: "It's not that I am smart; it's that I stay with problems longer." When you can articulate your understanding of the problem, talk about your research and the insights you gained, and discuss how it all led you to a solution, you demonstrate to your interviewer that you know how to stick with a problem until you get to the heart of it.

Reveal your "big idea." Your big idea connects the problem to your solution and your solution to the target audience. How did you solve the problem you've just described? Why did you solve it that way? How did you communicate your message to the end user? How did you use your insights to create an engaging experience? Share your "aha!" moment with the interviewer, and engage her in your process.

Every time I assign a project, I marvel at how many different solutions can spring from a single problem. Everyone in the room brings a unique combination of life experiences,

education, and skills that lead to designing something that no one else can. When my student Marc Rosario (who lived in the Philippines as a child) wanted to re-brand a Filipino food product in the United States, his firsthand knowledge of both cultures was instrumental to his developing a design solution for the American market. Every design problem can be solved in many ways, but your interviewer wants to know how *you* solved it and why you chose that direction. What concepts did you explore? How did you distinguish the great ideas from the good? Explain the big idea of your project so you can emotionally connect your audience to the touchpoints you've created.

Let's say, for example, you received a creative brief that introduces a manufacturing company that is undergoing a major expansion but losing skilled technicians who are aging out of the workforce. The creative brief outlines the client's urgent need to recruit and train graduating high school students and military service members, to educate them about the long-term benefits of a manufacturing career, and to encourage

them to enroll in a specialized training program that the client offers to new hires. In your research, you notice that the company still employs an elderly woman who's worked there for over 60 years, so you interview her and find out that her father spent his entire career with the company, too. This gem of a discovery inspired your big idea, a "Many Generations" campaign that the company used to recruit and train skilled technicians to meet growing demand.

Explain the touchpoints. Your touchpoints communicate, strengthen, and support the big idea of your project; they are the vehicles your viewer uses to experience the brand. After you introduce the big idea, talk about why you chose to use those touchpoints and describe their relevance. Lead with the most significant piece. For example, when my former student Stephen Sepulveda developed the presentation for his "Views and Brews" project, he focused first on a mobile app that he designed to serve as the primary interaction between the company (a new business idea combining craft beer and hiking) and the end user (a craft beer-drinking hiking enthusiast).

His app included real content— consistent messaging that supported his idea and relevant visuals to engage the viewer. His prototype made the viewing experience believable and clearly displayed his technical ability. He followed up by discussing the other pieces he had created to support the brand and how they also supported his big idea.

When you've described how the primary touchpoint connects to your big idea, you can move on to discuss how you selected the supporting pieces that reinforce that main touchpoint and the overall project idea. Why did you use illustration instead of photography?

Why do you think these two typefaces complement each other and speak to the audience? What elements of the website layout carried over to the magazine design? When you're asked how you did something, be prepared to talk about it and show your sketches, false starts, and prototypes. Point out any content in your pieces that you created, such as the illustrations you made, photos you shot, or anything else you produced to create, support, or enhance your idea. Every element and phase of your design process is another

component of how you solved the problem and how you demonstrated the skills, technical acuity, and craftsmanship to execute it. The more you prove what you can do in an interview to separate yourself from competing candidates, the more likely you are to stand out to a prospective employer.

My RBSD colleague and Kean graduate Jim Burns, who is now vice president of product design and development at EastPoint Sports, tells the story of how he received similar advice on one of his first interviews, wise words that have served him throughout his career. "You have a beautiful and well-structured portfolio," the interviewer told him. "But here's the thing to remember: when I look through your book, it has to be so good that I want to run down the hallway and show it to someone else. If I don't react that way, then you've missed the mark." She offered Jim a job in Grey's design "bullpen," but cautioned him against getting trapped and urged him to rethink his portfolio. "Show some sketches. Show your design-thinking," she said.

Jim didn't take the job, but he took her advice to heart, and today he encourages his students to tuck away a few folders of sketches and references on how they came to their prized and featured projects. "If someone asks you about how you solved the problem or came up with an idea, you can show them how you got to the solution," he says. "It's what I look for in the people I hire."

Share the credit. If you had a significant role in a collaborative project, give credit to the team and be specific about your contribution to bringing the project to fruition—maybe you designed the brand identity or coded the website using your HTML and CSS technology skills. A hiring agent may see the same project in more than one portfolio, so don't wait until you are asked to mention that you were part of a team. Talk about the value of the collaboration and how the contributors strengthened the overall project idea and its final execution. Working as part of a team is a valuable skill that employers look for in their employees; if you have any team experience, share it.

Prepare and practice. An art director wants to know the journey of how you came to the work, as much as or more than how the projects turned out. When you learn how to communicate or "tell your story," you can demonstrate what you can do and how you can do it. The only way to pull this off effectively is to be prepared with a script and practice until you can speak about it like you're having a conversation. Tell your story to every person who'll listen, and encourage your listeners to suggest ways to make it more believable and emotionally engaging. Present it to your pet and/or yourself in the mirror, because when you say something out loud, it may sound quite different than it does in your head. You don't need to be perfect, but you do need to practice long enough that talking about your work and your process becomes second nature; you're comfortable presenting the information and feel confident about your delivery.

When you're presenting, your objective is to make it seem like you are genuinely and naturally sharing your experiences, thoughts, and ideas.

Good luck.

HOW TO TELL A STORY ABOUT YOUR PROJECT

The formula outlined here will help you frame and manage how you tell the stories of your projects. Follow the steps from bottom to top, and add the answers to your project worksheet in Chapter 7.

1. Clearly state the "problem to be solved" in one or two sentences.

2. Communicate two to three key insights from your research that enhanced your understanding of the problem.

3. Connect your insights to the big idea and your solution to the problem. Try doing it in six words or less.

4. Identify the touchpoints and validate why you selected them for the project. Discuss how they support the big idea.

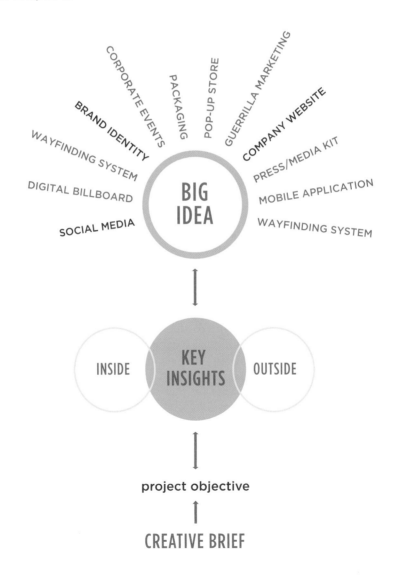

STAND OUT

A key factor in getting hired is the ability to connect to an interviewer by sharing a behind-the-scenes glimpse of your process, your personal journey, and your approach to design.

- Your objective during the presentation is to precisely and clearly tell the viewer about the problem and then show how you solved it.

- When you're telling a story about your work, start by giving your audience the context or background of the project so they will better understand how you used your design-thinking abilities and skills.

- When you're presenting, talk about key insights from your research that helped you understand and solve the problem, and discuss how your discoveries shaped your strategy and led you to the project's big idea.

- When you explain your touchpoints discuss how each piece reinforces the main touchpoint and your big idea.

- Practice your presentation until talking about your work and your process becomes second nature and you feel confident about your delivery.

- Working effectively as part of a team is a valuable skill; if you have any team experience, mention it in your presentation.

14. EMPLOY THE TOOLS FOR A DYNAMIC JOB SEARCH

Creating and maintaining your arsenal of resources.

As a designer seeking employment, your most valuable resource is a well-conceived portfolio that tells a compelling story about your capabilities and your brand—but it is by no means the only tool in your arsenal. Yes, most prospective employers will primarily focus on your book of work, but they also want to see how you handle more traditional touchpoints: your resume, cover letter, business card, and even social media. Remember, not everyone who reviews your portfolio will have design sensibilities; your overall presentation should include a range of components so you can tell your story to any audience in whatever language they're accustomed to and comfortable with—whether it's that of business or design.

Your portfolio is essentially your resume, but additional touchpoints can strengthen the bridge you're building between you and a prospective employer. Each offers another opportunity for your audience to learn about your brand through signature engagements (portfolio, website) and a series of small but meaningful interactions (business card, thank-you note) that will connect you to your viewer, whether it's a creative director in need of specialized skills or a lone HR manager tasked with weeding out all but the most desirable candidates. Frankly, when you're looking for a professional design job—whether it's full employment or contract work—you'll be expected to produce collateral materials that are more creative and engaging than people seeking other kinds of work. How you create and use even the most traditional touchpoints speaks volumes about the type of designer you are. So, just as you have worked hard to put together a portfolio that tells the story of your brand, you'll need to think seriously about how your touchpoints support the narrative you've created and "pass the test" (see Chapter 6).

Don't be afraid to rethink standard conventions and reinvent your approach, as long as you demonstrate your design think-ing and reinforce the personal brand you've established. Just don't wait until the last minute to create the materials you'll inevitably need. With all of the feelers you'll be sending out, you should be ready for a call at any time. A recruiter who sees your digital portfolio online might request a resume by email. Your friend's supervisor may want a few of your business cards to hand out in the design department. An interviewer may ask you to leave behind your list of references. You shouldn't have to panic, scramble, or risk handing over something that looks like it was just thrown together. Remember, design everything.

CREATE A COMPELLING AND CONCISE RESUME

The purpose of your resume is to provide a snapshot of relevant information about your education, work experience, skills and expertise, and other accomplishments that a prospective employer can use to qualify you for an interview. It shouldn't be a detailed rehashing of every task you've ever performed for every employer you've ever worked with, but rather a clear, focused summary of your relevant career highlights. You're not telling the whole story; you're giving a preview and inviting the reader to ask you for more details.

You're entering a highly saturated job market, and everyone is clamoring for the attention of prospective employers. A hiring manager receives dozens of applications for every open creative position—that adds up to a lot of time spent looking at resumes. And, like it or not, someone who has a pile of resumes to wade through tends to begin by looking for easy and obvious reasons to rule out the majority of them, so he or she can focus on just a few desirable candidates. Before you begin designing your resume, think about the following:

Does the information warrant inclusion?

Take into account the content of your portfolio and your other touchpoints. Is the award-winning project you featured in your portfolio mentioned in your resume? Does your resume reference a skill that isn't displayed in any of your portfolio projects? When your resume and portfolio complement each other, they work together to give your audience a full picture of who you are, without bombarding them with details. As a rule of thumb, your resume should be no longer than a single page if you graduated within the last five years and two pages if you've been in the workforce for more than five.

Do you get to the point?

A few hiring managers or art directors may want to spend quality time going over each resume they receive, but the reality is that most of them are busy. After an initial impression and before they plunge in to get the details, they'll glance over your document to identify the highlights—you should make it easy for them to do that. Find a way to visually feature what's important and minimize the time your audience spends pinpointing what you've done and where you've been.

CONTENT COUNTS

No matter what your resume looks like, prospective employers will use the content it contains to identify key information about your work, education, and sometimes personal history. Later in the chapter, I'll provide the "anatomy" of a resume and detail how to qualify and structure the content, but for now you'll be gathering relevant facts about your job experience, education, and achievements. As you collect and move information from one place to another, be sure to capture the correct spelling, record dates accurately, and grab more specifics than you'll actually need. It's easier to edit now than to have to go back and repeat the process.

Your readers will expect to review an inclusive but well-organized catalog of your activities, so make sure your content is straightforward and simply stated. Remember, as a designer, your portfolio of work is really a resume that shows what you can do, so you can use the traditional resume as a tool to communicate information that your book of work (or the "About Me" section of your website) doesn't: employer names, locations, dates, and other practical details.

Avoid buzzwords and repetition whenever possible. Terms like "people person," "detail-oriented," and "responsibilities include" will tend to bore your audience, who probably just read a dozen other resumes populated with the same platitudes. Buzzwords like "synergy" and flowery adjectives are more distracting than helpful. If you want to stand out, look for fresher words to describe your expertise. "Action verbs" not only communicate what you've done but also evoke an emotion, sense of purpose, or sense memory in the reader. Sentences and phrases that employ dynamic terms such as "generated," "initiated," and "managed" precisely describe your experience to your viewer.

SAYING YOU'RE CREATIVE IS NOT CREATIVE.

Keywords are key. The first person to review your resume might not be a person at all. Employers, especially larger ones, often use computer programs and algorithms to scan resume text for words they've deemed to be relevant to the job requirements. To boost your odds of making the initial cut, use the job description as your guide and weave in the employer's keywords wherever possible (as long as the terms accurately describe your abilities, of course).

Ditch the objective. Unless you can come up with something very unique and specific to a particular position, a stated "objective" tends to restate the obvious: you want to be considered for the job. Anything else can come across as fluff, and employers tend to skip over it, especially when they've already seen too many generic or self-focused pronouncements. Instead, consider leading with a carefully crafted, professional summary that highlights your most impressive and pertinent qualifications and justifies why you deserve further consideration. Your summary is also a good place to incorporate keywords that do not mesh easily into the other details of your resume.

Show, don't tell. You'll prove your worth by emphasizing results rather than responsibilities. Use hard numbers when you can. Can you mention how many client accounts you've handled? How much revenue did a project you worked on generate for the firm? Did you develop a concept that was adopted for use in additional materials? Boasts about being "effective," "hard working," and "proficient" are pointless unless you can back them up with specifics. Quantify your contributions—thinking in terms of metrics emphasizes your value and results-oriented outlook.

Ask for help. Work with a writer, editor, or someone in your school's writing center who can help you develop a strong resume, give you useful feedback, or serve as another set of eyes to avoid grammar mistakes and other errors that can be easily overlooked. Not all designers are strong writers (we have other wicked skills), but your resume and supporting documents should be as professional as the other tools in your arsenal.

Practice good design. The design of your resume should not outshine the projects in your portfolio; it should embrace them. A resume that is consistent with your portfolio and your other touchpoints reinforces your ability to build a cohesive identity that promotes your personal design style. The layout of your resume should have lots of white space to improve readability and create focus for the viewer. Accentuate what's important by using a bold typeface, an engaging color, or a prominent line to direct your viewer's eyes to something you want them to notice. Keep it simple and professional.

Proofread, proofread, and proofread again. Double-check your contact information. Triple-check your spelling, especially when it comes to the proper names of organizations, departments, people, and job titles. Are your dates of employment accurate? Does the information match what's on your website, your social media profiles, and other applicable touchpoints? Nothing ruins a good first impression like typos and misspellings. Even though you're applying for a job in design, where images and artistry reign supreme, employers still want employees who know their "its" from their "it's." So make it your business to know the difference yourself and proofread your resume more than once, run a spell-check, and have a friend or colleague read it over before you create the PDF and send it out.

THE ANATOMY OF A RESUME

Education. List (most recent first) the college(s) you attended, degree(s) earned, design specialty, and the year you completed each. Do not list your high school. Don't forget to mention honors, achievements, and notable awards.

Design skills. List your skills; start with the strongest and work your way down.

Technology skills. List by name any specific technology or software that you have mastered or are familiar with. Be honest; an interviewer may ask you to demonstrate your skill. If you combine your design and technology skills in a single section, mention your design skills first. Don't leave out any additional marketable qualities you may have, such as speaking a second language, or a non-design-related talent or skill.

Professional and/or work experience. List design jobs, freelance projects, and internships (most recent first). If you have little or no professional experience, list all your jobs together. Use en dashes between dates, not hyphens! Employers will look for continuity in your career and other activities over time. Gaps and overlaps are not necessarily perceived as negative, but you may be asked about them later—so be prepared with an answer.

Extracurricular. Include your design-related skills and other talents and passions that ignite your interest. Your volunteer work can provide an extra glimpse of your personality and enhance your brand identity. Never include references on your resume—keep a separate list handy. If the interviewer wants references, she'll ask.

" SHOW WHAT
YOU'RE MADE OF "

MARGARET

art director • **marggrz.com**

hello@marggrz.com

EDUCATION

Robert Busch School of Design at Kean University
BFA in Advertising Design, GPA 3.956
NJ Stars Scholarship 2011-2015
Summa Cum Laude
Graduated, Spring 2015

County College of Morris
AAS in Graphic Design, GPA 3.88
NJ Stars Scholarship 2011-2013
Dean's List 2011-2013
Graduated, Spring 2013

RECOGNITION

Presented "New Jersey Food Bank"
promotional campaign student poster project
at Kean University Research Day, 2015

Selected for "Who's Who in American Colleges," 2012

Established and oversaw the County College of
Morris' Graphic Design Club, 2011-12

SOFTWARE

• ILLUSTRATOR • INDESIGN • PHOTOSHOP • MUSE

• HTML • AFTER EFFECTS • MS OFFICE

...and there's always room to grow.

EMPLOYMENT

Art Director, Designer, and Illustrator
2015-present
"Stand Out: Design a Personal Brand. Build a
Killer Portfolio. Find a Great Design Job."

Second Melody Creative Studio
Graphic Designer, 2013-2014
Summer Internship, which transitioned into
employment. Assisted with design projects for
clients in pharmaceutical, academia, and start-ups.

Illustrator and Designer
2014-2015
Design Fundamentals book series includes, "Notes
on Type," "Notes on Visual Elements and Principles
of Composition," and "Notes on Color Theory."

Entrepreneur and Craftsperson
2010-present
Henna tattoo artist and crafts vendor

Chabad Early Learning Center Teacher Assistant
2009-2011

SKILLS

Branding	Painting
Illustration	Storytelling
Identity design	Typography
Branded content	Henna artist
Promotional design	Photography
Advertising concepts & design	Passionate traveler
Social media concept & design	Bilingual: English & Polish

DETERMINE YOUR RESUME TYPE

Printed. Traditional print resumes are preferred by most employers because they are familiar, straightforward, and easy to work with. You may want to create a more elaborate resume that showcases one skill in particular, like my former student Max Friedman did with his illustrations. It's not a bad idea, but if you decide to go this route, you should still create a more conventional, text-based version with keywords that a computer program can scan for. Illustrations and other artwork are not searchable. A resume looks professional when it has a simple, clean layout, and the relevant facts are easy to distinguish.

Infographic. Through illustrations and graphics, the infographic resume offers your viewer an instant snapshot of your skills and experience. As a plus, this format provides an immediate opportunity to see how you use design to communicate. An infographic resume will be held to the same design standards as the rest of your identity— your design should never overshadow the information you're presenting. Traditional and infographic resumes can be saved as Word or PDF documents to be emailed upon request or uploaded to a website.

Video. An increasing number of job seekers are using video resumes to give prospective employers a better feel for their personality, presence, and cultural fit with the organization. Thirty- or sixty-second videos can highlight your most compelling attributes and experience and offer a glimpse of how you might be an asset to the organization that is hiring. And you can post a video to your website, social media channels, and YouTube, and link to it through your resume and LinkedIn profile.

Producing a video that shows off your creativity provides an ideal opportunity to put your motion or video skills into action. If you're an illustrator, for example, you can create an animated short that focuses on how you would be the right person for the job.

Give your video resume the same amount of care and attention that you gave your portfolio stills in terms of composition, background, lighting, and picture quality. If you make an appearance in the video, be sure to dress professionally and do the recording in a quiet place. These kinds of details matter— many hiring managers use video resumes as an initial filter, so if

yours doesn't grab attention, get to the point, and convey professionalism, your viewer is likely to hit the stop button and move on.

Twesume. Condense your job-seeking objectives into 140 characters and use your Twitter account (#twesume) to spread the word that you're looking. Employers want to know what you can do, so make sure your twesume is short and delivers the necessary information only. A tweet can quickly spread the word that you are searching for a job, and a message that is descriptive ("Web designer seeks freelance work in Chelsea NY") or creative ("Newly launched animation pro rockets toward fulfilling relationship with a Houston-based ad agency") will entice readers to view your resume. Include a link to your website portfolio, your Twitter, or other social media pages.

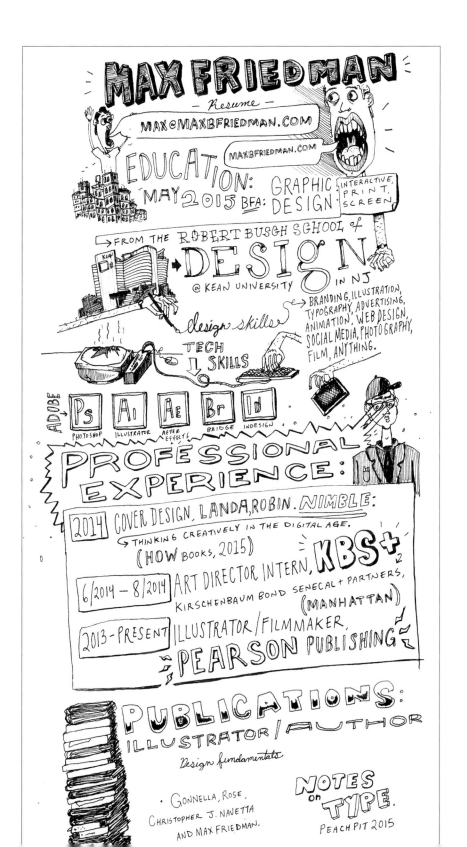

THE COVER LETTER

A thoughtful, well-composed cover letter may no longer be as important as it was back when most people placed their resumes in a stamped envelope and mailed them, but it can still be a deciding factor in whether a prospective employer decides to take the next step and review your resume. These days, instead of mailing a cover letter, candidates use the body of an email to provide that initial overview. In some cases, you may not need a cover letter at all (when you're uploading a resume directly to a job site, for example), but every job opening has different requirements, and you should be prepared.

Draft a basic cover letter you can use as a template, and tailor it to each job posting you respond to.

Personal information.

If you're mailing a traditional printed resume and cover letter, use the letterhead that you've designed that reflects your personal brand. If you're emailing a cover letter, be sure to display your contact information in a prominent, easy-to-identify location so the employer doesn't have to search for it if she wants to reach you.

Employer information.

In a traditional business letter, this is known as the "inside address," which is that of the recipient. In a job search, you won't always know exactly whom you're reaching out to. When you're sending an email, list the employer's contact info if you have it. If not, leave this section out.

Salutation or greeting.

If you know who your contact person is, it's important to use the appropriate salutation or greeting at the beginning of your cover letter or note. Many companies don't list a contact person when they post jobs, because they don't want to be directly contacted by overeager candidates. If you know the name of your contact person at the company, leave off the salutation and start with the opening paragraph of your letter (email) or use a general salutation such as "Dear hiring agent" or "To whom it may concern."

Body text.

The body of your cover letter tells the employer what position you are applying for, why the employer should call you in for an interview, and how you intend to follow up. These ideas should be conveyed in three (or no more than four) separate paragraphs of one to three sentences each.

Paragraph one.
Why are you writing? (This is a good place to mention where you saw the job posting or heard about the opening.)

Paragraph two/three.
What value can you offer the employer? (Be specific: mention a particular project that connects to the opening or professional experience that connects to the company.)

Final paragraph.
How do you plan to follow up? (Will you call in a couple of days? Send an email? Wait for someone to contact you?)

Signature closure.

Close your letter in a professional manner. If you plan to use an original or clever phrase, make sure it's polite and respectful. In a traditional printed letter, leave a space for your handwritten signature and add your full name directly below the space. If you're sending an email note, type your name under the signature line and include your contact information (email signature) beneath that.

Signature.

Sign your letters, in either mailing or emailing format, to personalize your cover letter.

TIPS FOR AN EMAILED COVER LETTER

Subject line. Get right to the point and be concise. When people look through their emails, they want to know what they're about to open before they click. If you're too wordy, your message will be cut off somewhere in the middle. If you're too clever, the employer may mistake your note for spam.

Graphics. An email note is not the place to show off your programming or design expertise. Emails overstuffed with embedded images, hyperlinks, and multiple attached files can be flagged by a company's security filter and never reach your recipient. Or, if your email takes too long to open, the recipient may lose patience and simply move on.

New Message x

To: Michael Ventura

Subject: Junior Art Director Position_Margaret Grzymkowski

Dear Mr. Ventura,

My colleague Rayneiro Carratala mentioned that you may be looking for a junior art director, and I am very interested in learning more about the position.

Rayneiro says the right candidate will have strong branding and illustrations skill—and a robust entrepreneurial spirit. As you can see from the attached resume, I recently illustrated and designed the interior layouts for *Stand Out: Design a Personal Brand. Build a Killer Portfolio. Find a Great Design Job*, a unique guidebook for job-seeking design students, and created a comprehensive brand identity for Mona's Henna and Donut Shop, a new venture that unites two seemingly unrelated business concepts.

I also understand you prefer someone who has professional design experience. In addition to the projects above, I created illustrations for the *Design Fundamentals* book series, including: *Notes on Type, Notes on Visual Elements and Principles of Composition*, and *Notes on Color Theory*. This work gave me more than just on-the-job training, it provided me with insights about the value of strong production skills and the importance of effective teamwork.

This link—marggrz.com—will take you to my online portfolio. After you've had a chance to review some samples of my work, I would welcome an opportunity to discuss your requirements and my qualifications for the open position. I will give you a call sometime next week to set up an interview. Please contact me if you have any questions or need more details about my capabilities.

Sincerely,

Margaret Grzymkowski

Margaret Gryzmkowski

MARGARET
art director · marggrz.com

Resume_MGrzymkowski.pdf (2577K)

Send 🗑

REFERENCES CAN HELP YOU STAND OUT

Naturally, your job references should be people who have great things to say about you and your creative brilliance and stellar work ethic. These recommendations can come from many different kinds of people in your life, but it's not a good idea to include just anyone who is fond of you and willing to help. If your performance was less than stellar or you did not do your best in a particular job, don't ask someone from that employer to refer you.

Before you identify your professional references, ask yourself the following questions:

Is this person discreet?
You should be able to trust your reference's judgment. You don't want to lose your current job, for example, because someone lets it slip that you're on the hunt. Unless your search is out in the open, be mindful of whether the individuals you approach are likely to blow your cover. The creative industry has a surprisingly active grapevine, so think before you ask.

Is this person familiar with you and your work?
Select people who understand the type of work you are doing and jobs you seek. It should be a person you have worked with in the past (professor, mentor, art director) and one who understands the type of person you are. The last thing you want are job references who tell the hiring manager they don't really know you that well or can't recall much about your work.

Have you asked this person to act as a reference for you?
I frequently get calls from recruiters who want my insights and recommendations about a current or former student. Sometimes I don't know the call is coming, because I was never asked to be a reference. If I had been asked, I would have given some advance thought to how I would answer questions and refreshed my memory of that candidate by reviewing his or her most recent work online. Before you add someone to your list, ask in advance for permission via a phone call or email, and when the time comes, give your reference notice that someone may call. Also find out how your reference prefers to be contacted.

Build your list of references.
Ask three to five people to serve as your job references, get their contact information, and create your list. Once they've agreed, you don't have to contact them again until you reach a point in the interviewing process when they might be contacted.

Give your references a heads-up as soon as you know they might be contacted. Let them know who will be reaching out to them and how, and give them a time frame, if you have one. You can also share relevant details about the position you're applying for, including the job title, company name, and main responsibilities. It may be helpful to provide your references with a link to the job posting.

Keep your job references informed about the outcomes. Whether you get the job or not, send a note thanking each reference for the time and effort expended on your behalf. A little goodwill goes a long way. You may need that person to vouch for you again, in either this job search or the one a few years down the road.

SOCIAL MEDIA

Many, if not most, employers use social media when they are filling a position. Some place more importance on it than others, but before you hand over access to your social media, you should be confident that the employer won't see something that will hurt your chances. And remember, they will not ask for your permission to do some online investigation. One of the first things I do when a new resume lands on my desk is Google that person. If I search your name, what would I discover? Google yourself and find out.

When you're looking for work, social media can be an effective personal branding tool, but only if you use it properly. Deliberate intent and forethought count, and can help you avoid unintended negative consequences such as jeopardizing your current job search, current job, or future career prospects.

Setting up your profile.

When you set up a professional online profile on any social media platform, use a picture of yourself—not the sun setting over the Grand Canyon or the hamster who owns your heart. I meet a lot of people and can't even begin to remember everyone's name. It doesn't help to find a baby picture or a puppy if I'm trying to connect to a face and recall who someone is. And please keep your private persona private. Sure, you had a great time at Burning Man, but there's no need for a current or future employers to see your tutu before they know anything else about you. Pay attention to your social media privacy settings, and use your Twitter account wisely.

Any profile or page you set up on social media should reflect the brand identity you've developed. Make your page(s) attractive to visitors. You might assume that designers naturally create compelling imagery across platforms, but many do a surprisingly mediocre job with their headshots and other photos. If you're serious about branding yourself using social media, use high-quality images.

Curate your content.

When you're job hunting, everything you publish online should support your career goals. Want to attract cutting-edge companies? Don't clutter your profile with designs from your more conservative clients. Instead, show a mix of work that appeals to a diverse audience. Looking to work at a legal or financial firm? Don't post risqué projects. As with a digital portfolio, put only your best and most recent work on social media platforms. Your retweets and shares should also be consistent with the image you want to project. Create a blog and become a subject matter expert on a design-related topic or anything at all.

Hello Margaret !

Stay up to date. Take the time to post and publicize recent projects you've completed, awards you've received, and your participation in industry-related events, conferences, and webinars. It's important to actively take part in the ongoing conversation on social media—especially if you want to work in technology.

Create a LinkedIn account. The most prominent and widely used professional networking site is LinkedIn, which was specifically developed for the world of business. It may not be as flashy as some of the other platforms, but many recruiters and human resources managers today use it to find talent.

Here are a few tips to get you noticed:

- Upload a flattering and good-quality headshot.
- Make your summary catchy and persuasive.
- Use relevant keywords to describe your abilities.
- Include links to your portfolio website, blog, and other relevant social media platforms.

Additionally, explore all of the available social media platforms, both up-and-coming and well-established networks, and create a presence on any that can help further your career goals or promote your professional brand. Once you're established, check back frequently to see if you've had any activity or contact from a potential employer. You wouldn't want someone to leave a note that you don't discover until weeks or months later, long after the position was filled by someone else. The best social media sites for your professional brand vary by the position you seek. If you're a graphic designer or photographer, for example, consider joining Instagram. Web designers can position themselves as industry experts by creating a YouTube channel and uploading tutorials and tips. You can also livestream via Periscope to give followers a behind-the-scenes look at your creative process.

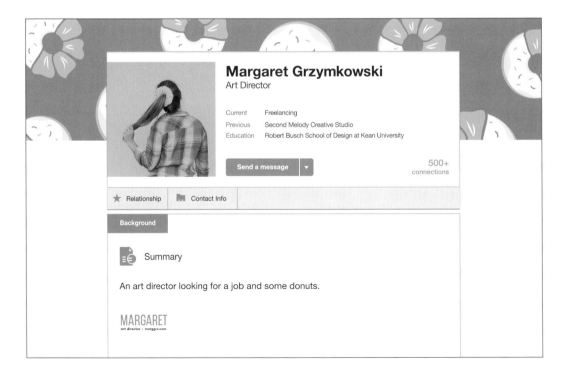

THE BUSINESS CARD

Every time you send something or leave one of your touchpoints behind, you give someone an opportunity to experience your brand. They may not connect you to your brand the first time they experience it, but after seeing your portfolio, reviewing your resume, reading your cover letter, and investigating your social media connections, they will accumulate enough interactions to recognize your brand and understand your potential value. A very important micro-interaction takes place when someone studies your business card.

I don't know whether it's my strong print background or if I just like to be wowed, but when I see a designer put a little more effort into the design and printing of his or her business card, that designer becomes more memorable to me. In Chapter 3, I shared with you the relevance of your business card content, but I want to stress that the business card is more than a tool for communicating your contact information. The type of printing you choose, for example, can enhance the impact of your card. Even when you are promoting yourself only through a website and a digital portfolio, the business card is the only tangible presentation touchpoint of your brand. You can't hand a URL link to someone you bump into at an event, but you can hand them a business card with a URL link on it. Your card doesn't have to include a lot of bells and whistles, but I recommend you design something into your card that causes the reader to pause and pose a question, "What is this paper stock?" or "What technique achieved that effect?" Always keep a small supply of business cards with you—you never know when someone will ask for one.

MARGARET'S BUSINESS CARDS
TELL 10 DIFFERENT STORIES
(See Chapter 5 for my other cards.)

THE THANK-YOU NOTE

In the foreword of this book, Gail Anderson urges you to send a handwritten thank-you note to interviewers. You don't have to include a lot of text or details; you're simply showing a prospective employer that you have manners, and you will make time to follow up.

If you're unable to handwrite and mail a note, be sure to send a note via email. Simply thank the interviewer for his or her time and, if you can, mention something you talked about in the interview. "I was especially interested in how your company approached the XYZ project,"

or "Here's that link to my Instagram account that I promised." The recipient will appreciate that you thought about them after the interview ended and that you made the effort, especially in today's fast-paced, me-first business environment.

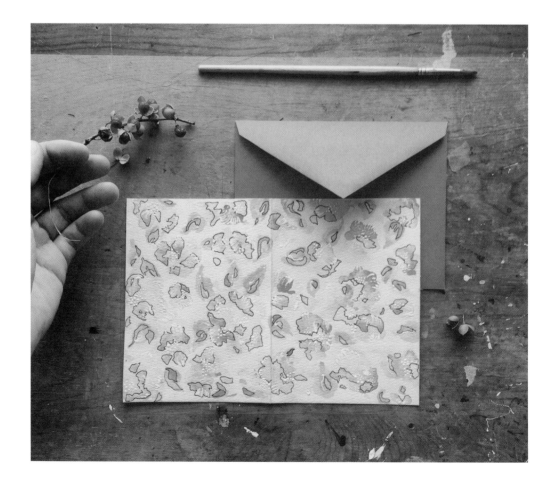

STAND OUT

To find a job, you need an arsenal of tools in addition to your portfolio, such as a resume, cover letter, business card, and a social media presence.

- Your resume shouldn't tell the whole story; it offers a preview and invites the reader to ask for more details.

- A resume looks professional when it has a simple, clean layout and the relevant facts are easy to distinguish.

- Thirty- or sixty-second video resumes can highlight your most compelling attributes and experiences and offer a glimpse of how you might be an asset.

- Select references of people you've worked with in the past, who understand the type of person you are professionally.

- Explore all of the available social media platforms and create a presence on any that can help further your career goals or promote your professional brand.

- Send a thank-you note. Recipients will appreciate that you thought of them and made an effort to follow up, especially in today's fast-paced business environment.

15. LAUNCH YOUR JOB SEARCH

Understanding trends, seeking opportunities, and creating a plan to find a job.

The design industry is a big field—it's big business. When you're launching a design career, especially in the beginning, the challenge of finding your niche in such a broad, diverse, and continuously evolving profession can be intimidating, even for the most talented and passionate designers. Rather than being overwhelmed at the endless possibilities and, out of fear and desperation, settling for the first job you're offered (whether it's one you want or not), you can prepare yourself by understanding the terrain in front of you and then focusing on where you really want to go: what industry do you want to work in? What type and size of company do you want to work for? In what environment are you most likely to thrive, professionally and financially? You touched on this as you developed your creative brief in Chapter 4; now it's time to reference those worksheets and hone in on some particulars.

JOB SEARCH STRATEGIES

Be mindful of trends. Being mindful of what is going on around you keeps you in "the now," relevant in your profession, ahead of the competition. If you want to find success as a design professional, you have to pay attention to trends—what's current, what's coming, and what's obsolete—because it will have a tremendous impact on the choices you make for your future. A specialty that was hot years ago, such as typesetting (that is, composing type for print) is obsolete today because everyone with a computer can now set type. (I do not agree that everyone with a computer knows how to "set" type properly, but you get my point.)

A technique or technology that didn't exist six months ago may be in huge demand next week.

You can't just follow industry trends; you have to look at what's happening in the bigger world around you. When you go shopping, what are people buying? What do you observe when you hang out with friends? What has gone viral in social media circles?

When I first started out, commercial printers called the shots; you had to get in line behind whoever placed the biggest orders and was willing to pay the most. In the digital age, many businesses don't even bother printing a company

brochure; they set up a website, establish a presence on social media, and print their own literature on demand. As this trend was taking hold, commercial printers were forced to innovate and negotiate to find and retain customers. Those that didn't keep up went out of business.

Trends directly affect the job that you're going after. Every project you develop for your portfolio must be relevant to the industry and company where you're seeking employment, as well as the trends that they are experiencing.

Moving images (video and motion), for example, are hot right now. To demonstrate that

you understand what's current, your portfolio should include video in your projects, especially if you are going into an industry that uses this medium as a core communication touchpoint, such as advertising. If you don't know how to create video, it's up to you to get up to speed; take a course or use online tools (tv.Adobe.com, Lynda.com, Peachpit.com), and learn how to use Adobe After Effects or Apple Final Cut Pro. If a new version of a Creative Cloud program is released, update the software on your computer, learn the new features, and add it to your arsenal of offerings.

Art directors, who spent their professional careers identifying and following trends, want to see that you're keeping up, if not ahead of the curve. A company with an eye toward the next big thing wants to know that you can help them make it happen.

In our profession there's no avoiding trends. I've seen designers get comfortable with a particular style or skill or version of software and resist the inevitable changing landscape of their future. Their careers plateau, and they are soon replaced by people who can embrace the future, whatever it may be. Trends create new jobs, and if you can identify what they

low-cal
+
local

are before the rest of the crowd does, you will have time to learn what you need to know to get there. Our world is changing constantly. You have to keep up.

Leverage your relationships. Networking and "word of mouth" are two very effective strategies you can use to identify job prospects. When you put the word out that you're looking for a job, all of your relationships have the potential to lead you to an employer.

When I was in private practice, for example, I attended a fundraising event at my former high school where I bumped into a graduate from another class. We hadn't been there at the same time, but I knew her from other events we had attended together. When I mentioned to her that I was in need of a copywriter, she said, "My niece is a freelance writer!" Her recommendation did the trick; I called her niece, interviewed her, hired her, and we still work together today. (Her name is Jennifer Bohanan [wordsmatter.com], and she is the development editor for *Stand Out*. Not only is she a great writer and collaborator, she has become a good friend, too.) Aunt Judy's networking skills helped us bypass the cumbersome traditional search process, saving us time, money, and effort.

Busy art directors, employers, and even hiring managers appreciate a streamlined process to hiring a new employee.

When you're looking for work, put the word out with everyone you know—the guy in the deli where you buy coffee in the morning, your barber, and the couple whose kids you used to babysit. People who care about you, and those who know the quality of your work, are usually happy to help and will sell your abilities better than any cold call or online application can. And they can do some of the investigative legwork for you. In the end, you never know which of your connections will pay off with a referral for a job. You just have to make sure that everyone knows you're on the market. Include on your list:

Past internships and employers. If you've had an internship, the people you worked with know what your capabilities are, but even if you've been employed in a non-design job, you should use any connections you've forged. You don't have to be overbearing; make some calls and let them

know you're looking. If they don't have a position available, ask them for a few people who may be potential leads.

Professors, mentors, and alumni. A shared educational experience is a valuable connection, even if you don't have a close relationship with a particular individual. People like to promote the value of their school, and they feel a bond with others who also attended. At the RBSD, we have a job board where alums post opportunities, and many of our current and past students find jobs through this network.

Networking contacts. Connect to other professionals at business events and functions designed to bring people together. Everyone started somewhere, and most people are pleased to give a student or young designer a career boost if they can. Tap into your social media channels and work your LinkedIn contacts. Eventually, someone will need help, even if it is only for a temporary freelance job.

Friends and family. Call your Uncle Jerry, your Cousin Nicole, and even that Facebook friend who works as a receptionist at an ad agency. Tell them you're available, and ask them to keep their ears open. Many designers have told me they don't like to ask for a job with someone "too close to home" because they feel like it's a handout. My response is that all you are asking for is an introduction. You still need to prove your worth to an employer.

Treat every conversation like a presentation. Don't miss an opportunity to promote your personal brand. Whether you're at a wedding, the gym, or the beach, treat everyone you interact with like they'll be reporting back to a prospective employer. Be positive, courteous, and direct, but not pushy. Think about your personal brand and whether you're doing justice to that best version of you. When you make a strong positive impression, people remember, and if a job opportunity comes up, they may think of you. If they have come to trust your brand, they'll tell you about the job so you can go after it, or put in a good word for you.

HOW TO SEARCH FOR WORK

One of the first places I interviewed after graduating from college was at a mechanical parts company that was located in Penn Station, in the heart of Manhattan. The job involved designing brochures and developing renderings for the company's catalog. I was offered the position at an annual salary of $30,000 (equivalent to about $64,000 today, according to dollartimes.com).

When I got the offer, I broke out in a sweat. All I could think about was the refrigerator in their reception area and the kind of projects they wanted me to do. I declined the offer. A month later, I accepted a position for $15,000 in a studio where I would be doing the kind of design work I loved. I have never regretted that decision.

Before you start your search, it's a good idea to spend time thinking about what your "ideal" professional life looks like, from the type of work you want, to the space you'd like to occupy, to the culture of the business where you work, and the salary you need to earn. What characteristics are absolutely required and which (like a refrigerator in the reception area) are deal-breakers?

Having a clear vision of what you want will help you narrow down the places you'll go to look for it.

What type of work do you want to do?

Do you have a specialty that you're passionate about? Do you have a particular skill that you'd like to utilize? Do you have a dream job like Connor Paglia (from Chapter 12) that sent him straight to Major League Baseball looking for a position?

If you are reading this book, you probably already have a general sense of the type of job you're looking for. (If you don't know, I recommend doing some research or contacting a creative recruiter to provide some insights on what is available to you based on your area of expertise, skill level, and years of experience.) Ideally, you will be able to identify a job that provides the opportunity to do what you love most, because when you spend so many hours working, you don't want to end up feeling like you should be doing something else.

Your design job should not be a burden; it should feel like you are doing what you should be doing.

In what company cultures are you likely to flourish?

Do you prefer a tranquil, quiet environment or a bustling, informal atmosphere? Do you want perks—like Friday afternoon cocktail hour with your colleagues and bonuses tied to performance—or would you prefer set hours and a predictable paycheck? Do you want to work in a big city or small town? My lovely design assistant, Margaret, knows her perfect type of company; she wants to design for clients during the day and give henna tattoos to colleagues after hours. When you spend so much time in one place, it should come to feel like a home where you are safe and comfortable, surrounded by people who you love or just really respect and like.

Where will you find your opportunities to grow?

Are you looking to settle into an agency where you can work your way up to positions of greater responsibility and authority, or are you building credentials and expertise to bring to your next job or employer? You should never stop looking for your next break. You may not be in active pursuit of something new, but keep your eyes open, especially if you are interested in moving to another group within an organization or seeking a position in another firm. An unexpected opportunity may present itself— you may choose not to go after it, but you should try to be aware when one exists.

As part of your personal brand assessment, you outlined a five-year plan for achieving your vision of your career. Your mission statement can provide the channels you need for growth, such as improving on and learning new skills, getting an advanced degree, joining design industry organizations, or volunteering for an organization in an industry in which you want to work. No matter what you do, keep moving yourself and your career forward. Don't become obsolete.

Is diversity important to you?

Do you want to play a variety of roles in the workplace or have a limited focus? Would you prefer to work with a variety of customers and companies or build relationships with one or two big accounts? Which is more appealing— working on different types of projects or developing an expertise in one or two skill areas?

A recruiter once told me that he hires designers who don't just have the personality and skills to work on the accounts he or she was hired for but also for other accounts in a variety of roles so that when there is an opportunity for advancement or need, the designer can be reassigned. This is a particularly good option for young designers who can explore alternate roles or project types before settling into a specialized area of expertise.

How important is it to work somewhere with a social conscience?

Do you care if your employer does business with ethically ambiguous clients? Would you like to work for a firm that encourages its employees to take on pro bono projects? This is extremely important to some designers, including my former student Maria Finelli (from Chapter 12) whose goal to "work for companies with underlying social responsibilities" was included in her mission statement. Some of the projects in Maria's portfolio were not-for-profit companies; she used those pieces to communicate that social responsibility was important to her. As an ethical person, she wants to make sure any company she aligns with shares similar values.

Always avoid working for companies and clients that have questionable business practices because associating your reputation with theirs can compromise your personal brand. In Chapter 2, I shared a lesson my dad taught me: if you earn people's trust, you will always make it back to the top, regardless of what anyone takes away from you. (In this case, it could be your job.) There are plenty of ethical people in the design world, and some future employer will recognize your decision and possibly move you into a leadership role because of your responsible business practices.

Are you looking for a good mentor?

Would you like a strong guiding hand to show you the ropes, or do you prefer autonomy and solving problems on the fly? Do you want to move through your career journey with someone you trust, someone who's got your back?

There are many reasons to accept a job offer, but the one I promote most often to young designers is to find a good art director who will teach and inspire you. If you're lucky, that person will become a mentor who cares about your career and introduces you to opportunities simply because they want you to succeed. A mentor can serve as a trusted sounding board and connect you to people you should know. A strong connection with a mentor gives you someone to confide in long after the job is over.

Think about contacting an art director you admire and asking if he or she will look at your book. You'll get some feedback for improving your projects, and you'll put yourself on someone's radar for a potential job.

What are your salary requirements?

Are you paying rent or living at home? Are you supporting a family or pursuing a bohemian lifestyle? Certain industries, such as financial services and health care, tend to pay higher salaries, so if you need to make more money, they might be the types of companies you need to look at. If your needs outside the workplace are not taken care of—a safe neighborhood to live in, access to affordable and good-quality child care, or simply putting food on the table—you probably won't have the focus needed for your work.

At one point in my career, my compensation was contingent on my bringing in clients. So there were some months that I had only enough money to pay my mortgage and feed my dogs and others when I would "spontaneously" stop by my parents' house around dinnertime. (They eventually caught on but welcomed it as quality time spent with their hardworking daughter.)

When you're contemplating salary possibilities, The Creative Group's (TCG) *Salary Guide for Creative and Marketing Professionals* has some valuable insights such as current and future hiring trends and hot jobs. In addition, TCG provides online resources, such as a salary calculator to help you understand competitive salaries in different geographical locations.

What hours do you need to work?

Do you need or want a full- or part-time job? Are you more creative in the morning? Do you require a flexible schedule or set, predictable hours? Only you know what the obligations of your life require, and if you are a night owl who will never be able to make an 8:30 a.m. staff meeting on time or you need to pick up your children by 6 p.m., be honest with yourself (and a prospective employer) right from the start. You may be able to crawl out of bed earlier or find someone to pick up your kids on occasion, but understanding your long-term time commitment to a job is very important.

You may not get everything you're looking for (or even know whether the company offers it until you're actually interviewing), but you'll be better prepared to make smart decisions about what is and isn't acceptable when the time comes. It's all about understanding an employer's expectation and realizing your potential to create a win-win situation for both of you.

CATEGORIES OF DESIGN JOBS

Design jobs tend to fall into three distinct groups, although some companies may offer different or hybrid situations. Each has its benefits, depending on what you want and need.

SALARIED PROFESSIONAL		
OVERVIEW	BENEFITS	BEFORE YOU ACCEPT
A career as a salaried professional can provide you with competitive pay and the other benefits of full-time employment. When you work for a company, you become part of a team, and your main focus will be designing, rather than the behind-the-scenes work of running a business.	**Job security** As long as the company is solvent, you'll have a predictable income stream, regular pay increases and bonuses, and opportunities to move up. **Benefits** Health insurance, retirement plan, 401K, and paid vacation/sick days. **Social opportunities** Working with a group of people has its benefits (laughs, play, collaboration), and shared goals create a great environment for people to meet and network with others. You must be mindful of office politics and personality clashes, however.	**1.** What is the salary, and is there room for negotiation? Do you provide regular pay raises and/or a bonus program? **2.** What are the options for health insurance, when am I eligible to participate, and do you pay all or part of the premium? **3.** Does your firm have a retirement plan, and if so, are my contributions matched and up to what percent? **4.** Does the company offer reimbursements for education and training? Comp time? **5.** How much vacation time do I get, and am I required to take it at a certain time(s) of the year? **6.** How much sick leave do I get? Personal leave? Paid holidays?

A full-time job can mean full-time access to an art director who is willing to mentor you.

It's not trial-by-fire, but it is a good way to demonstrate that you're a hot prospect for full-time employment.

CONTRACT-TO-HIRE		
OVERVIEW	BENEFITS	BEFORE YOU ACCEPT
Almost like a trial period for you and the employer, an internship or freelance job can evolve into a perma-nent position when both you and the employer see value in the relationship. Contract-to-hire jobs provide the employer an opportunity to test your skills and per-sonality to see if they meet the needs of the organiza-tion and if you fit into the company's culture.	**"Testing the waters"** You can use contract-to-hire employment to determine whether you've found the company and people you want to work with. **"Foot in the door"** This kind of position may not be ideal in the long-term, but it could help you break into a company or industry where you want to work. (Make sure you understand the scope of the employer's intentions, because some contract-to-hire jobs don't lead to full-time positions.)	**1.** What is the purpose of the assignment? (Am I filling in for an employee on maternity leave? Working on a large project for a temporary period? Exploring the potential to be a full-time worker after a trial period?) **2.** How long is the project expected to last? **3.** How will I be paid for the work—by the hour or the contract period? **4.** How will I be assessed at the end of my contract?

You and your employer can check each other out before you make a long-term commitment.

FREELANCE		
OVERVIEW	BENEFITS	BEFORE YOU ACCEPT

OVERVIEW	BENEFITS	BEFORE YOU ACCEPT
As a freelancer, you'll focus on long- or short-term projects or fill in for someone who is on leave from a full-time team. In most cases, the work has an end date, after which you'll need to go out and find something else. Understanding the particulars of the assignment in advance can help you determine whether a freelance opportunity is right for you. Some companies (clients) hire freelancers for their design projects, but as an "independent contractor," be aware that you may need the skills of a business owner (i.e., negotiating fees, writing contracts, invoicing, etc.), in addition to those of a designer. If you want to freelance for a living, there are plenty of good books on the market that can tell you how to set up and manage your own design company or freelance business.	**Flexible hours** Many designers freelance (onsite at a company or from the comfort of their own studios or homes) because the hours are flexible and the potential to make more money for taking on additional work may be greater than with a salaried position. **Diversity of assignments** Freelancing is great for building a varied portfolio and trying out different work environments. **Multiple clients** You can work for more than one client at a time (if the workload permits) and choose which clients you want to work with. (Caution: Never over-extend your commitments if you want to build a reputation for being reliable.) **Additional income** Some fully employed designers take on outside projects, but I recommend getting your employer's approval first and then living up to any assurances that freelancing will not interfere with your full-time gig or compete with existing clients.	**1.** What type of client will I be working for, and what project(s) will I be working on? **2.** How long is the project expected to last? How many hours per day or week are required? **3.** Does this project have the potential to extend or lead to other assignments? **4.** How will I be paid—by the hour or the project?

A freelance project can lead to a full-time job or inspire you to start your own business.

BEFORE THE INTERVIEW ...

Research the company. **Learn** what you can about the company culture, clients, history, and people you will be interviewing with.

Prepare questions. From your research, develop three to five thoughtful, relevant questions to ask at the end of the interview, or when the opportunity arises.

Charge your tablet. **Make sure** your battery is full before you leave home. Test your presentation and make any necessary changes before you're onsite.

Take inventory. In addition to your portfolio, don't forget to pack the essentials: your resume, business cards, a notepad, and a pen. Bring only what you need, and minimize the personal items you bring with you.

Dress appropriately. **Choose** interview clothes according to the culture of the hiring company. Make sure they are clean and neatly pressed, your shoes are polished, and your jewelry is suitable.

Groom yourself. **Get** a haircut and a manicure. Trim your eyebrows and facial hair. Brush your teeth or carry a mint.

Plan your travel. **Identify** how you will get to the interview, taking into consideration time for transportation delays and a security screening.

Bring contact information. **Be sure** you have the phone number of the person who arranged your interview and that of the person you are interviewing with, in case there is a problem at the security desk or if you get delayed.

Arrive early. **Plan** to be there 10 to 15 minutes before the scheduled interview and leave yourself a 30-second check of yourself in a bathroom mirror or on the elevator before you're called in.

Turn off your cell phone. **Shut it down** completely; vibrate is not acceptable. If you forget and it rings during the meeting, apologize and do not answer it.

Be confident, because you are awesome.

WHERE TO LOOK FOR WORK

CareerBuilder's YouTube video, "Twenty Years, One Solution," states that 20 years ago (around 1995), candidates used two sources—phone and newspaper—to look for a job. Today a candidate uses an average of 16 sources across career websites, social media, and talent management firms. That's a lot of places to look for work, but if you have a pretty good idea of what you want to do, the skills you may need to get there, and the kind of place where you want to exercise those skills, you can narrow the scope to target worthwhile opportunities.

My overall advice is to network in places that have the "lowest hanging fruit," such as the people with whom you already have relationships.

In addition to this list, you can find design industry resources at the end of this book and on the standoutportfolio.com website.

Friends and family. Your friends and family can be your eyes and ears when it comes to identifying job openings in places where you want to work or in places you have yet to discover. Let them know you're looking, ask them to make inquiries for you, find out whether they have a relationship with anyone who might be able to help you out, and see whether they're willing to make introductions for you. (You still need to sell yourself and prove you are the right person for the job.)

Professors, mentors, alumni. You've just spent the last few years building relationships with the people associated with your school. Use them! People who share a common educational experience will feel a bond with you, and your professors want you to succeed.

Check to see if your university or college has a job site. If you were a good student in the classroom, a professor or industry contact you met in school will be willing to recommend you for a job opportunity if one comes along, or give you a glowing review when asked by a potential employer.

Creative recruiters. A recruiter has relationships with companies that hire designers for a variety of positions—part-time, full-time, contract-to-hire, and freelance. These people can help connect you to design-specific job opportunities or break you into an industry that you haven't been able to penetrate. I encourage less-experienced designers to work with a number of creative recruiters at the same time because each will expose you to different types of companies and the positions available. This approach will give you experience and help you to define the types of jobs and companies you want (or don't want) to work for. Creative recruiters offer hiring resources, such as career counseling, portfolio reviews, and skills-based and interview training.

Creative recruiting is also done through online sites such as Behance and Coroflot where recruiters contact you directly after reviewing your work. Some recruiters who are looking to build long-term relationships with their designers offer benefits such as health insurance, tuition reimbursement, and holiday pay. The company seeking employees typically pays recruiters, so consider them as an extension of the company that employs you.

Design industry clubs and professional membership associations. Most membership organizations have job boards that you can search. (Check back regularly.) And don't just haunt the websites—find out when and where they're hosting their next event. Most clubs encourage student participation (future full-paying members!) and will provide discounts or let you attend for free. Once you're there, you can network and start to build relationships with others in your industry, who likely did the same thing when they were students.

Social media channels. Identify where you're interested in working, get on the company's social media feeds, and try to find out as much as you can about the company and the projects it works on. Show a genuine interest in the people who work there and try to make a connection with like-minded people who can share what they know from the design industry grapevine about job openings or changes happening at a specific company.

Former student Lilliana Vazquez told me that after she interviewed at one company, she got involved with the social media channels of the people she met and "worked it" until she got the job. Also, get on the Twitter feeds of designers you admire or who do what you'd like to do. Jobs posted on Twitter or LinkedIn are filled quickly—try to be the first one there.

A specific company or firm. Many companies have job openings listed on their website, along with instructions on how to apply. If you have a particular company in mind, you can make a direct approach; find a contact in the human resources (HR) department or identify who the art director is and send that person a note or promotional piece. Do you know anyone who works at the company? Ask him or her to connect you to someone who makes hiring decisions.

Freelancer sites. The Internet is home to a huge variety of sites that post opportunities for people looking for freelance work. I strongly advise you to use only trusted sources, to which you have been referred, and not any that seem too good to be true. There are plenty of players out there looking to take advantage of someone.

Before you commit to working on a project, make sure you understand who you will be working for, the scope of the work, who owns the rights of work not used, and the payment terms.

General recruiting sites. It probably won't hurt to post your resume on massive general recruiting sites, such as monster.com or hire.com, but it's unlikely to land you the design-specific job you're looking for. Those sites rely on algorithms and keywords, and that kind of automation rules out applicants before they ever get in front of a real person with the expertise and experience to make a fair judgment. Some companies post job opportunities because they are required to by their HR department, but many already have a candidate in mind to fill the role.

Career fairs. Unless a career fair specifically targets designers, you'll probably find few opportunities at this kind of event. If you attend one, bring resumes, business cards, and your portfolio, and network to see where it could lead.

STRATEGIES FOR THE INTERVIEW

Interviewing is a lot like dating; you show off your best self at the same time you're evaluating what the person sitting across from you has to offer. You're looking to make a connection that benefits both parties—in this case, one that leads to a good design job. It's essential to present a confident, professional, and authentic version of yourself so both you and your prospective employer can focus on what's most important—your brand, your work, and your potential value to each other.

Every encounter with a potential employer is an opportunity to develop, exercise, and polish your interviewing skills. Each time you interview, you'll feel more comfortable, and you'll get better at it. Before you're shaking hands with an inquisitive hiring manager, art director, or business owner, however, you need to plan your approach.

Be prepared. In advance of your scheduled interview, review the results of your personal assessment and your creative brief. Recall your brand promise and your elevator pitch. Think about how you will succinctly summarize your value, talk about your most positive attributes, and react if something unexpected occurs.

Plan your travel—have you thought about how you're getting there and how much time you'll need? You may have a great story to tell and excellent, relevant examples, but if you show up late, harried, disorganized, and making excuses, it's a first impression that will be hard to overcome.

Before you leave home on interview day, determine what you need, and take inventory to make sure it's packed and ready to go. Stow any items you're planning to present in a place

that's easy to reach. Is your tablet charged? Do you have a pen and blank paper for taking notes? Did you pack enough resumes and business cards?

Dress the part. The clothes you wear to an interview act as an important touchpoint for your brand. The way you dress should visually communicate your personal style, and it should be consistent with your brand.

Keep in mind that every company has a different culture. Your style of dress can have a different impact from industry to industry, company to company, and person to person. When you're planning what to wear, take time to learn what you can about the company culture before the interview to find out what might be considered an acceptable form of attire.

I recommend assembling two to three outfits in advance so you'll have what you need when you get called back for subsequent interviews.

Be professional. Presenting yourself as a professional is just as important as your book of work. In the limited time that an interview provides to demonstrate your professionalism, keep these basic rules in mind:

Be punctual. When you're planning your travel, allow plenty of time for "roadblocks" outside of your control, such as bad weather, traffic, or mass transportation delays.

Take criticism gracefully. It's rarely personal, so don't react in a way that's angry or defensive. You can discuss the logic behind your choices, but if your interviewer disagrees, acknowledge it and move on. You'll have plenty of time later to consider whether their suggestions were valid, and the feedback might be helpful.

Be mindful of your demeanor, tone of voice, and body language. An interview is not the place to be too informal and overly familiar. Save personal conversations for your friends and family.

Prepare to be questioned. You're likely to spend a large part of the interview answering questions—about yourself, your experience, your achievements,

and your goals. When you're giving an answer, be thoughtful and genuine, and keep in mind that your objective is to make connections between you, the person you are interviewing with, and the position you're interviewing for. You can achieve this objective by thinking in advance about what you might be asked and how you might respond.

Your answers should not be scripted or memorized word-for-word, but whatever you say should indicate that you've done some reflection on this very matter and have some thoughts to share. The Internet can offer an infinite number of resources for the most commonly asked interview questions. Research what's out there and practice your responses many times before you're face-to-face in an interview.

Expect the unexpected. In the design field, you're likely to encounter interviewers who don't follow a typical question-and-answer format. When you find yourself being steered in an

unpredictable direction, simply maintaining your composure is the most effective response. Thinking in advance about possible scenarios (some more likely than others) and how you intend to react can help you avoid being thrown off balance.

Prepare your own questions. An interview is a two-way street, and interviewers typically provide an opportunity for you to ask questions: "Do you have any questions for me?" is almost inevitable at some point during most interviews, and you should be prepared to answer, "Yes," and follow up with a short list of thoughtful and questions.

When you're researching the company, develop a list of topics and try to frame them as open-ended questions that can't be answered with a simple yes or no. ("What's the best part of working on the Hershey account?" "How did you start your design career?") Listen carefully to the answers, and then share a thought or two that demonstrates you were listening.

Sometimes, in the course of an interview, you'll find that your interviewer has answered all of your questions. This is why it's a good idea to listen actively to everything they tell you throughout the meeting and quickly jot down notes if a question comes up while they're speaking. "You mentioned that your company is changing its client base to service more financial services companies—could you tell me a little more about how it will impact your department?" Or, "I noticed that you have a 3-D printer in the production area—what's the most complicated piece you had to create?"

When an employer invites you to ask questions, they appreciate hearing something that demonstrates you've been paying attention.

In the end, you can never truly predict what is important to your interviewer, and he or she may not be at liberty to discuss some of their key sensitivities. (Perhaps the last person the interviewer hired couldn't hit deadlines, the interviewer's workload just doubled because her supervisor is on leave, or the firm is about to take on a large and challenging new client.) Your best response in any scenario is to be authentic, attentive, and respectful to the people around you.

Make an impact after the interview. You can usually sense whether or not you aced an interview by how you feel after it's over, but whether you're elated or dejected, you can increase your chances of making a positive and lasting impression in three easy steps:

Leave something behind. A visual reminder of your work—such as printed samples of your portfolio or a self-promotion package—continues to tell your story after you've left the interview. Make sure it is appropriate for the audience and reflects your brand. Personalize it so it seems like you made it just for them.

Send a thank-you note. After the interview, send a thank-you note immediately to every individual you met with. In each note, thank each person for his or her time and briefly make any additional points you think would help support your candidacy. An email note is acceptable, but Gail Anderson, who wrote this book's foreword, says to send a handwritten one, and I agree!

Follow up. After the meeting is over, deliver on any promises you made (additional samples, references, etc.), and don't be afraid to make inquiries about the status of the job. Be persistent but courteous. Someone may appreciate your tenacity and decide to give you the job based on that.

“ YOUR BEST RESPONSE IN ANY SCENERIO IS TO BE AUTHENTIC, ATTENTIVE, AND RESPECTFUL TO THE PEOPLE AROUND YOU. ”

PRACTICE, PRACTICE, PRACTICE

Just as an actor runs lines before a performance, you'll need to practice your answers before you interview. Practicing the techniques listed here will help build your confidence under pressure. Your objective is to make it seem like you are genuinely and naturally sharing your experiences, thoughts, and ideas.

Use flash cards. Write your answers to the interview questions on the flip side of an index card. Shuffle them, and practice answering a different order.

Record yourself. Prop up your cell phone and answer the questions you've prepared. Pay attention to how you articulate your responses and manage your body language. You may not like what you see when you play it back, but you'll have time to correct those flaws before you get in front of a live person.

Rehearse with another person. Ask a trusted friend or family member to ask you some of the questions you've prepared. Use their feedback to make your answers more on point, concise, and flow more smoothly.

Conduct a mock interview. A mock interview is the same as a real interview, but without the promise of a job at the other end. Ask a professional, such as an instructor, mentor, art director from a previous job, or someone you met at an industry-sponsored event, to run through their favorite interview questions with you. (The One Club and the ADC are two examples of organizations that offer portfolio review sessions.) Prepare as you would for an interview, set a specific time frame, record yourself (if applicable), and ask for constructive feedback. The objective is to practice how to interview, gain interviewing experience, and learn how to improve your performance.

Now that you have done your homework and know where you would like to find a design job, it is time to develop your job plan. Writing a job plan is an important step, even if you are not ready to implement it right now, because after you finalize your portfolio and presentation, you will be equipped with a plan of action to guide you in your search.

List your personal contacts. Tap into resources of the people you already associate with and organizations you are already involved in.

Select places you want to work. List companies you apply to as well as creative recruiters who can help you find the jobs you want.

Create a social media plan. Identify the channels and connect with people who work at the companies where you want to work.

my job search plan

1. PERSONAL CONTACTS

The job you seek could be closer than you imagine. Tap into your existing relationships and the organizations you are already involved in.

PREVIOUS JOBS:
- ☑ Internships
- ☑ Part-time
- ☐ Full-time
- ☐ Freelance

COLLEGE:
- ☑ Professors
- ☑ Mentors
- ☐ Guest speakers
- ☐ College events
- ☑ Colleagues
- ☐ Career center
- ☑ Alumni
- ☑ Job board

PERSONAL NETWORK:
- ☑ Industry contacts
- ☑ Parents (and grandparents)
- ☑ Parents' friends and business associates
- ☐ Siblings
- ☐ Siblings' friends and business associates
- ☐ Extended family members (aunts, uncles, cousins)

MY PERSONAL CONTACTS

Previous jobs:

Second Melody Internship (call Mike!)

Hibernia Inn Customers
- Sebastian Castillo
- Corey Dawson
- Evan Higgins
- "Kat" Collis

College:
- RBSD job board
- Professors Robin Landa
 Denise Anderson
 Rose Gonnella
- Ask Ed Jonnston for his River Run Media contact
- Friends who graduated in the last year

Personal network:

Dad's textile industry design contacts

Art Directors Club Portfolio Night
- Alex Medina - Eric Weber
 - Jill Delavecchia

Mom's bank marketing Director (in house design dept?)

STAND OUT

Identify the type of work you want to do and the places you want to do it, and develop a plan to get you there.

- Pay attention to trends— what's current, what's coming, and what's obsolete.

- Spend time thinking about what your "ideal" professional life looks like and narrow down jobs where you'll search.

- Leverage your relationships—family, friends, mentors, professors, mentors, colleagues, alumns—because referrals from the people you know are highly effective when you're networking.

- Never compromise your personal values or brand for a job, or you can damage your professional reputation in the long term.

- In an interview, a lasting and positive impression is the result of careful attention to many small details that, managed collectively, offer an overall impression of your personal brand.

- Create a personal job plan that outlines a strategy for your job search.

16. MANAGE YOUR STAND-OUT CAREER

Sharing personal career stories to inspire others.

On a recent class trip to New York, my portfolio students visited four RBSD alums who are successfully employed at Saatchi & Saatchi Wellness. When I asked the graduates and a room full of Saatchi personnel about the lessons they could impart to students, one person answered, "Do something purposeful." Another said, "Stay passionate," while a third responded, "Learn as much as you can." In other words, their messages varied.

Over the course of your career, you will be given a lot of advice. Listen to it all. One day, a tidbit of wisdom will come back to you and resonate to your very core. You will find your mantra to live by, and you will have wisdom to share with others.

I have two bits of advice to share. First, do what you love most, and money will follow. Find a purpose (or calling) to wake up with each day and give meaning to why you are doing what you do. For several years now, I have kept a fortune cookie fortune taped to my monitor that reads, "Pleasant experiences make life delightful. Painful experiences lead to growth." It reminds me that some days may not be pretty, but the process of learning will take me to a better place. Living a purposeful life will bring happiness and personal satisfaction. Be mindful; not every day includes balloons and cake, just like a "perfect" job is not always a party. When you make life decisions that are true

to who you are, though, you'll find that the lows are shorter and highs last longer.

My second piece of advice is to trust your instincts. Rely on your gut when it comes to choosing an idea, picking a color, or hiring a designer. Instinct is your best friend, the entity that would help you make the right choices if you got stuck on a desert island together. Your instinct is a beacon in a storm, a full-bodied cabernet paired with a piece of dark chocolate (I'm projecting again), and a hug when you need it. When you nurture and develop your instinct, it will always be there for you.

In this chapter, I've asked people I know well or who I have met in my professional journey to share guidance with you. Each one has taught me something, mostly because I was open to listening and learning from their knowledge and experience. Some are not creatives *per se*, but their advice

is universal, and designers should look to the world—not just the design industry—for inspiration. Be open to what they've experienced, and find something to inspire you in what they have to say. They may offer a bit of advice that stays with you through your life and carries you through to the greatness you hope to achieve. Keep listening. You may meet someone along the way, when you are open to the message, whose insights become part of your core. And don't dismiss a project, meeting, or situation that does not go as well as you hoped, because the outcome—learning something—can give you far more than a new piece for your portfolio.

Every stage of your life has brilliance, and as you get older and your experiences add up, you'll find that sharing what you know with others is simply joyful, just as the people in this chapter discovered by sharing with you.

Ria Venturina

"Release your inner child, and love what you do."

It's going to be just fine after you graduate. Everything will come easy for you. You'll land your dream job, start living in a big city, and your pay—oh man, your pay! Okay, this will happen for some, but it may not happen for you, at least not right away. Read on if you're still a few steps short of "standing out" (pun definitely intended).

First, ask yourself this question: can you see yourself working in your field of study for the next 10 years? Interviewers who look at your portfolio can see the difference between work with passion and work with *meh*. My passion for advertising and design helped me stand out from my peers. Before I embraced that, figuring out what I wanted to be was a constant struggle. When I finally imagined myself with a long career in advertising, my work blossomed. According to *Business Insider*, people spend an average of 90,000 hours at work during their lifetime. Considering we only have that one lifespan, we should be using our time wisely. (Netflix, of course, is an exception.)

Second, let your inner child out. The inner child who holds your imagination can help you think outside the box. In the working world, I learned that most designers can be replaced. The irreplaceable ones are those who can think. Conceptual thinkers are one-of-a-kind and can see the big picture. They have a secret power that can make sense of abstract thoughts. Advertising feeds off of imagination and innovation because it lives in an abstract world. It's the perfect planet for an abstract thinker. Let your inner child play. Let her (or him!) create a monster wearing a tutu in a submarine. Trust me, somewhere in the future you'll be thanking that inner child.

Finally, be confident in everything you do. Walk into every interview like you already have the job. You have worked hard to create something that represents you; it's an honor to show off your talent to potential employers. They make time to hear what you have to say, so say it proudly. Confidence can also create opportunities to enhance your skill and networking abilities. You will stand out when you create a "can do anything" presence among your team members, yourself, and—who knows?—maybe even the CEO of Google.

Ria Venturina is an art director at Saatchi & Saatchi Wellness. See riaventurina.com.

CAN you imagine yourself doing this job for the next 10 years?

Robin Landa

"To be nimble, become a T-shaped creative thinker."

Employers want to hire nimble thinkers, people who are not only content experts but who also are agile in adapting to new technology and new directions in their fields. Employers and clients call upon creative professionals to quickly conceive and execute grand ideas and to react nimbly to rapid changes in industries, technology, and business sectors. Generating viable ideas in the digital age presents new challenges for all creative professionals.

Designers need to be empathetic, interdisciplinary thinkers working across media. They must fully understand what each specific media channel can do and how each can be utilized to deliver an engaging brand experience, contributing an integral element of the brand narrative. Many art directors, graphic designers, and creative directors face the new challenge of creating relevant, original content for brands, causes, and organizations. Unique content in the form of films, stories, digital

utilities, interactive games, or other forms of entertainment for online platforms, such as Facebook, YouTube, or Twitter, as well as live events, must give people a story to tell, one that engages them enough to share.

To face these new challenges:

- Cultivate your creative thinking and prepare your imagination; and

- Become a design expert with additional knowledge gained by keen interest in a broad range of subjects.

NIMBLE

Thinking Creatively in the Digital Age

ROBIN LANDA

Learn to view graphic design, branding, or advertising problems by thinking of them as content creation rather than artifact creation. Address any assignment with the frame: This is the very first graphic design or advertising solution; there are no exemplars, no models. To do this, you must have an open mindset—you must set aside the closed conventions of what design, branding, or advertising is supposed to be. You strive to make a brand social and create original content that people will find engaging, relevant, or beneficial. Ask: Is the idea flexible? Is it entertaining? Is it informative? Does it have value? Is it true? Is it true for others? Will it positively impact society? Does the idea inspire content that people will share? How will the idea manifest and function for the capabilities of specific channels and platforms?

The motto of this mindset is: *Entertain. Inform. Be useful. Do good.*

Prepare with studies in the liberal arts, art history, and design criticism. Become a T-shaped creative—a content expert with additional knowledge in a broad range of subjects. The vertical bar of the T represents expertise and skills in one's field of study and practice; the horizontal bar of the T represents knowledge in areas other than one's own, interest in other disciplines and subject matter, depth and breadth in one's thinking as well as the capacity to collaborate across fields with other experts.

Rapid technological changes have altered the nature of work, human behavior, and what creatives need to be able to do. Keep David Ogilvy's wise advice in mind: "If you want to be interesting, be interested."

Robin Landa is the author of 24 books, including Nimble: Thinking Creatively in the Digital Age. *She is a distinguished professor at the Robert Busch School of Design, Michael Graves College, Kean University. See robinlandabooks.com.*

Cesar Rubin

"Listen, watch, and stay open."

If I were to have a conversation with my younger self about my future, I would tell myself five things:

1. Listen to your gut.

It's not enough to just hear what is actually being said; you have to read the subtext "between the lines" and hear the message that isn't being stated outright.

2. Observe people.

Walk around New York City, or any big city, and when you see people on their way somewhere, reading something, or talking on their phone, make up stories about their lives and experiences.

3. Watch the classic movies.

Ideas and solutions appear in the most unexpected places. Devour what fuels your creativity—and what doesn't.

4. Stay open to criticism and trying new things, even when it makes you uncomfortable.

Taking on challenges and working outside of your comfort zone will bring out the best in you.

5. "No" doesn't exist.

Everything speaks to us; you just need to be open, listen, and see things that aren't there. As creatives, it's our job to be visionaries and to create the things we want to happen.

All of your successes will happen because you never gave up. You will make people around you better and empower them to feel ownership. You will learn that when your team grows, so do you.

Cesar Rubin is a freelance creative director. See cargocollective.com/cesarrubin.

Alan Robbins

"Keep passion at the center of your choices."

Early on I knew a simple fact about myself: I love making things. The process of coming up with new ideas, working them out step by step, paying attention to the strengths and weaknesses of materials, seeing new things emerge in the world—all of it has been a lifelong passion. It was only later that I discovered that design is an actual profession. The beauty of being a designer is that you can build a career around this passion.

It almost doesn't matter what I am doing as long as I feel creative about it and that I am making something new; that accounts for the zigzag nature of my career. I have worked as an art director at an ad agency developing campaigns for companies large and small; as a creative director at a marketing company developing branding for a variety of clients; and as a freelance designer for many companies in the toy and game industry, inventing board, card, text, and digital games. I have been a professor for 25 years, developing new courses and trying to pass on my passion to create things to my students. At the same time, I have authored over 35 books—mysteries, short stories, and numerous essays about creativity, design, and technology.

See what I mean by zigzag?

Job titles and project goals can change, but the basic passion remains. Putting words together to tell stories; shapes and colors to create graphics; or parts and pieces to make games is all design to me, that delicious creative process involved in making dreams real.

My advice to anyone asking about life as a designer is this: no matter what you do or which path you take, straight or crooked, the trick to success is keeping your passion—for creativity, for making new things, for helping people, whatever it is—at the center of your choices. Money and prestige are fine, but they are also transient. Enthusiasm keeps you going in the long term.

Even if you zig or zag down your career path, you never get lost when passion is at your core, because you are always doing what you feel you are meant to do.

Alan Robbins is a professor at the Robert Busch School of Design, Michael Graves College, Kean University. See alanrobbins.com.

221

Paula Bosco

"The road to a stand-out career begins with honest evaluation."

As an industry expert with nearly 20 years of regulatory legal and compliance experience in the financial services sector, I have come to learn that building a stand-out career is not something that just happens; it requires deep thought, hard work, and a level of dedication that is consistent yet flexible. It doesn't happen overnight, but rather is achieved through a series of experiences that define—and continually redefine—who you are, as both an individual and a professional.

The road to a stand-out career also requires a high degree of honesty—with yourself as well as with others. At its most basic level, that honesty starts with a truthful evaluation of your strengths, weaknesses, goals, desired work environment, etc. However, at some point, that honesty must evolve to include an evaluation of other considerations that may not be so obvious when you're starting out as a young professional. For instance, what are your core values and beliefs? Will the career choices you make regarding prospective employers/clients, location, and work projects be consistent with those values and beliefs? If there is a disconnect, will it be temporary or permanent? Will you be able to work, thrive, and stand out in the face

> " A CAREER WITHOUT PASSION IS LIKE A CAR WITHOUT FUEL: YOU WON'T GET VERY FAR. "

of that inconsistency? Similarly, what sacrifices—personal, creative or otherwise—are you willing to make and at what cost? It's hard to keep building a stand-out career when you no longer remember the reasons for the choices you've made or when you lack control over the things that make you truly happy.

Finally, understanding that your responses to these questions will (and should) change over time is paramount, as is your willingness to ask yourself new questions that are undoubtedly shaped by your growing body of experience.

Although it's almost impossible to build a stand-out career without mastering the basics, there is one additional ingredient that is most important: passion. I once read that a career without passion is like a car without fuel: you won't get very far. And you certainly will not stand out.

Passion involves:

Thoughtfulness. Are you doing what you love?

Hard work. Are you willing and able to keep doing it and to make sacrifices along the way?

Dedication. Are you committed to your process, your brand, and your goals, and to developing the requisite skills and knowledge to be successful?

Honesty. Are you being truthful with yourself?

Passion requires a willingness to take risks—not the reckless kind that can lead to undesired consequences, such as a loss of credibility or brand diminution, but rather the kind of risk that forces you to think and act outside of your comfort zone. Passion also requires an understanding—and acceptance—of the fact that you may (and, at some point, will) experience failure. How else will you be able to define and keep redefining your core values and other non-negotiable aspects of your professional life? Once you become honest about your level of passion, you will be in a much better position to build a fulfilling and lasting career—one that truly stands out.

Paula Bosco, MBA, JD, is the president of the Bosco Group. See bosco-group.com.

Ron Badum

"Arm yourself with the right resources and tools."

As a creative director in advertising and marketing for more than 30 years, I have found that the best way to stand out from the competition is to be armed with the right resources and the right tools. Without these two elements, any designer can get lost in a competitive crowd.

First and foremost for designers is the quality of their network. A well-established pool of multidisciplinary professionals is essential and makes it possible to call upon any variation of skill sets required for any particular project. Throughout their entire careers, outstanding creative people continually maintain and nurture positive relationships with talented and respected individuals from a multitude of industry specialties.

The second element that successful designers have in their arsenal is a basic but essential tool: their portfolio of work. You should always treat your portfolio like it's a living, breathing entity that needs your attention. Keep it current and fresh, delete anything you are not proud of, and make sure it represents your latest and best projects. The most successful designers always have their best thinking ready to show at a moment's notice. With a well-designed and up-to-date website, you'll always be ready to show and talk about your work.

Do an outstanding job of maintaining these two elements, and your career will reward your efforts.

Ron Badum is creative director at Badum Creative Group. See badumcreativegroup.com.

Joseph Serrani

"Sweat the small stuff."

It's your job to sweat the small stuff, to become an invaluable asset that your peers and superiors can rely on. It's not about being a doormat but about earning the reputation that when you work on something, it's going to be looked at, cared for, and well-executed, and that the people you work with actually like working with you. This is very important when you start out, especially in graphic design and advertising. Both fields are small enough that you can and will see some of the same people you work with now again later on in your career. So, it's really important that people like your partnership. Honestly, your work can be amazing, but if no one wants to work with you, you won't be working.

Joseph Serrani is an art director at Saatchi & Saatchi Wellness. See dapperjoe.com.

Jim Burns

"Build a strong foundation as a problem solver."

If someone takes guitar lessons because he wants to be a fantastic player, it's unlikely that he would head into his second lesson and tell the instructor, "Oh, I've already done that. You covered it last week." Yet my design students sometimes react to an assignment by saying, "We already covered that drawing technique!" or "I already did enough sketches for last week!" What they're really telling me is that they're not putting forth the effort required to master their craft.

People who become great begin by establishing a foundation and reinforcing it through practice. They pick up their sketchbook, guitar, or whatever it is that they're learning, and they keep at it until they can draw or play like it's their second language. When you have a strong foundation, you can build a better house. If it's a mess, you'll never be able to put your structure together.

In my time as an adjunct instructor, I have focused on giving students the base knowledge and design-thinking skill sets that form a strong base.

For example, I teach perspective drawing differently than some of my peers: my approach is to give students a pencil and an eraser—no rulers. I don't have them follow guides. (I'm not saying there's anything wrong with drafting and similar pursuits, but that's not the focus I want to accentuate.) I do it because I want my students to think of paper as another tool. They can crumple it up, toss it over their shoulder, or rip it up and start over. My lesson is to make them realize that, together, their pencil and brain are way more powerful than a triangle, ruler, or any other tool they're using.

Sometimes, students will tell me that they're struggling, that they just don't "get it." My advice is this: make sure you understand the foundation of what you're learning. Practice even when it seems pointless and repetitive. Don't worry about where you're going. Someday you'll put it all together, and that's where you become valuable. It's what will make you an awesome problem solver, and better problem solvers make better designers.

Jim Burns is vice president of product design and development at EastPoint Sports, an adjunct instructor at the RBSD, and a freelance designer. See jpbdesign.com.

~ STAND OUT ~

Dave Fleming

"Know your goals and build relationships."

Over the course of my career, I have done lots of different things: I have been an entrepreneur, a salesperson, and a manager. I have been hired for almost every job I have ever applied for, and I've hired and fired many people, from counter help to management.

What I have experienced myself and observed in my most successful employees is this: to be successful, you have to know what you want from your career and where you want to be in the years to come. You have to set goals, and you have to write them down. Know them. Refer to them often. Work to achieve them. Your goals will change as your life changes, so you'll have to update them from time to time to get where you want to be. Your goals are all about you and what you want out of life. You'll only get there by moving forward on the path you lay out for yourself and by being positive and alert. It's not easy—lots of things will pop up to slow you down or make you settle.

With your goals in mind, and some skills and talent, you are ready to get started. Everyone has different reasons for wanting or needing a job—money,

location, hours, and social interaction top most lists. When you are called in to interview for the job you want, show up on time, look the part, and ask questions in addition to answering them. A good interviewer will engage you, but you can't count on that when it's your one shot at the job you want. You have to find out what the employer is really looking for. With this knowledge, you can show and wow them with what you bring to the table. The questions you ask will help plug you into what the employer needs. Help them see how you can fill the position with the best person for the job—you. Remember, it is all about the employer and how you can help them. Have a good game plan going in.

Don't take a job that doesn't fit into your goals or life, unless you need the money. If you do take a job for money, work it hard. Change it if you can, but if you can't, do a great job where you are, and use it to get your next job. Never burn bridges—you will want the

recommendation, and you may want to go back someday or do future projects with your former colleagues.

Once you're in a job, set up and get going. Have fun, enjoy the work, and form lasting relationships with the people in your industry. It will pay off big down the road. Always get better at what you do, keep learning, and stay up to date. Your employer will want results. It will be up to you to deliver what they want and on time.

Remember: if you have the talent, build connections, and keep your goals in mind, and you are willing to take chances when they come along, your career will be a ride to remember.

Have fun, make money, and be happy doing what you want to be doing.

Dave Fleming is an entrepreneur, salesperson, and manager.

Kristin Leu

"Leave your ego at the door, work hard, and pitch in."

As a fine arts major, I selected graphic design because it is creative and artistic. I learned about design's ability to interpret the meaning of content and tell a story visually. After I received my BFA, I worked as a graphic designer, art director, creative director, and business owner. In these roles, I discovered that design is a powerful tool to help solve problems and create change.

In order to fully understand design's value, I continued my education and received a master's degree in design management, which helped me bridge the gap between design and business. I learned design strategy, design thinking, and the "bigger picture" of design: good design has the ability to solve problems, educate, build awareness, save time and resources, increase productivity and revenue, and create sustainable change.

Throughout my education and career, I've worked with various teams: in-house, in design firms and advertising agencies, as a volunteer, and as an entrepreneur. While each workplace has variations in company culture and product offerings, there are a few common points to practice for a successful, fulfilling career:

Solve a problem. Good design is not enough. Remember that your clients are coming to you to solve a problem. Demonstrate how your design solves their problem, and tell your clients' stories in a visually engaging and creative way.

Practice your presentation skills. It's important to articulate the concepts and thinking behind your designs. You will be presenting to colleagues, clients, and prospects throughout your entire career.

Design every project to your best ability. Do not cut corners. Embrace the detail work and the production. Care about the entire process from concept to completion, and make sure it reflects your abilities and work ethic.

Collaborate, brainstorm, and be a team player. Leave your ego at the door, work hard, and pitch in wherever you're needed. Go above your job description, beneath your title, and beyond the project requirements to help your team succeed.

Enjoy the people you work with. Partner with colleagues in design and other disciplines who inspire you. Designers work long hours, so surround yourself with people you enjoy and whose work and principles you admire.

Share ideas and share the credit. There are a million good ideas out there, but it's the implementation that determines an idea's success. Collaborate with others, and you will achieve greater, more rewarding results.

Kristin Leu is principal and creative director at Leu Design. See leudesign.com.

Jennifer Bohanan

"Pick your battles and trust the process."

As a creative working in a commercial enterprise, you're in an interesting position. On one hand, you're called upon to eagerly generate fresh ideas and innovative approaches, often under tight deadlines and with vague objectives. On the other, you're subjected to an ongoing stream of input, opinions, and, yes, criticism from a lot of different people—your supervisors, colleagues, clients, and the vendors you do business with. Some will have helpful things to tell you; others may have no idea what they're talking about. You'll have to find ways to respond to—and work effectively with—everyone, and that can be a real challenge, especially when you're emotionally invested in what you're doing.

When you put a lot of yourself into a project, as designers (and writers!) tend to do, it's easy to get defensive when you feel that your work is under attack. And it can be frustrating, because despite your tremendous effort and the irrefutable logic behind every decision you've made, someone is inevitably going to ask you—or direct you—to change something. And you may have to make the change, whether you agree with it or not.

Until now, you've exercised your creative talents in a positive and encouraging environment.

Your friends and family are almost always impressed at your talent and commitment. Your instructors and mentors give you helpful suggestions about how to improve your work, which you can use or toss aside. You've had the autonomy to choose what you'd like to work on and where you'd like your focus to be.

That all changes in a business environment, where priorities compete, opinions clash, clients call the shots, and there's real revenue on the line. There's no room in that mix for ego.

When you find yourself feeling frustrated and vulnerable, resist the temptation to let your feelings get the better of you. It's a waste of everyone's time. Make it a point to develop a thick skin, put your ego aside, and really listen. Look beyond the source ("The boss's son said what? Isn't he still in high school!?") and try to understand how that different perspective fits into your total understanding. And always remember that it's not about you and your creative genius; it's about producing the best possible outcome given the parameters of that project.

The time will come when you'll believe something strongly, and you'll choose to stand up for

that idea. If you haven't spent the last few weeks, months, or years resisting others' input on everything and you've established yourself as an open, collaborative member of the team, there's a good chance that you've earned the respect you need to make your point and, quite possibly, change a perspective that differs from yours.

The path to a successful project is often filled with bumps and curves. At times it can feel like you're never going to get to where you need to be. But invite criticism, input, and feedback anyway. In my experience, by the time all those perspectives and opinions are considered and assimilated (even if you winced when you heard them), the outcome is infinitely better than anyone, including you, might have achieved alone. You'll get there. You just have to trust the process.

Jennifer Bohanan is a freelance writer and editor. See wordsmatter.com.

17. CASE STUDIES: DESIGN CAREERS

Exploring student careers that stand out.

On my first trip to Europe, I distinctly remember getting off the plane in London in the morning, tired and disoriented, but excited to have arrived. A few days later in France, my soon-to-be spouse and I had a similar experience stepping out of an overnight train from Paris to Nice; we were hungry (dining-car offerings were less "gourmet" than expected); tired (two additional passengers shared our closet-sized couchette); and worried (because we did not have a place to stay). I can still see it clearly: we gathered our big suitcases and personal effects, and walked out of the station into the unknown.

My maiden voyage to Europe reminds me of what it is like to start a career. I thought reserving a first-class berth on a train to Nice would be intimate and romantic. Instead, we were required to bunk up with two strangers. Even with the best-laid plans and highest expectations, things tend not to turn out as you predict. There are other unknowns: someday you may have a significant other in your life and/or children. At many points, you may contemplate whether to stay at a job or trade your current employment for another opportunity with potentially better projects, a higher position, or a bigger salary.

The students who share their stories in this chapter also walked into the unknown, unsure of how their careers would begin, but they all found a unique path for getting there and managing the journey. Two of my current students, Jennifer

Abujawdeh and Eric Vita, started their own design and print brokerage company while still at the RBSD (inksnobs.com). My former student, Jaime Mazauskas (from Chapter 7), landed his first job at Designer Greetings after several people in the company were impressed at the ManiaCrawl event he created and designed. Another former student, Connor Paglia (from Chapter 4), fulfilled a childhood dream of working for Major League Baseball. A third, Max Friedman (the only designer featured three times in this book— in Chapters 5, 12, and 17), was asked to join Droga5 in New York shortly after he won an ADC "All-Star" award. (Max asked me the morning after his "All-Star" win what he should do to find a job. Don't worry, I told him, they will find you.) Last, but certainly not least, graphic designer and artist Suzanne Anan, who was one of my first students, has spun herself

a beautiful life and now has her own business, blending her love of design, poetry, and art. All of these students, of whom I am enormously proud, have landed where they are by doing what they love.

Some days, you will be tired and disoriented (deadlines!), worried about balancing your professional and personal life (please contact me when you obtain that formula!), and may even contemplate moving on to whatever is next (trust your gut!). You may not always know where your career will end up, but if you are continually excited about where it seems to be leading, you are moving in the right direction. Just as an employer hires you and not your portfolio, your journey of meeting people, having experiences, and growing as a person is your reward. The destination is nowhere near as important. Be strong. Be confident. Be happy. Stand out!

Suzanne Anan

Visual Designer and Proprietress, Suzanne Anan Fine Art & Design

suzanneanan.com

My first design job out of college was at *The Star-Ledger/NJ.com*, owned by the Newhouse family. I heard they were hiring in their Newark, New Jersey, office, so I sent my resume. A month went by and I didn't hear anything, so I called and spoke to the hiring manager. I explained that I had sent my resume weeks ago for the graphic designer position and never received a response. I took the opportunity to describe how I was more than qualified for the position. They called me in for an interview a week later. I was hired the following month.

My plan was to stay for a while and seek employment opportunities at one of the sister publications the Newhouse family owned at CondeNast. All the while, I felt I had the best job working for a newspaper/media company. I went back and forth designing editorial covers and pages for both print and digital formats. One thing I did right was to continue my education. The company had a tuition reimbursement program, so I applied for a master's degree at New York University in its international study program

in Venice, Italy. I was accepted but realized that studying abroad for two years meant giving up my beloved position at *The Star Ledger*, so I resigned. However, resigning meant no tuition reimbursement because I was no longer an employee. I went through with it anyway; I wasn't going to miss this opportunity. It wound up being one of the best choices I could have made. This life-changing experience broadened my perspective. The education I received helped me to think globally and to create art and design for a multi-cultural and diverse audience.

I learned that my deep passion for painting nurtures my design. I always thought I would have to choose one over the other, but I find that I am the most

productive and creative when I am doing both. My fine art career has allowed me to exhibit abroad in cities like Florence, Paris, Dublin, and Tokyo. Through the years my work has evolved naturally. The experience of exhibiting art and of designing has led me to merge my disciplines to create art and branding opportunities on a large scale for interior spaces.

I keep a quote from Buddha in my studio that reads, "In the end, only three things matter: how much you loved, how gently you lived, and how gracefully you let go of things not meant for you."

Jennifer Abujawdeh

Principal and Creative Director, Inksnobs
inksnobs.com

I've always wanted to run my own business, and I've known it for as long as I can remember. My dad is a computer scientist who has worked to provide me with a comfortable life; he passed his strong work ethic along to me, and it positioned me to start my own business. Also, I've worked for several trade printers, which provided me with the resources to become a print broker. I used that experience to my advantage when I started InkSnobs. Those connections allowed me to offer better service to my clients.

I sacrificed a lot of my personal time for the company, and it has paid off very well. One thing I might have done differently is to learn more about managing a business in terms of accounting and the technical aspects of a web-based business.

Succeeding at anything in life requires time, energy, and passion. Without love for what you do, you'll lack the motivation to develop any of them. The most important lesson I've ever learned is that being able to fulfill your own dreams is exhilarating.

As I prepare to graduate from college, my career goals have changed significantly. Although I have always wanted to be an entrepreneur, it's more clear to me than ever that I need to strive to offer something that hasn't been provided before: meeting the needs of my consumers before they even realize they have that need.

Forward thinking is key, because where you're going is much more important than where you've been.

Eric Vita

Principal and Creative Director, Inksnobs

inksnobs.com

Ever since I started to learn about design, I knew I wanted to own a design studio, and now I am the co-owner of InkSnobs. When I dreamed about owning my own business, I didn't think it would happen until years after I graduated from college, but I am a full-time student who has two part-time jobs in addition to owning my own company. The most challenging part for me is balancing the business and my jobs with school. Time management is proving to be critically important.

I believe Jennifer and I had the right idea when we started InkSnobs—the first thing on our to-do list was to create a website and configure our product pricing. After that, we bought advertising and began to promote our company. If I could change anything, it would be to find more time to work on the business. As a full-time student, my time is limited, but I believe we are headed in the right direction.

The greatest advice I ever got was to not be afraid of mistakes. Mistakes are necessary before you can reach something successful.

As I graduate from college, I have multiple career goals. I want to continue growing Ink-Snobs, but I also want to work for a design agency. I believe it's a real-world experience that will help me continue to move our company in the direction it should go. If I could speak to my younger self, I would advise him to learn more about the business world. Without any previous business experience, this sort of knowledge would have helped me immensely.

" FOR A 15% DISCOUNT ON SERVICES USE THE CODE STAND OUT "

inksnobs.com | experts@inksnobs.com

Connor Paglia

Product Designer, Major League Baseball Advanced Media

connorpaglia.com

I have a memory from my design internship of sitting at my desk looking at the "MLB At Bat" app on my phone. I was as impressed with the overall design and functionality of the app as I was curious about what company designed and built it. After doing some research, I found out it was Major League Baseball Advanced Media (MLBAM). The timing was perfect: just as I was transitioning out of college, the MLB organization was transitioning into an in-house design agency and building a brand-new team to staff it. I found a job opening for a mobile product designer posted on glassdoor.com. I applied and hoped for the best.

When I was called in for an interview, I showed and told the story of my Mysterious Deep project, which demonstrated my attention to detail, my versatility with design, and the fresh ideas I could bring to the table. MLBAM hired me straight out of college, citing my solid portfolio, freelance experience, and my two internships.

In the time since I graduated, I've learned that the design industry will only continue to grow and that truly understanding a product and making it successful requires a full integration of more than just design. I plan to learn product management and develop the skills to own and lead a product of my own in the future.

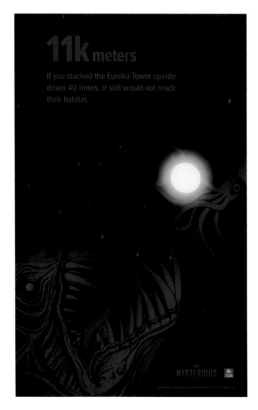

Jaime Mazauskas

Marketing Coordinator, Designer Greetings

jaimemazauskas.com

In spring 2014, my friends and I were planning our annual trip to WrestleMania 30 in New Orleans. As a New York Giants season ticket holder, I love tailgating but we knew it wouldn't be an option (because we weren't transporting a grill or tent from New Jersey to Louisiana), so I decided to create a poster for a bar crawl along Bourbon Street to WrestleMania at the Super Dome. Through the power of design, advertising, and social media, I was able to draw more than 200 people to the first annual "ManiaCrawl." The following year I planned the event again, for Wrestle-Mania 31 in San Jose, and this time around I developed an entire brand and web presence. I created a buzz for the event by networking through multiple podcasts, web series, and blogs. More than 750 people signed up for ManiaCrawl 2! This experience led to me a marketing coordinator position at Designer Greetings, where I essentially use all the tools I used to create awareness about ManiaCrawl.

The best career advice I ever got was to do what you love. I love working in design and marketing, and when I am able to combine those with things I love—like pro-

wrestling—it never seems like work to me. I love the Steve Jobs quote, "The people who are crazy enough to think they can change the world are the ones who usually can." I wasn't trying to change the world, but I had a ridiculous idea that I would be able to gather

hundreds of wrestling fans worldwide for an epic celebration of fandom before the biggest event of the year, and with hard work, dedication, passion, and a little courage, I was able to create a legitimate brand that is now recognized within the wrestling community.

Max Friedman

Junior Art Director, Droga5

maxbfriedman.com

My first job out of college was as a junior art director at an advertising agency in Manhattan called Droga5. The way I got the job proves that you never know what opportunities you'll miss out on if you don't work hard and strive for greatness. In cities around the world, the Art Directors Club hosts an annual portfolio competition for students and working professionals to showcase their work to top creative directors. I heard about the competition through my professor Robin Landa, who encouraged all of her students to register for the New York event. The individual with the best overall portfolio in each city (as determined by the head creative directors in attendance) would be deemed that city's "All-Star" and go on to compete in a week-long event with All-Stars from around the world. In a speed-date-style, 45-minute roulette showdown, participants had to meet with three different creative directors to sell themselves and years' worth of work in 15-minute increments. No big deal, right?

I actually won "Best Portfolio of Show." That honor was followed by a slew of emails

from companies inviting me to interview with them. From this experience, I learned that hard work pays off. About a week after the event, I received an email from the creative recruiter at the esteemed advertising agency Droga5 asking if I'd come in and meet executive creative directors Neil Heymann and Kevin Brady. They hired me, and it's where I work today.

My plan for the future has always been to be happy. The definition of happiness, however, changes over time. I have yet to meet someone whose life has gone according to a plan that they concocted when they were young. Plans and people evolve. There's no way to predict how one turn of events will affect the outcome of something else and

so on—the next thing you know you're on a plane to Africa to photograph wild elephants for *Esquire* magazine.

One thing I've learned in my journey thus far is to surround myself with people who are passionate about their goals. When you're around people who are better than you, you will push yourself to trump them. I am currently attempting to surround myself with the most talented people I can find, so I can grow and learn as much as I can from them. I hope to influence them as well.

Treating my collegiate projects as if they were real-world, extensive assignments prepared me for tackling professional projects. Approaching every project, no matter its scale or importance, with the same level of integrity, challenge, and passion is key to being able to deftly and successfully handle huge undertakings when they present themselves.

If I could speak to my younger self, I would say, "Learn from those who are around you, take as many chances as it takes, and believe in yourself. You'll change the world someday."

RESOURCES

Find the assets and organizations to help you stand out.*

Professional design organizations:

The Ad Council
adcouncil.org

Advertising Women of NY
awny.org

American Design Council
americandesigncouncil.org

American Institute of Graphic Arts (AIGA)
aiga.org

Art Directors Club
adcglobal.org

Association of Illustrators
theaoi.com

Design Management Institute
dmi.org

The One Club
oneclub.org

The Type Directors Club
tdc.org

Society of Illustrators
societyillustrators.org

Design publications:

3 x 3: The Magazine of Contemporary Illustration
3x3mag.com

Adweek
adweek.com

Applied Arts Magazine
appliedartsmag.com

*If an entity I've listed here is no longer active, try another, or conduct your own search for organizations with similar goals.

CMYK Magazine
cmykmag.com

Communication Arts
commarts.com

Creativity Magazine
creativity-online.com

Graphic Design USA Magazine
gdusa.com

Graphis Magazine
graphis.com

HOW Magazine
howdesign.com

Layers Magazine
layersmagazine.com

Print Magazine
printmag.com

Design blogs:

UnderConsideration
underconsideration.com

Creative Bloq
creativebloq.com

Cooper-Hewitt
cooperhewitt.org/blog

Design Observer
designobserver.com

Portfolio reviews:

AIGA (local chapters)
aiga.org

Art Directors Club
portfolionight.com

The One Club
oneclub.org/oc/education/portfolio/

Student design competitions:

ADC Awards
adcawards.org

AIGA
aigaredesignawards.com

Awwards
awwwards.com

CMYK
cmykmag.com/contests

Communication Arts
commarts.com/competitions/design#student

Creative Conscience Awards
creative-conscience.co.uk/home/

Creativity International Awards
creativityawards.com

Design Ignites Change Fellowship
designigniteschange.org

The Dieline Awards
thedielineawards.com

Graphis New Talent
graphis.com/competitions/recent-entries/

Print Magazine
printmag.com/design-competitions/

Webby Awards
webbyawards.com

World Studio AIGA Scholarship
scholarships.world studioinc.com

Young Guns
adcyoungguns.org

National design conferences:

Advertising Week
advertisingweek.com

AIGA Design Conference
designconference.aiga.org

Generate
generateconf.com

HOW Design Live
howdesignlive.com

Maker Faire
makerfaire.com

Social Media Week
socialmediaweek.org

Online job boards:

AIGA Job Board
designjobs.aiga.org

Behance Job Board
behance.net/joblist

Krop
krop.com

Freelancer
freelancer.com

Glassdoor
glassdoor.com

HOW Design Job Board
howdesign.com/design-jobs

Indeed
indeed.com

LinkedIn
linkedin.com/job

Monster
monster.com

Smashing Magazine Job Board
jobs.smashingmagazine.com

Skills instruction:

Adobe
adobe.com

Lynda
lynda.com

Jeff Witchel
(Adobe Certified trainer)
jeffwitchel.net

Peachpit Press
peachpit.com

Skillshare
skillshare.com

Envato Tuts+
tutsplus.com

Typefaces:

Adobe Typekit
typekit.com

CSS Font Stack
cssfontstack.com

Fonts.com
fonts.com

Google Fonts
google.com/fonts

Hoefler & Co.
typography.com

House Industries
houseind.com

Monotype
monotype.com

MyFonts
myfonts.com

Paper:

Crane
crane.com

French Paper
frenchpaper.com

Mohawk
mohawkconnects.com

Neenah
neenahpaper.com

Paper Presentation
paperpresentation.com

Strathmore
strathmore.org

Printing:

Blurb
blurb.com

Cranky Pressman
crankypressman.com

Jakprints
jakprints.com

Jukebox Print
jukeboxprint.com

Lulu
lulu.com

Mama's Sauce
mamas-sauce.com

The Mandate Press
themandatepress.com

Moo
moo.com

New Print Factory
newprintfactory.com

Sticker Giant
stickergiant.com

Vahalla Studios
vahallastudios.com

Print portfolio suppliers:

Klo Portfolios
kloportfolios.com

Lost Luggage
lost-luggage.com

Pina Zangaro
pinazangaro.com

Portfolio and Art Cases
portfolios-and-art-cases.com

Photography:

Adorama Rentals
adoramarentals.com

B&H Foto and Electronics
bhphotovideo.com

Lumoid
lumoid.com

Savage Universal
savageuniversal.com/products/
seamless-paper

Stock images:

123RF
123rf.com

Corbis Images
corbisimages.com

iStock
istockphoto.com

Getty Images
gettyimages.com

Library of Congress
loc.gov

Shutterstock
shutterstock.com

Thinkstock
thinkstockphotos.com

Stock mock-up graphics:

Best Design Options
bestdesignoptions.com

Craft Work
getcraftwork.com

Creative Market
creativemarket.com

Graphic Burger
graphicburger.com

GraphicsFuel
graphicsfuel.com

Graphic River
graphicriver.net

Niice
niice.co

Pixeden
pixeden.com

PSD Covers
psdcovers.com

PSD Mockups
psdmockups.com

Mobile and web prototyping:

Marvel
www.marvelapp.com

Invision
www.invisionapp.com

Web hosting and domain
name registrars:

1&1
1and1.com

Adobe Business Catalyst
businesscatalyst.com

GoDaddy
godaddy.com

Google Domains
domains.google.com/about

Hostway
hostway.com

Liquidweb
liquidweb.com

Name
name.com

Namecheap
namecheap.com

Network Solutions
networksolutions.com

Website builders:

Adobe Behance
behance.net

Carbonmade
carbonmade.com

Cargo
cargocollective.com

Dribbble
dribbble.com

Squarespace
squarespace.com

Weebly
weebly.com

WiX
wix.com

Wordpress
wordpress.com

Social media channels:

Facebook
facebook.com

Instagram
instagram.com

LinkedIn
linkedin.com

Twitter
twitter.com

Tumblr
tumblr.com

Pinterest
pinterest.com

Vine
vine.co

FOR ADDITIONAL INSPIRATION AND INFO, PLEASE VISIT:
www.standoutportfolio.com
www.pinterest.com/ProfessorDMA

CREDITS

Thank you to everyone who generously contributed their talent and artwork to make this book stand out.

ALL OTHER ILLUSTRATIONS
in this BOOK WERE CREATED
BY MY LOVELY DESIGN
ASSISTANT, HENNA ARTIST, and
EXTRAORDINARY ILLUSTRATOR,
MARGARET GRZYMKOWSKI.

— Denise

INDEX